Musical Concerns

Musical Concerns

Essays in Philosophy of Music

Jerrold Levinson

OXFORD
UNIVERSITY PRESS

OXFORD
UNIVERSITY PRESS

Great Clarendon Street, Oxford, OX2 6DP,
United Kingdom

Oxford University Press is a department of the University of Oxford.
It furthers the University's objective of excellence in research, scholarship,
and education by publishing worldwide. Oxford is a registered trade mark of
Oxford University Press in the UK and in certain other countries

First Edition published in 2015

Impression: 1

Published in the United States of America by Oxford University Press
198 Madison Avenue, New York, NY 10016, United States of America

British Library Cataloguing in Publication Data
Data available

Library of Congress Control Number: 2014951280

ISBN 978-0-19-966966-0

Printed and bound by
CPI Group (UK) Ltd, Croydon, CR0 4YY

1007419512

To five giants: Cole Porter, John Coltrane, Billie Holiday, Gabriel Fauré, and Johann Sebastian Bach

Contents

Acknowledgments viii

Introduction 1

1. Philosophy and Music 7

2. The Aesthetic Appreciation of Music 17

3. Concatenationism, Architectonicism, and the Appreciation
 of Music 32

4. Indication, Abstraction, and Individuation 45

5. Musical Beauty 58

6. Values of Music 67

7. Shame in General and Shame in Music 88

8. Jazz Vocal Interpretation: A Philosophical Analysis 99

9. Popular Song as Moral Microcosm: Life Lessons from
 Jazz Standards 115

10. The Expressive Specificity of Jazz 131

11. Instrumentation and Improvisation 144

12. What Is a Temporal Art? 155
 with Philip Alperson

Index 171

Acknowledgments

The author and publisher are grateful to the original publishers for permission to republish the following:

"Philosophy and Music," *Topoi* 28 (2009), 119–23.

"The Aesthetic Appreciation of Music," *British Journal of Aesthetics* 29 (2009), 415–25.

"Concatenationism, Architectonicism, and the Appreciation of Music," *Revue internationale de philosophie* 60 (2006), 505–14.

"Indication, Abstraction, and Individuation," in C. Mag Uidhir (ed.), *Art and Abstract Objects* (Oxford: OUP, 2012), 49–61.

"Musical Beauty," *Teorema* 31 (2012), 127–35.

"Values of Music," in V. Ginsburgh and D. Throsby (eds.), *Handbook of the Economics of Art and Culture* (Amsterdam: Elsevier, 2013), 101–18.

"Jazz Vocal Interpretation: A Philosophical Analysis," *Journal of Aesthetics and Art Criticism* 70 (2013), 35–43.

"Popular Song as Moral Microcosm: Life Lessons from Jazz Standards," *Philosophy*, supplement 71 (2013), 51–66.

"What Is a Temporal Art?" *Midwest Studies in Philosophy* 16 (1991), 439–50.

"Shame in General and Shame in Music," "The Expressive Specificity of Jazz," and "Instrumentation and Improvisation" are previously unpublished.

Introduction

Musical Concerns is my fourth collection of essays in philosophical aesthetics, and the first since *Contemplating Art*, published in 2006. It includes, with one exception, essays composed between 2006 and 2014. Unlike its three predecessors, *Musical Concerns* is devoted exclusively to philosophical issues concerning music, as its title rather plainly suggests. But that is not to say that I have been occupied philosophically only with music in the past eight years. For a fifth collection, *Aesthetic Pursuits*, currently in preparation, brings together essays from the same period devoted to philosophical issues concerning arts other than music.

The present volume begins on a light note, with an essay written for a special number of the Italian philosophy journal *Topoi*. The aims of "Philosophy and Music" are modest. They are, first, to highlight the similarities and affinities between its two subjects, and second, to explore the extent to which philosophy can be musical and music philosophical, with what I hope is due respect to both activities, among the most rewarding in which human beings engage.

"The Aesthetic Appreciation of Music" and "Concatenationism, Architectonicism, and the Appreciation of Music" are both concerned with musical appreciation, or otherwise put, with the kind of music listening that is both satisfying and appropriate to the music that is its object. In the first essay I characterize in broad outline the aesthetic appreciation of music, and underline why an engagement with music so characterized counts both as aesthetic and as appreciation, and also emphasize the role of perception of gesture in the grasp of musical expressiveness. My remarks on the character and conduct of musical appreciation, with primary reference to instrumental classical music, are then illustrated by a look in some detail at the first movement of Gabriel Fauré's Piano Quartet in C minor, Op. 15.

The second, somewhat barbarously titled, essay is a rejoinder to the extensive 2001 critique by Peter Kivy of my 1998 monograph on musical appreciation, *Music in The Moment*.[1] The focus for the most part is a debate between Kivy and myself regarding the relative importance to the appreciation of such music of a conscious awareness of *large-scale* or *architectonic* form. The view I champion, labeled "concatenationism," holds that the importance of an explicit grasp of large-scale form is, while not negligible, decidedly secondary, overshadowed by that of a grasp of small-scale, moment-to-moment musical connectedness, while the view Kivy favors, labeled "architectonicism," accords to an explicit grasp of large-scale or architectonic musical form a capital importance. I first summarize the gist of *Music in the Moment*, which presents and defends, with qualifications, a concatenationist perspective on music, and then endeavor to reply in point-by-point fashion to Kivy's attack on concatenationism. I conclude by noting some surprising empirical studies of recent years that indirectly support a concatenationist perspective on musical understanding.

"Indication, Abstraction, and Individuation" takes up after long absence the concerns of my early essays on musical ontology—"What A Musical Work Is," "Autographic And Allographic Art," and "What A Musical Work Is, Again"—twenty-five years after the last of those.[2] I here revisit and redeploy, with some modifications and concessions in light of more recent work on the ontology of art, my original suggestion to the effect that musical works of the paradigm sort in the classical tradition are not *pure abstract structures*, like geometrical forms, but instead, *impure indicated structures*. In the present essay I attempt to further clarify and defend the idea of musical and literary works as indicated structures, underlining the core notion of *artistic* indication as a singular psychological act that yields the individuation of such artworks desired on other grounds, and which is to be distinguished from neighboring sorts of action, such as acts of *simple* indication. In the last section of the essay I allow myself some general reflections on what artworks such as sonatas and poems, the product of indication in the special artistic sense I highlight, themselves indicate, though in other senses of that term.

[1] Ithaca, NY: Cornell UP, 1998.
[2] These essays can all be found in *Music, Art, and Metaphysics* (2nd edn, Oxford: OUP, 2010).

"Musical Beauty," written for a special number of the Spanish philosophy journal *Teorema*, has three objectives. The first is to highlight a distinction, grounded in common critical practice, between good music in general and specifically beautiful music, where the latter is naturally thought of as a subclass of the former. The second is to characterize the specificity of beautiful music in this restricted sense, partly through paradigm examples, and partly through traits associated with or underlying what we regard as beautiful music. The third is to address the special value of beautiful music as opposed to that of good music more generally. In other words, why do we need specifically beautiful music, provided we have an ample supply of more generally good music?

"Values of Music" was commissioned, somewhat improbably, for a social science handbook dealing with cultural matters. It takes the form of a not too systematic survey of the kinds of value that music can have or the variety of ways in which music can be valued. First and foremost is music's *musical* value, or the value of music *as* music, which is a species of *artistic* value, where artistic value is understood to include, but not be exhausted by, *aesthetic* value. But music clearly has value beyond its musical value; most obviously, music has *economic* value, whether as commodity, service, or skill. More generally music has, or can have, various sorts of *practical* value. Notable among the practical values of music are social value, entertainment value, therapeutic value, functioning-enhancement value, and self-affirmation value, on each of which and a few others I briefly comment. The relation between the practical and the musical values a piece of music can possess is somewhat complicated, and varies from case to case.

"Shame in General and Shame in Music" was composed for an annual lecture series in Rome called *Sensibilia*, whose dedicated theme in 2011 was shame, or *vergogna*. The essay falls into two largely independent parts. In the first part of the essay I offer general observations on the nature of shame, contrasting it with some neighboring emotions and underlining its positive and negative aspects, and illustrating my observations with some examples, including one from William Styron's novel *Sophie's Choice*. In the second part of the essay I turn to the somewhat odd question of whether there are varieties of shame specific to music, and offer a simple taxonomy of such following the different roles involved in the musical situation. In the final section of the essay I address the more traditional question of whether music can actually express highly cognitive and culturally conditioned emotions such as

shame, and return a guardedly positive answer. The discussion in this section is continuous with that in earlier essays of mine on emotion in music, notably "Music and Negative Emotion," "Hope in 'The Hebrides'," "Musical Expressiveness," "Musical Expressiveness as Hearability-as-Expression," and "Emotion in Response to Art."[3]

"Jazz Vocal Interpretation: A Philosophical Analysis" and "Popular Song as Moral Microcosm: Life Lessons from Jazz Standards" represent two extended studies of vocal jazz, one from a primarily performative point of view, the other from a primarily ethical point of view. Both essays were stimulated in part by my avocation of the past twelve years or so as a fervent if decidedly amateur singer of jazz standards, a repertoire to which I have become passionately devoted.

The first of these essays, "Jazz Vocal Interpretation," is concerned to provide an account of what the vocal interpretation of a jazz standard consists in, of how such an interpretation functions in context, and of what is communicated by such an interpretation. How does the listener understand what is conveyed by a jazz version of a song, through the musical choices, but also the voice, body, and gestures of the singer? And in what way does jazz vocal interpretation of a standard differ most importantly from jazz instrumental interpretation of a standard?

In the second of these essays, "Popular Song as Moral Microcosm," I begin by reviewing some general considerations on the issue of music and morality, addressing for the most part instrumental music, and distinguishing among different sorts of moral force that such music might be said to exhibit. In the second and longest part of the paper I turn my attention to the moral dimension of song, and in particular, to the ethical quality of a number of vocal standards in the jazz repertoire. In the third part of the paper I offer tentative reflections on the distinctive moral force that I claim some of these great standards possess. Though copyright issues precluded reproduction of the lyrics of these songs, from the hands of such as Cole Porter, Lorenz Hart, and Harold Arlen, they are all readily available online, and readers are strongly urged to consult them when reading this essay.

[3] The first and second of these can be found in *Music, Art, and Metaphysics*; the third and fourth in *The Pleasures of Aesthetics* (Ithaca, NY: Cornell UP, 1996); and the fifth and sixth in *Contemplating Art* (Oxford: OUP, 2006).

"The Expressive Specificity of Jazz" and "Instrumentation and Improvisation" are two studies of instrumental jazz, the first focused on its distinctive emotional expressiveness, the second on its distinctive processes of production. "The Expressive Specificity of Jazz" owes its existence to an invitation to a conference entitled *Aesthetik des Jazz* held at the Freie Universität Berlin in 2012, at which I was the only speaker to present his paper in English. Among the other speakers were two Italians, but even they gave their papers in German. Clearly, this was an occasion with ample scope for shame on my part. Be that as it may, in the essay in question I try to identify what is specific to jazz—or at least, to mainstream or unequivocal instances of jazz—from the point of view of expression. I address the vexing question of the essence or defining characteristics of jazz, and explain the concept of musical expression presupposed here that I have developed in a number of prior essays, the most recent of which is "Musical Expressiveness as Hearability-as-Expression." I next postulate a *Gestalt*, or distinctive sound, of jazz, which I attempt to characterize through both underlying musical characteristics and an appeal to paradigm examples, and suggest that such a *Gestalt* or sound comports well with the expression of certain emotions but comports ill with the expression of other emotions, rendering their expression in jazz virtually impossible. Before concluding I raise the question of the expressive specificity of all genres of music.

"Instrumentation and Improvisation" was written for a session in honor of the career of Philip Alperson, author of groundbreaking work on the philosophy of jazz, at a meeting of the American Society for Aesthetics in Philadelphia in April 2012. My essay is accordingly a critical appreciation of two of Alperson's later papers on those themes, "The Instrumentality of Music" (2008) and "A Topography of Improvisation" (2010), in the course of which I draw out and underline some connections between them.

"What Is a Temporal Art?," co-authored with Alperson, and the final essay in this collection, is the only essay included here not of recent vintage, though it has attracted the attention of aestheticians over the years, in part because there is little else in the literature that deals with its central issue. I have thus finally decided, with Alperson's consent, to reprint it, having overcome some misplaced hesitation about doing so.

The opening and closing sections of "What Is a Temporal Art?" serve to motivate the question of the title, to indicate some of its historical

sources, and to underline its continuing interest. But the core of the essay is a detailed examination of different senses that one might give to the term "temporal art," or alternatively, of different ways of understanding the temporality of an art form. Not unexpectedly, in almost all the senses canvassed, music, the temporal art par excellence, emerges as temporal, while in other senses other arts, such as film, literature, and dance, reveal their temporal colors plainly enough. The importance of the particular sort of temporality attributable to an art form is addressed at the end of the essay, though there is clearly more to be said on that score than we there manage to say.

I thank my editor Peter Momtchiloff for his exceptional flexibility and expert guidance in fashioning the present volume, and especially for the suggestion, here implemented in its first phase, that I offer two smaller, more homogeneous collections of essays in aesthetics, instead of the larger, more heterogeneous one that I originally had in mind. And lastly, I thank Rowena Anketell for her excellent and constructive copyediting.

1

Philosophy and Music

A curious question, how philosophy and music are related. One might as well ask, it would seem, about the relation between philosophy and magic, or the relation between music and pottery. Is there thus something about music and philosophy, two ostensibly quite different realms, that demands, or at least justifies, such an inquiry?

I hope eventually to uncover some not entirely superficial connections between those two vital human concerns. But I will begin by circling around the topic from the outside, focusing on relations of a fairly obvious sort that philosophy and music can bear to one another.

1. First, there is the phenomenon of *music inspiring philosophy*. This can take the form of a philosophical system such as that of Schopenhauer, which both accords music a supreme role in the search for personal fulfillment and also views music as a mirror of the underlying nature of things. But such inspiration can equally take the more modest form of a single work of philosophy, or more often, of philosophical literature, that is strongly influenced by a particular piece of music, or else by music in general. Here one could mention Herman Hesse's *Steppenwolf*, with its paean to the life-affirming force of Mozart even when heard through a tinny and crackling radio; Thomas Mann's *Doktor Faustus*, with its searching meditation on the relation between genius, morality, and power, and whose protagonist was modeled in part on Gustav Mahler and in part on Arnold Schoenberg; or Aldous Huxley's *Point Counterpoint*, with its suggestion, toward the end of the novel, that Beethoven's late quartets might serve as a gateway to a deeper understanding of reality, as a portal to, or perhaps substitute for, the supernatural.

Second, there is the equally familiar phenomenon of *philosophy inspiring music*. Possibly the best known example of this would be Richard Strauss's *Also Sprach Zarathustra*, an attempt to represent the spirit, if

not the substance, of Nietzsche's poetic-philosophical tract. Of more importance, and representing greater aesthetic success, would be Richard Wagner's opera *Tristan und Isolde*, which is indelibly stamped with the voluntarism and pessimism of Schopenhauer's philosophy, even if ultimately embodying in sound and text a philosophical perspective that diverges significantly from that of the philosopher.[1] On a lesser plane of achievement one might also cite Erik Satie's symphonic drama *Socrate* and Leonard Bernstein's *Serenade after Plato's Symposium,* which share a common inspiration in ancient Greek philosophy.

Worth mentioning under this rubric is Haydn's Symphony No. 22, which owing to its opening movement acquired the nickname of "The Philosopher." Though not really a case of philosophy influencing music, since that nickname was a late accretion and not a part of Haydn's conception of the music in question, it can still give pause to those of us who philosophize for a living. For the picture of philosophy conjured up by Haydn's movement is a plodding and earnest one, the product, in the main, of a slow walking bass and some rather ridiculous, doddering trills in the horns. Let us hope, however, that philosophers need not always trudge along unsmilingly and sententiously, even while engaged in the serious search for truth.

2. Sometimes *mathematics* is seen as a middle term between music and philosophy, mathematical procedures having some kinship with those of philosophical demonstration, and the same being claimed for musical organization and mathematical order. The connection between music and mathematics has been repeatedly affirmed over the ages, resting most often on the manifest arithmetical basis to both the overtone series of a vibrating string and the standard metrical and rhythmic divisions of musical time. But it is not as if there is any such manifest arithmetical basis to philosophical thought, so that way of connecting music to philosophy would seem to lead nowhere.

A more daring connection between music and mathematics, however, was famously bruited by Leibniz, who proposed that the comprehension of music was at base a kind of unconscious calculation or computation. If true, that would then in turn underwrite an affinity between music and philosophy, since the latter is undeniably a mode of reasoning or

[1] For a revelatory account of the power and import of perhaps Wagner's greatest opera, see Roger Scruton's study, *Death-Devoted Heart* (Oxford: OUP, 2004).

cogitation. But in fact there is little reason to think Leibniz's proposal more than a fanciful conjecture; there is, at any rate, no evidence that in following music with understanding we are doing anything like grasping or judging mathematical relations among elements of the musical stream.

On a more mundane level it is often observed that a taste and talent for music and a taste and talent for mathematics often go together, which would seem to suggest some underlying connection between them. But at best this connection is only valid for music of a highly organized sort, whose main tendency is formal and cerebral, such as the music of Bach or Webern and some kinds of modern jazz. The connection hardly holds for most popular music, such as rock, blues, soul, or country, whose core appeal is more corporeal and emotional. Nor does it hold, I would wager, for most non-Western musics, whether of Asia, Africa, or Latin America.

3. Let us then leave behind the venerable but ultimately unfruitful attempt to link music and philosophy through mathematics, and see if we can instead identify commonalities or affinities of a more immediate and more promising sort. The following three suggest themselves:

a. Both philosophy and music typically aim, in different ways, at *wholeness* or *completeness*.
b. Both philosophy and music are forms of *thought*, displaying the sort of evolution and elaboration characteristic of thinking.
c. Both philosophy and music are impractical in a superficial sense, not being oriented toward the securing of material rewards, and yet in a deep sense *practical*, being preeminent tools for coping with the challenges, demands, and inevitabilities of life.

I now develop these suggestions in more detail.

First, *wholeness* or *completeness*. The standard object of the activity of composing music, naturally enough, is to end up with a musical composition. Or more simply, a piece of music. But what is a piece of music? It is preeminently a whole, a microcosm, a little world, complete in itself, and capable of standing alone.[2] It is also undeniably a creation, something brought into being by the mind and body of a human being.

[2] Of course this ideal of musical wholeness or completeness is less in evidence, or is even pointedly declined, in various modes of modern music, where an ideal of open-ended composition instead holds sway. I am thinking of aleatory and repetitive styles of music associated with names such as Cage, Stockhausen, Reich, and Glass.

In parallel fashion, the standard object of philosophical activity, at least of a sustained and professional sort, is to issue in a piece of philosophy, that is to say, a text, in which is expressed a philosophical position, system, or worldview. And such a piece of philosophy normally aspires to a similar condition of wholeness, completeness, and self-sufficiency, while being as well a paradigm of creativity, something wrested from the void and cast into definite form by the effort and talent of the philosopher.

Musical compositions and philosophical texts are thus notable exemplars of wholeness, not only in their overall form, but also in what they typically aim to express or convey to the audiences for which they are intended. The unity and completeness of a piece of music, especially a classical composition of the eighteenth or nineteenth century, is manifestly a prime object of aesthetic delight; think of Bach's Sixth "Brandenburg" Concerto, Mozart's G minor String Quintet, Haydn's F minor Piano Variations, or Beethoven's "Archduke" Trio. But the unity and completeness of a great philosophical text, such as Descartes's *Discourse*, Hume's *Enquiry*, Spinoza's *Ethics*, or Kant's *Prolegomena*, is also, for attuned readers, a source of such delight, and a concern with the form as well as the content of these treatises was unmistakably in the forefront of the minds of their authors.

Next, *thoughtfulness*. Neither a philosophical text nor a musical composition is *literally* an instance of thinking, in the sense of a series of thoughts or sequence of mental events. But each can with justice be said, variously, to *represent, embody,* or *reflect* thinking in the literal sense, and each is fitted to *evoke, summon,* or *elicit,* in the mind of a comprehending reader or listener, a parallel process of thought.[3]

But why call musical succession—the succession from note to note, from chord to chord, from motive to motive, from phrase to phrase— thinking at all? Here I take the liberty of quoting from an answer to that question that I articulated elsewhere:

Musical succession has features that set it apart from succession in general. It is a purposive-seeming, goal-directed temporal process, an intelligent form of continuation in time, and one that is naturally subject to assessment in cognitive

[3] For more careful consideration of senses in which music can be regarded as an instance of thought, see my "Musical Thinking," reprinted in *Contemplating Art* (Oxford: OUP, 2006).

terms, such as *coherence*, or *logicality*, or *making sense*. In addition, it is succession that we know emanates from a human mind, and that we hear under the influence of that postulate.[4]

Indeed, a central criterion of success for both musical and philosophical discourses, the products of musical and philosophical activity, is that such discourses compel attention, hold together, proceed logically, and carry along the listener or reader from beginning to end. There are, furthermore, many qualities characteristic of thought, both positive and negative ones, that music can exemplify literally. For instance, all of the following: fluidity, turgidity, doggedness, digressiveness, hesitancy, persuasiveness, elegance, subtlety, coarseness, cogency, turbidity, feverishness, originality, ingenuity, unpredictability, wittiness, amiability, and brilliance. As has often been noted, much instrumental music exhibits a specifically *dialogic* or *conversational* character, reflecting different voices or agents within the musical stream, and when that is the case the attribution of such qualities of thought appears even more firmly grounded.

Still, there are salient differences between the thinking embodied in or represented by philosophical texts or lectures and that embodied in or represented by musical compositions or performances. The former sort of thinking preeminently involves *reasoning*, or the drawing of *inferences* from propositions, according to truth-preserving or probability-preserving principles. The latter sort of thinking preeminently involves *sequencing*, the concatenating of inarticulate sounds in such manner as to somehow hang together and to succeed one another cogently, but that is by no means a matter of reasoning or inferring. At bottom, philosophical thought aims to demonstrate, to establish, to compel belief, and is judged successful mainly in the proportion to which it achieves that goal. Musical thought, by contrast, aims to captivate, to absorb, and to move emotionally, and is judged successful mainly to the degree that it achieves that rather different goal.

Now it is true that in both musical and philosophical thought the objective is to achieve, at each step, what one may call *conviction*. That is, one seeks to have each step to follow convincingly from the preceding one. But whereas philosophical argument, in proceeding from given

[4] "Musical Thinking," 214.

premises, normally presupposes that only *one* inference or continuation from those premises is justified, or most highly justified, musical discourse, by contrast, is not inherently committed to the continuation it offers as being the *only* logical or sensible one in light of what came before or of where one was in the musical progression.[5]

Music, in other words, is preeminently a sphere of choice, freedom, and invention, with numerous possibilities that offer themselves at every turn in the unfolding of a composition, even if stylistic norms, historical conventions, and psychological limits constrain the sphere of possibility to a certain extent. But philosophy is an attempt to establish, by reasoning, reflection, and conceptual analysis, among other methods, positions and theses that can claim something like truth, and that can be seen as supported by arguments that, if valid, exclude the claims of competing theses and positions. Put otherwise, philosophy is not just any old thinking. Philosophical thinking centrally involves argument, reasoning, inference, demonstration, and so on, and these are not properties that musical sequence or progression can easily, or perhaps ever, instantiate.

There is, however, something we have been overlooking. Namely, that there is *another* side to philosophy, one to some extent independent of its argumentative or demonstrative side. And that is the side of philosophy that concerns simply the articulation and development of *conceptions* or *visions* of the world, which conceptions or visions may be defended by accompanying reasons, but need not be. The question thus poses itself of whether music might take on some of the colors of philosophy in similarly presenting—most certainly without supporting reasons—conceptions or visions of some aspect or dimension of the extramusical world.

Difficult, to be sure, but not a suggestion to be dismissed out of hand. For surely some music offers a vision—in sound, of course, but nevertheless a vision—of aspects of human reality, the likeliest such aspects being emotions, attitudes, behaviors, and forms of life. Think of the slow movement of Beethoven's Ninth Symphony, the first movements of

[5] According to Luc Ferry's reading of Nietzsche (see his *Qu'est-ce qu'une vie reussie?*, Paris: Grasset 2004) this constitutes one of the fundamental differences between *science* (including philosophy) and *art*, that the former must show, in opposition to other positions, that it alone is in possession of the truth, whereas the latter is not so constrained, but as it were creates its own myriad "truths" with every successful venture.

Mahler's Sixth Symphony or Bruckner's Eighth Symphony, of Vaughan Williams's *Fantasia on a Theme of Thomas Tallis*, Scriabin's *Vers la flamme*, or Messaien's *Des canyons aux étoiles*. These are musics that, in addition to absorbing us on the purely musical plane of melody, harmony, rhythm, and timbre, offer vistas of the psychological, emotional, and spiritual landscape of the human being, depicting states running from serene contentment to anguished defiance to religious awe to mystical transcendence. And in the affording of compelling visions of human reality music thus joins philosophy in one of its central pursuits, even if the visions afforded by music, unlike those afforded by philosophy, are not elaborated and defended in articulate terms. When such musical visions carry conviction, it is not, of course, by force of argument or reasoning, but rather through the intuitively felt rightness of what they give listeners to experience.

Finally, *practicality*. Certain works of music might be said, in something like the manner of great works of literature, to serve as invaluable instruments to ethical reflection and self-knowledge. Take, for instance, the slow movements of Beethoven's late piano sonatas—those from Op. 90 onwards—which variously illustrate in sound states of profound resignation, otherworldly bliss, and "the peace that passeth understanding," and which arguably allow receptive listeners to enter into such states and to comprehend them from the inside. One need not claim that acquaintance with such music is absolutely *necessary* for such reflection or knowledge, but only that it can serve to *facilitate* it, and sometimes in a manner more effective than could be achieved by other, more discursive, means. And that would not be surprising if one recalls that both moral understanding and awareness of self must involve, to some extent and at some stage, an imaginative grasp of states of mind and an estimation of their value and importance, to oneself and to others. So insofar as great works of music can make such states more available, more transparent, or just more vivid to us, they have a real practicality for life.[6]

[6] I have touched on the relation of music to moral and personal development elsewhere. See "Music and Negative Emotion," in *Music, Art, and Metaphysics* (Ithaca, NY: Cornell UP, 1990); "Evaluating Music," in *Contemplating Art* (Oxford: OUP, 2006); and "Art, Value, and Philosophy," in *Mind* 105 (1996), 667–82.

That philosophy by definition has such real practicality, even when it doesn't pay the rent—being in part a rational inquiry into how best to live—surely goes without saying, and so needn't detain us further. And yet we may need to be reminded of it from time to time, a fact which would have astonished our philosophical forbears, the ancient Greeks.

4. I now address a different sort of question about the relationship of music and philosophy, one that is perhaps of most concern to contemporary composers, insofar as they think about the relationship at all. It is the question of whether composers have need of philosophy in order to compose well, or whether they at least stand to profit as composers from an immersion in philosophy or the elaboration of a philosophical basis for a particular compositional practice.

As is well known, certain composers self-consciously choose to compose according to a system, rather than simply by feeling or intuition and in a style unconsciously absorbed from their musical formation. Here I am thinking of Schoenberg and his system of composing with the twelve tones of the chromatic scale treated as wholly on a par, of Xenakis with his method of composing with ensembles of sounds generated by stochastic processes, of John Cage and his various devices aimed at evacuating choice, preference, and personality from the composing of music in an effort to "let sounds be themselves," and of Steve Reich and Philip Glass and their music of subtly varied motivic and rhythmic repetition.

Now, such musical systems might themselves loosely be considered species of philosophy, ones justifying and guiding the compositional process. But more properly it is the reflective principles behind such systems, rules, and methods that can reasonably be considered philosophical. In the case of Schoenberg, the idea that musical beauty and expression might exist outside the confines of the tonality; in the case of Xenakis, the idea that sounds organized according to statistical principles might more powerfully convey an image of natural processes than sounds organized according to familiar melodic and harmonic desiderata; in the case of Cage, the idea that sounds should be liberated from their dependence on personal interests and allowed to induct listeners into more meditative and impersonal states of mind; in the case of Reich and Glass, the idea that close attention to minute changes in musical character can issue in a heightened perception and appreciation of the sensuous moment.

It is worth observing that in the case of some bodies of music, the systems or philosophies behind the composer's compositional activity seem to add more to the interest of the musical works that result than in other cases. Thus, I would venture that the interest of Schoenberg's music is *not much* enhanced by a knowledge of its conformity to dodecaphonic principles of composition; that the interest of Xenakis's music is *somewhat* enhanced by knowledge of the stochastic notions that underlie his compositional practice, and similarly for the interest of the music of Reich and Glass by knowledge of its underlying aims; and that a knowledge of the Zen Buddhist ideals behind much of John Cage's musical activity adds *considerably* to the interest of many of his otherwise baffling and formless soundscapes.

Still, in the preceding examples what one has, at most, is a philosophical idea about the role and potential of *musical sound*, rather than a philosophical idea about something *non-musical* and *non-sonic*. So, are there composers who are guided in their compositional practice by philosophical ideas that do not directly concern music or sound? Of course. Consider Wagner, and his concern with the relations between love, sex, death, and redemption; Schumann and his preoccupation with friendship, as reflected in the imaginary *Davidsbund* and the piano works associated with that; Beethoven and his concern with freedom, personal and political; Scriabin and his obsession with mystical union. Yet how much of these philosophical ideas ends up effectively embodied in the music that they produced, apart from any text, remains difficult to say.

5. At first glance there is at least this clear asymmetry between philosophy and music. There undeniably exists a subject within philosophy called *the philosophy of music*, a subject that goes back at least to Plato and Aristotle, and which is quite vigorously pursued in our own time. This is not surprising, since every significant aspect of human reality, for example religion, morality, science, language, consciousness, and so on, calls out for philosophy, that is to say, conceptual, normative, and speculative examination of the phenomenon involved. But there is just as manifestly no such thing within music as *the music of philosophy*, at least when that phrase is straightforwardly and soberly understood. And this is equally unsurprising, since music, unlike philosophy, is not essentially a critical or analytical enterprise taking other phenomena as its object.

But let us now understand that phrase less straightforwardly and less soberly. Immediately a metaphorical reading of it comes to mind. The

music of philosophy would be the distinctive sound, melody, rhythm, and so on, of a given way of philosophizing, of theorizing the world and its meaning in a rational and systematic manner. Each of the great philosophers might be said to exhibit such a distinctive way of philosophizing, as reflected not only in *what* they focus on or bring to our attention, but in *how* they present and argue for the positions they adopt or the perspectives they recommend on what they are treating.

The music, in this sense, of Schopenhauer's philosophy is quite different from that of Kant's, even though they share a language and some metaphysical premises, while the music of Berkeley's or Hume's philosophies is quite removed from either of those. And the wilder musics of Nietzsche's and Kierkegaard's philosophies display affinities, independently of the voluntarist and irrationalist themes their philosophies have in common. To speak thus of the *music* of a philosopher's thought is to speak of something rather more specific than its style, though perhaps it enters into that. It is to call attention to its rhythm, whether halting or flowing; to its cadence, whether striding or mincing; to its timbre, whether light-toned or dark-hued; to its texture, whether linear or convoluted; and to its melody, whether severe or ingratiating. Indicative of the real existence of distinctive musics in the writing of the great philosophers is the fact that the identity of the philosopher is sometimes discernible from a paragraph or two, even when the specific ideas or themes being discussed do not permit such identification. Perhaps that is even true in the case of the present, decidedly modest, philosopher . . .

2

The Aesthetic Appreciation of Music

Appreciation and Related Notions

In what does the aesthetic appreciation of music consist? A useful answer to this question will require, at a minimum, some indication of how both "appreciation" and "aesthetic" should be understood in this context. So first, what is meant by the *appreciation* of music, and second, what is added by specifying that such appreciation is *aesthetic*?

The notion of *appreciation* is a complex one. To appreciate something arguably involves, on the one hand, perceiving, cognizing, or otherwise experiencing it, where such experience may involve the imagination, and on the other hand, deriving satisfaction from it or regarding it positively. In other words, appreciating something implies both having an adequate experience of the thing, one that qualifies as acquaintance with it, and as a consequence of that experience, being pleased by or taking a favourable view of it. Briefly, in appreciating something one is experiencing it in a way one finds intrinsically rewarding.

Appreciation thus contrasts with a number of other relationships a listener might have to music. It is, most obviously, distinct from merely *perceiving* some music, which does not imply a positive reaction to it, and to merely *regarding positively* some music, which does not imply experience of it. Appreciation is also distinct from *evaluation* per se—that is, the activity of assigning or trying to assign a definite value to music heard, because evaluation misses out the essentially sympathetic tenor of appreciation, which seeks to avail itself of whatever value some music has to offer, rather than to arrive at a precise assessment of that value.[1]

[1] See S. Feagin, *Reading with Feeling* (Ithaca, NY: Cornell UP, 1996).

Appreciation is, further, distinct from simply taking pleasure in hearing music, since that might come about without one's really listening to the music, but merely because the music served to relax one while one lent it only half an ear.

So much for appreciation. How, then, does *aesthetic* appreciation of music differ from *non-aesthetic* appreciation of music? Well, heard music might be appreciated for its soothing effect, or for its suitability as a background to socializing, or for its aptness as an accompaniment to dancing, or for its therapeutic powers. These would all be ways of appreciating music, but presumably not ways of appreciating music *aesthetically*. Why not? Because the focus of appreciation is not the music *itself*, that is, the music's sonorous appearance as such, but rather the *uses* to which the music can be put, or the *consequences* of listening to it. Aesthetic appreciation of music is appreciation of music for its hearable form and content, rather than for its instrumentality in relation to external purposes.

But we must be careful here. Excluding from the aesthetic appreciation of music the appreciation of music for *external purposes* that it happens to serve does not mean excluding from the sphere of aesthetic appreciation all consideration of music's *internal purposes*, or in other words, of its *inherent functionality* in virtue of being music of a certain kind. On the contrary, much music has as part of its basic conception the fulfilling of certain functions, such as religious, patriotic, celebratory, or memorial ones, and has clearly been designed with such functions in mind. In such cases, proper appreciation of the music *as* music, and thus, *aesthetic* appreciation of it, must involve some attention to the manner and degree to which the music, through its formal, aesthetic, and expressive properties, answers to the aims integral to the kind of music in question.[2] One might add that music's functional aptness can be considered an aspect of its form in the *broad* sense, dealing as it does with a relation between an internal aim of the music and its form in the *narrow* sense, that is, its musical structure, and that so considered, it is a perfectly appropriate object of aesthetic attention to music, conforming nicely to the most traditional conception of that.

[2] For further discussion, see S. Davies, "Aesthetic Judgments, Artworks, and Functional Beauty," *Philosophical Quarterly* 56 (2006), 224–41.

Let that suffice for the general notion of aesthetic appreciation in its application to music. We must now briefly consider, before proceeding, how the aesthetic appreciation of music stands to related notions such as taking an aesthetic *attitude* to music, aesthetically *attending* to music, deriving aesthetic *satisfaction* from music, and having an aesthetic *experience* of music.[3]

Let us begin with the first of those. How should one characterize the aesthetic *attitude*, in the sense of a *frame of mind* or *mental set* conducive to, or possibly even prerequisite for, aesthetic experience?[4] The notion of the aesthetic attitude has deep roots in the aesthetic theory of the eighteenth and nineteenth centuries, figuring prominently in the philosophical reflections of, among others, Shaftesbury, Hutcheson, Kant, and Schopenhauer. Without attempting to review that long history, we can simply enumerate some of the features that theorists have traditionally ascribed to this attitude.

Foremost among these is the feature of *disinterestedness*, by which is meant the disengaging or sidelining of purely personal and narrowly practical concerns, so as to allow full engagement with the properties of the object perceived. A second feature stressed by some theorists can be labeled *object-directedness*, and amounts to a disposition to dwell on the object perceived for its own sake, to surrender oneself to contemplation or delectation of it. A third feature often proposed is that of *cognitive freedom*, or inclination to engage in imaginative activities of discovery, exploration, and connection-making with the object perceived, without confining oneself to conventional ways of classifying or categorizing it; the activities of perceiving-as, perceiving-in, perceiving metaphorically, and perceiving under a concept, that Arthur Danto, Richard Wollheim, Roger Scruton, and others have done so much to bring to our attention, figure here centrally. A fourth feature sometimes proposed, which one might label *interpretive openness*, and which might justly be considered an extension

[3] There is a fair amount of skepticism in the aesthetics literature as to whether any nontrivial specification of the aesthetic attitude or of aesthetic experience is to be had, reaching as far as outright denial that there are any such things. I will not join this debate here, but will simply assume that the extreme skeptical position is unwarranted.

[4] One characterization of the aesthetic attitude along those lines runs as follows: "Traditionally, the aesthetic attitude is defined as an attitude or state of mind that is entered into, voluntarily and consciously, by an individual, making that individual receptive to having an aesthetic experience" (D. Fenner, "Aesthetic Attitude," in M. Kelly (ed.), *Encyclopedia of Aesthetics*, 1 (New York: OUP, 1998), 150).

of the third, is a disposition to interpret, that is, to look for meaning, significance, or symbolic import in the object perceived. Finally, a fifth feature commonly thought of as central to the aesthetic attitude is that of *emotional receptivity*, or readiness to register and respond to an object's expressive dimension, to be alive to its human content and not simply a passive admirer of its formal design or technical ingenuity.[5]

Note that there is no conflict between this last feature, emotional receptivity, and that of disinterestedness, properly understood: disinterestedness entails the putting out of gear and out of mind, as far as possible, of distracting personal or practical concerns, but it in no way entails the deactivation or disengagement of one's sympathetic or empathetic capacity, one's willingness to enter into the life, the body and soul, the blood and guts if necessary, of the artistic object—whether painting, film, symphony, or play—with which one is confronted.

Whether these five features are present in every instance of an ostensibly aesthetic attitude toward an object, and whether these features as a whole adequately define a distinctive and identifiable state of mind, is not entirely clear, but let us assume that there is something that answers, more or less, to such a characterization, and proceed to address the other notions listed above in which the concept of the aesthetic is crucially invoked, those of aesthetic *attention*, aesthetic *satisfaction*, and aesthetic *experience*. An attitude, we may say, is roughly a disposition to think, feel, or react in a certain manner, in short, a disposition to experience things in a certain way. So an aesthetic attitude is thus a specific readiness for, or inclination toward, experience of a certain sort. As such an aesthetic attitude or frame of mind cannot by itself *constitute* aesthetic experience, but only *prepare* and *shape* its occurrence. The substance of aesthetic experience, so to speak, must rather consist of various mental activities or processes of thinking, feeling, and reacting, all of which require, preliminarily, attention. So in order to arrive at an adequate conception of aesthetic experience we must now investigate this crucial middle term, namely *aesthetic attention*.

[5] For various suggestions, see J. Stolnitz, *Aesthetics and the Philosophy of Art Criticism* (New York: Houghton Mifflin, 1960); M. Beardsley, *The Aesthetic Point of View* (Ithaca, NY: Cornell UP, 1982); T. Leddy, "Practical George and Aesthete Jerome Meet the Aesthetic Object," *Southern Journal of Philosophy* 28 (1990), 37–53; and R. Stecker, *Aesthetics and the Philosophy of Art* (Lanham, MD: Rowman & Littlefield, 2005).

I have elsewhere suggested that aesthetic attention is roughly attention directed to an object's form and content and to the relationship between them. That is to characterize aesthetic attention in terms of *what attention is focused on.*[6] Another suggestion is that aesthetic attention is attention to an object that is not guided by any pragmatic purpose, but is instead aimed simply at having as full and adequate an experience of the object as possible. That is, to characterize aesthetic attention in terms of *what motivates the attention being paid.*[7] These two ways of characterizing aesthetic attention are not incompatible, and can profitably be conjoined in most theoretical contexts. Either way, aesthetic *satisfaction* from music can then be characterized straightforwardly as satisfaction deriving from aesthetic *attention* to music.

That leaves as requiring clarification for only the notion of an aesthetic *experience* of music. Let us simply say that an experience of music is an aesthetic one when it involves aesthetic attention to, and aesthetic satisfaction from, the music. Saying that, of course, makes it automatic that aesthetic experience is *positive* experience, that is, experience that is desirable, valuable, or to be sought. Now, though it is not entirely incoherent to speak of aesthetic experience that is neutral or negative, that is, either devoid of aesthetic satisfaction or else involving aesthetic dissatisfaction, a virtue of taking the positive notion of aesthetic experience to be, as it were, the default notion is that we can then roughly equate, on the one hand, *aesthetically appreciating music* and, on the other hand, *having an aesthetic experience of music.* And so that rough equation will be assumed here.[8]

[6] See J. Levinson, "What Is Aesthetic Pleasure?" in *The Pleasures of Aesthetics* (Ithaca, NY: Cornell UP, 1996) and "Pleasure, Aesthetic," in *A Companion to Aesthetics* (2nd edn, Oxford: Blackwell, 2008). "Pleasure in an object is aesthetic when it derives from apprehension of and reflection on the object's individual character and content, both for itself and in relation to the structural base on which such character and content rests." See also R. Eldridge, "Form and Content: An Aesthetic Theory of Art," *British Journal of Aesthetics* 25 (1985), 303–16.

[7] See G. Kemp, "The Aesthetic Attitude," *British Journal of Aesthetics* 39 (1999), 392–9.

[8] Some have suggested that the keynote of aesthetic experience is that it is experience that is valued for its own sake: see G. Iseminger, "Aesthetic Experience," in J. Levinson (ed.), *The Oxford Handbook of Aesthetics* (Oxford: OUP, 2003); G. Iseminger, "The Aesthetic State of Mind," in M. Kieran (ed.), *Contemporary Debates in Aesthetics and the Philosophy of Art* (Oxford: Blackwell, 2005); and Stecker, *Aesthetics and the Philosophy of Art*. Two experiences may thus differ, even if they have the same perceiving or registering at their core, if in one case the perceiving or registering is valued for its own sake, while in the other case it is not;

Principal Elements of the Aesthetic Appreciation of Music

With those preliminary clarifications accomplished we are now in a position to address the primary concern of this essay, namely what the main elements are in the aesthetic appreciation of music, and in particular, what the role is in such appreciation of music's affective or expressive dimension and of the listener's response to that dimension.

Assume, then, that aesthetic *attention* to music is non-pragmatically driven attention to music focused on its form, content, and the relationship between the two; that this normally gives rise to some measure of aesthetic *satisfaction*, as well as to a positive *estimation* of the music in question; and that together such attention, satisfaction, and estimation amount to aesthetic *appreciation* of the music.

So apart from appreciation of music's expressiveness, which will be our main concern in what follows, what does the aesthetic appreciation of music involve? Or otherwise put, to what does it attend? Here I can only lamely follow in the footsteps of the many distinguished musical commentators who have so ably charted this terrain—Aaron Copland, Leonard Bernstein, Anthony Hopkins, Peter Kivy, and Roger Scruton, to name just a few—and I will be mercifully brief.

First, there is appreciation of musical *form*, on the small and the large scale. On the small scale, there is appreciation of melody, or movement in pitch space, involving awareness of the components of melody, such as motifs and phrases. Next, though not really dissociable from the preceding, there is appreciation of rhythm, the pattern of duration of tones, and distribution of accents. Next, there is the appreciation of harmony, or the quality of different pitches sounding together, yielding intervals and chords, and the appreciation when present of polyphony, or the simultaneous sounding of distinct melodies or melodic strands.

Completing this quick survey of the basic elements of music from the appreciative point of view, there is appreciation of timbre or tone color, the distinctive sound quality imparted to music by instruments of

in the first case, but not the second, one has aesthetic experience. This conception of aesthetic experience is entirely compatible with that sketched in the text, but I choose not to adopt it here because of its reliance on the somewhat obscure idea of valuing something for its own sake. (For further discussion, see my "Toward a Non-Minimalist Conception of Aesthetic Experience," in *Aesthetic Pursuits* (Oxford: OUP, forthcoming).)

particular kinds, and the appreciation of dynamics, or variations of loud and soft over time. Awareness of the local unfolding of music in these respects, requiring little more than moment-to-moment attention to music's temporal evolution, constitutes the core of musical appreciation on a concatenationist[9] view of music. On a larger scale, appreciation of musical form includes awareness of melodic repetitions, of harmonic scheme and harmonic rhythm, of sonata or other sectional form, of global balances and symmetries, and constitutes the core of musical appreciation on an architectonicist[10] view of music.[11]

So much for musical form as such. The next aspect of music that falls within the scope of musical appreciation is musical *motion* or *movement*, which is, in complex ways, generated for the most part by small-scale musical form. When we hear music as music we do not simply hear *changes* in the basic musical parameters of melody, rhythm, harmony, dynamics, and timbre. Rather, in virtue of such changes, we hear motion or movement, of an *imaginary* or perhaps *metaphorical* sort, *in* music: we hear music rising, falling, soaring, plunging, expanding, shrinking, advancing, retreating, rushing, lingering, trudging, leaping, swelling, subsiding, and so on.[12] It is scarcely possible to overestimate the importance of the phenomenon of musical movement, without which much else of interest in music would simply evaporate. Heard musical movement is the scaffolding for almost all that engages us in music beyond the level of the basic parameters.[13]

[9] See J. Levinson, *Music in the Moment* (Ithaca, NY: Cornell UP, 1998).

[10] See P. Kivy, *Music Alone* (Ithaca, NY: Cornell UP, 1990).

[11] For debate on the pros and cons of a concatenationist versus an architectonicist view of musical understanding, see P. Kivy, "Music in Memory and *Music in the Moment*," in *New Essays on Musical Understanding* (Oxford: OUP, 2001); and J. Levinson, "Concatenationism, Architectonicism, and the Appreciation of Music," *Revue international de philosophie* 60 (2006), 505–14 (Chapter 3 of this volume). The latter references a number of recent studies in cognitive psychology of music, by E. Bigand, B. Tillmann, P. Lalitte, et al., that offer significant empirical support for a concatenationist model of musical comprehension.

[12] For valuable discussion of the phenomenon of musical movement, see S. Davies, *Musical Meaning and Expression* (Ithaca, NY: Cornell UP, 1994); M. Budd, *Values of Art: Pictures, Poetry, and Music* (London: Penguin, 1995); and R. Scruton, *The Aesthetics of Music* (Oxford: OUP, 1997). Important earlier discussions include E. Gurney, *The Power of Sound* (1880; New York: Basic Books, 1966); S. Langer, *Feeling and Form* (New York: Scribner's, 1953); and D. Ferguson, *Music as Metaphor* (Minneapolis: University of Minnesota Press, 1960).

[13] For different views on the nature and status of the motion heard in music, see Davies, *Musical Meaning and Expression*; Scruton, *The Aesthetics of Music*; Budd, *Values of Art*; and

This brings us to the next, intimately related, aspect of music that must figure in aesthetic appreciation of it, namely the impression music affords more broadly of *agency*, in virtue of the movement we hear in it. This aspect of music can be epitomized under the rubric of *gesture*. It is in virtue of musical movement of various kinds that music is heard as pervaded by gestures of various sorts, such as sighing, caressing, threatening, questioning, inviting, despairing, or rejoicing ones, and so as, in effect, acting or behaving in those ways.[14]

Gesture in music serves as the crucial middle term between musical movement and musical expression. It is because music often presents the appearance of *gestures* of various sorts that it can be heard, by analogy with the role of physical gesture in behavioural expression of emotion, as if it were *itself* an expression of emotion. Music's readily lending itself to such hearing—to hearing *as* expression—is at base precisely what music's expressiveness consists in.

If music did not appear to move in a certain manner it could not appear to us as gesturing in a certain manner, say, angrily; and if it did not appear to us as gesturing in that manner, it would not readily be heard by us as if it were expressing anger, and hence, would not be expressive of anger. In short, the picture is something like this: small-scale form in music gives rise to musical motion of specific character; musical motion, together with other, for example harmonic, features of music, gives rise to musical gesture; and musical gesture gives rise to musical expressiveness, most notably emotional expressiveness.

Having arrived at the dimension of the aesthetic appreciation of music which is my main concern here, namely, music's expressiveness, I will shortly try to deepen our understanding of what that involves. But before proceeding I briefly take note of three other aspects that music may present for aesthetic appreciation, apart from those of form, motion, gesture, and expressiveness.

most recently, the enlightening exchange consisting of M. Budd, "Musical Movement and Aesthetic Metaphors," *British Journal of Aesthetics* 43 (2003), 209–23 and R. Scruton, "Musical Movement: A Reply to Budd," *British Journal of Aesthetics* 44 (2004), 184–7.

[14] See J. Levinson, "Sound, Gesture, Space and the Expression of Emotion in Music," and "Musical Expressiveness as Hearability-as-Expression," both in *Contemplating Art* (Oxford: OUP, 2006). By "gesture" is meant not only gesture narrowly speaking, but facial expression, posture, gait, stance, and bearing.

One is that of *non-expressive aesthetic qualities* that music can present, which qualities in the main supervene, as do expressive qualities, on its basic musical properties, those enumerated earlier under the heading of small-scale musical form. Non-expressive aesthetic qualities include higher-order perceptual qualities such as grace, delicacy, charm, humour, menace, mystery, and so on, which do not, strictly speaking, connote psychological states capable of outward expression, and so are not a part of expressiveness per se, but which qualities clearly constitute an important part of the interest and appeal of music for a listener.[15]

Second is that of *narrative-dramatic content*, exhibited by much if not all music, which presupposes content at the level of gesture and expression but goes beyond that, and which operates over a more extended timescale, as befits meaning on the order of a psychological-emotional tale, either recounted or enacted.[16]

Three is that of *representational content*, the sort of content exhibited most obviously by program music, though not restricted to that genre, whereby music, through its form, virtual motion, and expressive coloration, succeeds in conveying to a receptive listener an audible image of some object, person, or event, a sonic appearance in which such a thing can be aptly heard.[17]

Note that even though we can to an extent discuss separately the aspects of music on which musical appreciation focuses, and have, of course, just done so, two points should not be lost sight of. First, there are close, and in some cases conceptual, *connections* among such aspects, so that even in thought these aspects are not entirely separable. Second, in the actual experience of music these aspects are normally heard *together*, as fused with one another, with higher-order such aspects, such as emotional expressiveness, heard as inhering in and emerging out of lower-order ones, such as melodic, rhythmic, and harmonic character.

Note also, as many writers on this subject have affirmed, that *perceiving* emotional expressiveness in music does not require *feeling* the

[15] For further distinctions and elaborations, see J. Levinson, "What Are Aesthetic Properties?," *Proceedings of the Aristotelian Society Supplement* 78 (2005), 211–27.

[16] See F. Maus, "Music as Drama," *Music Theory Spectrum* 10 (1988), 56–73, and J. Levinson, "Music as Narrative and Music as Drama," *Mind and Language* 19 (2004), 428–41 (reprinted in *Contemplating Art* (Oxford: OUP, 2006)).

[17] See P. Kivy, *Sound and Semblance* (Princeton: Princeton UP, 1984).

corresponding emotion, or perhaps any emotion at all, while listening.[18] What it normally does require, or so I have repeatedly urged, is *hearing* the music *as* an expression of that emotion, or *imagining* the music to *be* an expression of that emotion, or at the least, being *disposed* to so hear or so imagine.[19] Nevertheless, the aesthetic appreciation of music ideally involves not merely perceiving, recognizing, or remarking the expressiveness of music, whatever the mechanism of that may be, but *responding* emotionally to that expressiveness, whether empathetically, sympathetically, antipathetically, or in some combination of these ways. Being moved in some manner by emotionally expressive music, at least on some occasions of listening, is arguably a *sine qua non* of fully appreciating it.

Gabriel Fauré, Piano Quartet in C Minor, Op. 15, First Movement

I now offer a selective tour of a movement from a piece of chamber music by Gabriel Fauré, underlining its salient expressive moments and the musical motions and gestures that importantly underlie that expressiveness. It goes without saying that an aesthetic appreciation of this music requires sensitivity to such expressiveness, and to the motions, gestures, and other musical features that are its foundation. The movement, marked *Allegro molto moderato*, exhibits a rather free, late-Romantic sonata form. The principal theme (A), announced boldly by the strings with syncopated interjections from the piano, is characterized by a noble and restrained passion. After the full statement of theme A there is a climax at measure 12, leading to a more relaxed second statement, an octave higher in the strings and with less emphatic, more florid piano accompaniment. The second theme (B), at measure 37, has a contrasting character, though not sharply so, that can be characterized as flowing

[18] See, among others, P. Kivy, *Sound Sentiment* (Philadelphia: Temple UP, 1989); M. Budd, *Music and the Emotions* (London: Routledge & Kegan Paul, 1985); and S. Davies, *Musical Meaning and Expression*.

[19] See J. Levinson, "Music and Negative Emotion" and "Hope in the *Hebrides*," in *Music, Art, and Metaphysics* (Ithaca, NY: Cornell UP, 1990; J. Levinson, "Musical Expressiveness," in *The Pleasures of Aesthetics*; and J. Levinson, "Sound, Gesture, Space and the Expression of Emotion in Music" and "Musical Expressiveness as Hearability-as-Expression" in *Contemplating Art* (Oxford: OUP, 2006).

and dreamy. The development might be said to commence around measure 48, after a full statement of theme B. At measure 72 the principal theme undergoes transformation into a gentler form, a transformation reinforced by an added motif in triplet rhythm which imparts a more supple feeling to the music. For the next fifty measures or so of this leisurely development section the four instruments dialogue at turns in a gentle and wistful manner, featuring mild variants of the A and B themes. The character changes somewhat at measure 135, with the arrival of a passage with prominent pizzicati, leading to a second climax with ascending octaves and tremolo strings at measures 152–7, which in turn announces the recapitulation.

Throughout the largely tranquil middle section of this movement one is aware of the noble passion of theme A ready to erupt anew, as it finally does at the recapitulation at measure 158, a frisson-inducing moment, at least for this listener. Theme B only returns at measure 194, with a shift to C major, in which key the music remains until the end, featuring unusually gentle reminiscences of the principal theme beginning at measure 218, and capped off by six final measures of untroubled tonic harmony, devoid of melody.

I single out three points of special interest regarding the appreciation of the expressive aspect of this music by an attuned listener. First, the sense of visceral excitement as the music rises in pitch and volume, and whenever passages with strong rhythmic accents succeed more evenly flowing ones. Second, the peculiarly satisfying emotion, afforded by sonata form and other large-scale musical forms, of homecoming—the feeling of returning to and regaining one's starting point—a feeling that accompanies the restatement of the movement's principal theme in the original key. Third, the singular spiritual elation at the end of the movement, and particularly its closing passages, which bring an unexpected shift from minor to major. In each of these responses *to* the music the implication of movement heard *in* the music is fairly evident, as the terms "rise," "return," "shift," and "homecoming" employed in the preceding description would suggest. One also has the impression, almost throughout, of a kind of respiration, a musical breathing in and out, as the music rises and falls, strengthens and subsides, inflates and deflates, but in a far from mechanical manner.

And needless to say, a sense of the music as in motion is vividly implicated in such an impression.

Three further observations now on motion in music. First, one might say of certain musical motions that they act more or less *directly* to express—and potentially, to arouse—emotion, through the expressive gestures that they partly constitute, and that this action operates on the *small scale*, without connection to surrounding musical context. This would be the case, for example, of a musical motion evoking the gesture of a vigorously shaken fist, inducing one in turn to hear in that an access of anger. By contrast, one might say of certain other musical motions, for example, the thematic-harmonic return at the beginning of the recapitulation of a sonata movement, that they act *indirectly* to express—and potentially, to arouse—emotion, and that this action operates on the *large scale*, as a function in part of the surrounding musical context, of which the practiced listener will have a background awareness, even if the effect of that action is experienced, as in the other case, in the immediate.

Second, it cannot be without importance that in listening to music one is often prompted to *bodily movement*, in corporeal echo or sympathetic vibration with what one is hearing, the most adequate and satisfying form of which is, of course, dancing, as Roger Scruton has justly emphasized.Whether it is the head, the feet, the arms, the shoulders, or the hips that are thus activated, what could testify in clearer fashion that there is in music movement *of some sort*, to which it is almost impossible to keep oneself from responding, except by an artificial effort dictated most often by social constraints. And where there is heard movement, heard gesture and heard action are often present as well, and thus potentially, emotional expression.

Third, it cannot be without importance that the state or condition which consists in *being moved by music*—whereby a psychic motion, so to speak, is produced in us—and the state or condition which consists in *being made to move by music*—whereby a physical motion is produced in us—are closely linked. And this to such an extent that the former almost never occurs without the latter, whether that be only in the form of a frisson running down the spine, a sigh escaping from the chest, or a noticeable rise in heartbeat. Without a doubt, motion and emotion in music are indissociably intertwined, and the aesthetic appreciation of music is inevitably centrally focused on both.

The Connection between Music and Dance

In this final section I briefly explore the special connection between music and dance, and in particular, that which has been held to obtain by Roger Scruton between the understanding of music and the impulse to respond to music by dancing.[20] I first recall some of Scruton's most pertinent observations on this score.[21]

In dance, Scruton affirms, gesture "moves of its own accord and unimpeded to its goal." But in music, gesture enjoys even greater freedom, "which excites us beyond anything we can encounter in our own bodily movement" (p. 340). The ancient Greeks, notes Scruton, "thought of music as something in which we *join*" (p. 355). "When someone dances to music, he responds to the way it sounds . . . but he would be dancing to the music only if his movements express his attention to the music. 'Dancing to' is the name of an aesthetic response" (p. 356). Scruton concludes that we should see the response of the attuned listener to music "as a kind of latent dancing—a sublimated desire to 'move with' the music, and so to focus on its moving forms" (p. 357).

Put more prosaically, Scruton's points about the music/dance connection seem to be these. First, that musical gesture is somehow both *less constrained* and *more potent* than choreographic gesture. Second, dancing *to* music heard, and not merely *as a result of* music heard, constitutes an aesthetic response to music, one that connotes and embodies some measure of musical understanding. Three, apart from the impulse to actual dance which music heard with understanding may inspire, musical understanding is itself essentially a kind of *latent* dancing, whereby one moves with musical movement, but on a psychic or imaginary plane.

I recall these three points not so much to dispute them but because I find them insightful and more or less on the mark. I nevertheless raise questions for each, with the aim of suggesting modifications or qualifications that would render them more wholly acceptable.

1. The freedom and power of musical gesture as opposed to bodily gesture. My questions here are these: First, freer in relation to what? Second, more powerful in what respect?

[20] I note that I have engaged with other issues in Scruton's *Aesthetics of Music* in my critical notice of it; see J. Levinson, Review of Roger Scruton, *The Aesthetics of Music*, *Philosophical Review* 109 (2000), 608–14.

[21] All page references in parentheses are to Scruton, *The Aesthetics of Music*.

We must ask whether the sphere of bodily gesture is really more limited than that of tonal gesture. One might think it was well the reverse, given that tonal space, with its fixed scales and standard rhythmic divisions by twos and threes, is not a continuum, whereas the space of bodily movement, not being antecedently partitioned in that manner, effectively is. And though it is true that there are clearly physical constraints on the sorts of motions, configurations, and gyrations of which the human body is capable, whether within the sphere of dance or outside of it, there are also physical constraints on the production and reception of sounds by creatures such as us.

And is it really the case that musical gesture is invariably more powerful, more capable of exciting us, than bodily gesture, at least of certain sorts, or in certain contexts? The question is complicated by the fact that bodily gesture, including that comprised within dance, has a more immediate and transparent significance than that which music presents: the fist that is shaken in one's face, the traveller collapsing of exhaustion at one's feet, the leap in air in defiance of gravity, the outstretched hand that invites an intimate uptake, are hardly wanting in power, and are unmistakable in their import. Corporeal gesture is all the more potent the smaller the distance at which one confronts it, as in the theatre if lucky enough to have a seat close to the stage. And dance gestures observed that one emulates in one's own body have an effect even more pronounced on one's mental state.

What, then, distinguishes musical gesture from bodily gesture, if not so much its greater freedom or greater power? I would suggest that it is rather its greater *subtlety* and *finesse*. That is to say, the nuances of musical gesture that we are able to discern, and to which we can and do respond differentially, are notably finer, or finer-grained, than those of bodily, including terpsichorean, gesture. And this leads, in many cases, to an experience that is *richer* and more *complex* than that to be had from responding, however sympathetically, to observed bodily gesture. This is, of course, not a new suggestion; versions of it are to be found in Mendelssohn, Schopenhauer, Gurney, Langer, and other theorists of musical meaning.

2. The signaling or manifesting of musical understanding through a dancing response. My question here is this: Should we not worry, on the one hand, that a given dancing response to music heard may be *too coarse* to answer to all the gestural-kinetic-dynamic features of the

music? A dancing response might indicate some sort of grasp of the music's grosser aspect, but is not likely to signify a full comprehension of the music as the distinct individual it is. And should one not equally worry, on the other hand, that a given dancing response to music heard may be *too elaborate* or *overdeveloped* in relation to music that provokes it, displaying features that do not correspond to the musical motions registered but going beyond them, taking off from them and using them merely as a springboard? In such cases, in other words, there is more, or extraneous, matter in the dance than is to be found in the motional dimension of the music.

3. The understanding of music as itself a kind of latent dancing. This is a intriguing suggestion, but once again, it prompts a doubt. Is the idea of "dancingly inwardly" without actually moving, when one attends to music's movement comprehendingly, anything more than an extravagant metaphor for the familiar perceptual-cum-imaginative activity often called *following* music? One might agree, but then note that the idea of *following* music is itself irreducibly, if less blatantly, metaphorical. Fair enough, but at least its scope seems larger to me, and more adequate to a listener's musical comprehension generally, than that of inwardly dancing to music. In any event, as Scruton would be the first to insist, though sober philosophical analysts may be tempted, in the interests of clarity and truth, to escape the pull of metaphor, its hold on us is deep: if repressed in one place, it seems only to surge up irrepressibly in another.

3

Concatenationism, Architectonicism, and the Appreciation of Music

1. This essay is about what musical appreciation fundamentally consists in. Why do we listen to music, how do we listen to music, and what is the main source of our satisfaction in listening to music? The answer to these three closely related questions, I believe, is to be found in the phenomenon of *following* music, that is to say, of attending closely to, and getting involved in, its specific movement, flow, or progression, moment by moment. That is to say, it is not so much a matter of *thinking* articulately about the music as it passes, or *contemplating* it in its architectural aspect, as it is a matter of *reacting* to and *interacting* with the musical stream, perceptually and somatically, on a non-analytical, pre-reflective level.[1]

This belief was the germ of my book, *Music in the Moment*,[2] whose claims have stirred up a fair amount of controversy.[3] But in no one has *Music in the Moment* elicited as vigorous and oppositional a response as in Peter Kivy, who published an extensive attack on it in his collection of essays, *New Essays on Musical Understanding*.[4] Now perhaps this just

[1] To say that *articulate*, or linguistically mediated, thought does not play a paramount role in the appreciation of music by ear is not, of course, to say that no thought of *any* kind is going on. On the contrary, there is thought of a specifically *musical* kind centrally involved in both the creation and the reception of music. See my "Musical Thinking," *Midwest Studies in Philosophy* 27 (2003), 59–68.

[2] *Music in the Moment* (Ithaca, NY: Cornell University Press, 1998).

[3] See, for example, the symposium on *Music in the Moment* that appeared in *Music Perception* 16 (1999), 463–94, including replies by me to four commentators.

[4] "Music in Memory and *Music in the Moment*," in *New Essays on Musical Understanding* (Oxford: OUP, 2001), 183–217. All page references in parentheses in this chapter are to this text.

comes down to a difference in musical habits, personality, or disposition. That is, perhaps Kivy tends to listen one way, and to derive pleasure from that, whereas I tend to listen another way, and derive pleasure from that. So what is there to dispute? Apparently plenty. This essay will thus be devoted to countering, as far as I am able, the objections that Kivy has made to my claims in *Music in the Moment*. But first, I recall in summary fashion what was maintained in that book, and second, I endeavor to correct some distortions of my position that Kivy introduces into his representation of it.

The root idea of *Music in the Moment*, taken from the nineteenth-century English psychologist and musician Edmund Gurney,[5] is that a piece of music is a temporal process, and so never apprehended by us as a whole, but rather only in portions of limited extent, ones that can be aurally grasped as almost-present-at-one-time, or as I put it, "quasi-heard." If that is so, then comprehension of an extended composition must be fundamentally a matter of sequential apprehension of locally graspable parts of small extent—what I call, following Gurney, "bits of music"—rather than a matter of synoptic apprehension of large-scale relations or of a piece's global form. The view of musical comprehension built around that idea I dub "concatenationism", invoking an image of music as a chain of interconnected and interpenetrating links. For concatenationism, the architecture of a piece of music, however rewarding it might be to analyze, and however important it might be from a compositional point of view, cannot be the primary appreciative focus of attention for ordinary listeners.

That view, concatenationism, is elaborated and defended in the opening chapters of *Music in the Moment*. But the latter chapters of the book are in fact occupied with possible grounds of qualification on concatenationism; they are concerned to assess the role that architectonic awareness might play in musical understanding despite the fundamentally concatenationist nature of such understanding. Five possible grounds of qualification are acknowledged: (a) architectonic awareness's enhancement of the perceived impressiveness of individual bits; (b) architectonic awareness's enhancement of the perceived cogency of transitions between bits; (c) architectonic awareness's facilitation of

[5] His *chef d'œuvre*, *The Power of Sound*, first published in 1880, is a tome of about a thousand pages, and covers a remarkable range of issues in musical aesthetics.

quasi-hearing; (d) architectonic awareness's role in the perception of higher-order aesthetic properties; and (e) architectonic awareness's role as a source of distinct musical satisfactions.

These grounds of qualification thus divide roughly into two sorts, those concerned with architectonic awareness's possible contribution to basic musical understanding—(a), (b), and (c)—and those concerned with architectonic awareness's role in musical understanding of a more-than-basic sort—(d) and (e). That there are basically two different sorts of potential qualification on unmitigated concatenationism, which if valid, qualify the thesis in different ways, is something that might have been underlined more clearly in the book. In any case, the upshot of my consideration of these potential qualifications, in which I concede something to the claims of architectonicism, especially as regards the second sort of concern, is a *qualified* concatenationism, at some remove from the unmitigated concatenationism with which I begin. But there is unfortunately little sign in Kivy's engagement with my position that he has qualified, rather than unmitigated, concatenationism in his sights.

2. Before replying directly to Kivy's attack on the views expressed in *Music in the Moment*, I must draw attention to Kivy's regrettable tendency to misrepresent those views by making them out to be more extreme than they are. Consider first how Kivy glosses the relationship between what I label "quasi-hearing" and what I label "basic musical understanding": According to Kivy "quasi-hearing, so defined, as 'conscious attention ... carried to a small stretch of music surrounding the present moment ... synthesizing the events of such a stretch into a coherent flow' constitutes what Levinson calls 'basic musical understanding'" (186). But though quasi-hearing is, I maintain, the *core* of basic musical understanding, it is not the *whole* of it. Basic musical understanding requires not only the sort of perceptual processing of the musical stream that I label "quasi-hearing", but also the right sorts of affective-cognitive responses to parts successively heard. Thus, it is false to say, as Kivy does, that for me quasi-hearing by itself constitutes basic musical understanding.[6]

A similar distortion is evident in the next gloss of my position offered by Kivy: "In other words, one (more or less) has the whole musical kit and caboodle, as far as understanding and enjoying music goes, when

[6] *Music in the Moment*, 32.

one has basic musical understanding [claim 1] . . . and one cannot have either understanding or enjoyment of music without it [claim 2]" (187). Though I indeed affirm the second of these claims, I do not affirm the first, even with the "more or less" qualification in force. The point, after all, of labeling *basic* musical understanding "basic" is an implied contrast with *advanced* musical understanding, and so also with *complete* musical understanding, where that is understood as the conjunction of basic and advanced musical understanding. So though I indeed accord basic musical understanding a considerably *greater* weight than most other theorists of musical experience, I do not hold that it constitutes "more or less" the *whole* of musical understanding and enjoyment.

Here is yet a third tendentious gloss: "the most significant implication of Levinson's position with regard to basic musical understanding [is] that it comprises, for all intents and purposes, the total listening experience, and that therefore the perception of large-scale musical structure and form is just about irrelevant, contributing but negligibly to either comprehension or enjoyment" (188). This is an unfair summary of my view in two respects. First, I do not claim that perception of large-scale form *of all sorts* is of minor relevance to musical understanding, but rather that *conscious* or *explicit* perception of such form is of minor relevance. I thus willingly grant that *subconscious* or *tacit* perception of such form, at a subpersonal level, *may* be highly relevant to musical understanding.[7] Second, it is one thing to claim that conscious or explicit perception of large-scale form *is of minor relevance* to musical understanding, but another thing to say that it is *just about irrelevant* to such understanding, and the latter is not a claim that I advance.

3. Kivy next turns his attention to three intuitions that I take to support concatenationism, intuitions regarding what the understanding of music fundamentally consists in. The first intuition is that what ordinarily counts as knowing or getting some stretch of music is being able to *follow* it, that is, have a quasi-hearing experience of it. The second intuition is that a strong mark of musical understanding of some stretch of music, if not quite a *sine qua non* of such understanding, is *reproductive, continuational,* or *recognitional* ability in regard to it. And the third intuition is that a strong mark of musical understanding of some

[7] The extent to which it actually is relevant has been the subject of some intriguing recent experimental work, on which I comment in the last section of this chapter.

stretch of music, if again not a *sine qua non* of such understanding, is grasp of its expressiveness or emotional content.

Kivy is skeptical about each of these intuitions. Let us examine the grounds of his skepticism in each case. Regarding my first intuition, Kivy maintains that although "getting" music as primarily a matter of making sense of its local happenings may work for a Schoenberg quartet, or a fragment of Chinese classical music, it does not work for something like the fourth movement of Mahler's Ninth Symphony. When someone says she does not "get" this music, affirms Kivy, "she surely does not mean that she cannot make sense of the local happenings, that she is unable to follow the musical logic from point to point. [For] it is written in the same harmonic language as 'Melancholy Baby'. It is [rather] that she is lost, all at sea; she doesn't have the big picture; she doesn't know where anything belongs, or why" (200).

But what makes Kivy so confident that the musical success of the Mahler does not significantly lie, as with "Melancholy Baby" or a Schoenberg quartet, in its moment-to-moment cogency, whatever large-scale form it may possess? Surely not everything written in the "major/minor harmonic system" is equally cogent throughout, or just as importantly, equally quasi-hearable on first or second listening? It seems that Kivy is here confusing two things, (a) the *capacity* to have basic musical understanding in a given musical system; and (b) basic musical understanding of a *particular* piece of music in a given musical system. Obviously, that a listener possesses (a) does not entail that she possesses (b). Kivy notes that people frequently say of classical music that they don't get it, and then confidently goes on to declare that "they cannot mean they don't, in Levinson's sense, basically understand it" (200). But I maintain that that is *precisely* what they do mean, and that only Kivy's conflation of (a) and (b) blinds him to that fact.

Regarding my second intuition, Kivy simply rejects it, insisting that one can understand music by ear without being able to reproduce, continue, or recognize it. But I submit that Kivy fails to see how reasonable that intuition is, offering as it does a disjunction of three abilities that might be said to signal musical understanding, and the dubiousness of a claim to such understanding in the total absence of such abilities. Kivy notes that reproductive ability, such as the ability to hum or sing a bit of music, is not an infallible sign of understanding. But first, this is less clear if one makes explicit that it is only "musical" reproduction that

counts, that is, reproduction in such fashion that someone versed in music of that sort could derive the sense of the music from the reproduction. If so, the extent to which such reproductive ability could fail to betoken underlying musical understanding seems small. And second, my second intuition is broader than Kivy's representation of it, in fact acknowledging as strongly indicative of basic musical understanding not only reproductive ability in regard to the music in question, but also continuational ability and recognitional ability.

These three closely related abilities, all of them reflective of musical memory, are yet strictly independent. One could, for example, have continuational ability without reproductive ability, or recognitional ability without either continuational or reproductive ability. But surely someone who displayed *none* of these abilities could well be suspected of not having achieved basic musical understanding of a given piece, and that, on the contrary, one who solidly displayed all three, and in a musical fashion, could not plausibly be thought to lack basic musical understanding of the piece in question.

Regarding my third intuition, Kivy agrees that music's possession of expressive or emotional properties is largely a local, rather than a global, affair. But he holds that this does not weigh greatly in favor of concatenationism as opposed to architectonicism, because he is "perfectly content to place *both* basic musical understanding *and* the perception of music's expressive properties at a lower level of musical attainment . . . [and] global features at a higher level" (202). To this I can only reiterate my own conviction that a grasp of music's expressive dimension, roughly, what it says to us as human utterance, is at such a high level of importance as regards the understanding of music that to lack sensitivity of that sort is virtually not to understand music at all. Music grasped solely as sonorous play or temporal pattern or architectural shape is effectively music missed. If music were not, among other things, a vehicle for articulating and externalizing the inner life of feeling it would not have the immense importance for us that it manifestly does have.

4. Kivy claims that my way of asking whether explicit awareness of sonata form is crucial to basic musical understanding of a piece in sonata form is question-begging, since the latter is by definition local understanding, while the former is by definition global understanding, so of course the former is not crucial to the latter (191). But that is not the case, for the one kind of processing might very well underlie and be requisite

to the other, even if, as such, they are of different natures. The question I was asking was whether conscious awareness of sonata form was necessary in order for the bits of a piece of music in sonata form to both cohere locally and exhibit appropriate aesthetic properties, that is, to sustain basic musical understanding of the piece. And to that I returned, and continue to return, a negative answer. In the book I elaborate a distinction between *intellectual* hearing-as-a-sonata and *perceptual* hearing-as-a-sonata, and make the case that although the latter is necessary to properly grasp a movement in sonata form and experience its aesthetic properties, the former is not.[8]

Kivy next raises a question about the precise nature of structural, formal, or broad-span apprehension of music. Is this, he wonders, merely an extension of normal quasi-hearing, or something rather different in nature? Kivy thinks it has to be the latter (192–5), and I am inclined to agree. But he concludes from this that concatenationism, which locates the core of appreciative listening in quasi-hearing, implies "a more or less blanket condemnation of broad-based, structural, or formal listening" (196). Once again, however, this ignores the substantial qualifications on concatenationism that emerge from the discussion in later chapters of *Music in the Moment*. A qualified concatenationism is perfectly compatible with a role for broad-span apprehension in the appreciation of music, so long as that role is recognized to be both (a) of secondary importance and (b) ultimately dispensable to the most fundamental sort of engagement with music that we are capable of.

Architectonicism, Kivy's opposing view on the understanding of music, is characterized by him as follows: "Architectonicism I take to be the position that global listening is not everything but that it is not nothing either: rather, that it contributes a very substantial part of the satisfaction to be had from classical music" (202). One of the chief supports of architectonicism, which holds that a significant part of musical appreciation resides in the perception of large-scale form, is the phenomenon of musical *unity*. Kivy says that unity, which he holds to be distinct from coherence, "is an important feature of some classical music, [and] that it requires something beyond quasi-hearing – namely, architectonic hearing – for its apprehension" (203). Kivy offers this in

[8] For related discussion, see Erkii Huovinen, "Levels and Kinds of Musical Understanding," *British Journal of Aesthetics* 48 (2008), 315–37.

support of his conviction that musical unity, which he identifies with monothematic structure, is something distinct from musical coherence: "Many, I think most, of Mozart's instrumental movements, for example, are not unified, yet are supremely coherent" (203).

Is this not almost a *reductio* of the distinction between unity and coherence in music, at least insofar as unity is supposed to be an aesthetic virtue? If there is musical unity that does not issue in experiencable musical coherence, of what appreciative importance is it? Kivy's answer seems to be this: "When music is unified [in the sense of monothematic structure] . . . that unity can only be perceived by architectonic listening . . . When conscious awareness [of thematic connectedness of later and earlier parts of a piece] occurs in your local listening, it provides deep musical satisfaction" (204). But here I simply disagree. That the satisfaction of perceiving mere unity, unproductive of any experiencable coherence, is a deep one, relative to the satisfactions of involved quasi-hearing, strikes me as just a formalist article of faith. At any rate, I can hardly be accused of overlooking formal satisfactions of that sort, since I devote much of *Music in the Moment* to acknowledging their reality and to estimating their significance. My estimate of their significance, though, is simply much less than Kivy's.

Kivy next asks why, on my view of the matter, architectonic listening is so difficult to carry off, and he responds that it must, for me, have to do with the temporal nature of music, recalling my observation that to perceive the whole of an extended piece of music at one time, as one can with a painting, seems impossible. He then suggests an alternate model of what it is to hear such a piece of music, or substantial portions thereof, as a whole: "there is a perfectly possible mode of listening, properly called architectonic or synoptic, that does not require the absurd notion of hearing a temporal sequence atemporally. It is the mode . . . of perceiving the present musical moment, so to say, through the lens of one's conscious memory of what has transpired and one's expectation of what is to come. It does require 'having the plan in your head' . . . But why, it may be asked, should architectonic listening require anything beyond deep and concentrated attention? . . . Briefly . . . architectonic listening . . . requires a frame of reference. There will be no pay-off in musical satisfaction from the kind of deep and concentrated attention I am talking about unless one is trying, in the act, consciously to place what one is hearing within some schemata at one's disposal" (206–7).

But most of the satisfaction that Kivy adduces here, for a listener who listens synoptically or architectonically, is in fact available to a listener who does not listen in that fashion but has yet internalized the norms of style, genre, melodic continuation, and harmonic progression appropriate to the music in question, and is able, for instance, to perceptually hear a sonata as a sonata, whether or not able or inclined to do so in a consciously synoptic or architectonic mode.[9] I don't deny that some sorts of satisfaction require listening in that mode, I only claim that architectonicists like Kivy exaggerate the importance and centrality of such satisfactions in musical appreciation.[10]

Kivy allows, in a concessive moment, that I am right to insist that basic musical understanding, with its core of quasi-hearing, "is a necessary condition for any other form of musical understanding" (210). But, says Kivy, I am guilty of inferring from this that basic musical understanding constitutes the *major* part of musical appreciation: "It simply does not follow that, because basic musical understanding is a necessary condition for architectonic and other forms of musical understanding, it must make the dominant or largest contribution to our musical satisfaction" (210). Just so. The dominant role for basic musical understanding does not follow merely from its being more fundamental, in the sense of being a precondition of any other kind of understanding. But the brief I offered for according basic musical understanding pride of place was not as simple as that. It was, rather, that architectonic satisfaction in music was less important than concatenationist satisfaction because it was both *parasitic* on the latter and, at least in my observation, less *intense* and less *absorbing* than the latter.

Kivy claims that I view the architectonic form of a piece of music as "more abstract and less particularized than the piece itself" (211), a view that Kivy finds puzzling. But such form, as a standard analytical diagram

[9] In an essay entitled "Musical Literacy" I expand further on the importance to successful listening of the tacit acquisition, through knowing assimilation of the musical repertoire, of the right dispositions and habits of response. (*The Pleasures of Aesthetics* (Ithaca, NY: Cornell University Press, 1998), 27–41.)

[10] Kivy at one point remarks that consciously hearing, in a complicated fugue, the subject and its inversion combined, and hearing that under just those concepts, produces an undeniable musical satisfaction (208). And so it does. But note that this is an example of conscious appreciation of a local feature of the music, and thus not directly relevant to the satisfactions possibly afforded by *architectonic* listening.

might represent it, indeed is fairly abstract. It is more abstract than the specific pattern of tones itself, as witnessed by the fact that it can have instances that vary enormously from one to another, and that do not remotely sound the same, in contrast with instances of the specific pattern of tones. So there should be nothing puzzling in the idea that architectonic form is more abstract, and less particular, than that of which it is a form. And there should be nothing objectionable in the suggestion that musical attention should focus, first and foremost, on the concrete specificity of a piece as it unfolds in time, rather than on the architectonic form it exhibits in company with innumerable other pieces, actual and possible.

5. The bottom line of my examination of the relevance of large-scale form to musical appreciation in *Music in the Moment* was that *conscious* awareness of such form has at most a minor role to play in such appreciation. But that leaves open that large-scale form, perhaps registered by listeners on a *subconscious* level, without explicit attention being directed to it, has yet a quite significant role to play in such appreciation. I specifically allowed for that possibility in *Music in the Moment* by distinguishing between the *causal* and the *appreciative* relevance of large-scale musical form, underlining the logical separateness of the two, and making clear that skepticism about the latter does not itself ground skepticism about the former.[11]

However, the empirical has a way of trumping the logical, and that is what appears to be the case in this connection. A number of recent studies in experimental psychology of music suggest that not only may large-scale musical form be of minor *appreciative* relevance, it may also, somewhat surprisingly, be of minor *causal* relevance as well.[12] These studies suggest that either such form is hardly registered by even experienced listeners, on any level, or else that to the extent it is registered, it makes little contribution to the sense that such listeners have of the coherence, expressiveness, or other valuable property of the music being listened to.

[11] *Music in the Moment*, ch. 2.

[12] For an overview of this research, see Barbara Tillmann and Emmanuel Bigand, "The Relative Importance of Local and Global Structures in Music Perception," *Journal of Aesthetics and Art Criticism* 62 (2004), 211–22.

In one experiment, short pieces of music from three to six minutes in length were manipulated so that the pieces ended in keys other than those in which they began, thus undermining tonal closure.[13] This manipulation was in general not detected by musical subjects, and had no effect on experienced coherence, completeness, expressiveness, or pleasurability. An experiment in a related vein involved even shorter pieces of music, segmented into four segments which were then rearranged and sewn back together, again eliminating tonal closure; musical subjects performed roughly at chance at detecting the absence of such closure.[14] In another series of experiments, musical subjects did not evince clear preferences for original over rearranged orders of sections within sonata and variation movements by Mozart and Bach, or for original over rearranged orders of movements within extended pieces, such as whole sonatas by Beethoven.[15] And in yet another experiment, pieces of about three minutes in length, by Bach, Mozart, and Schoenberg, were segmented into little chunks of about six seconds each and chained together in retrograde order, an operation which, as the experimenters note, "destroyed the global organization of the piece but preserved the local structures inside the chunks."[16] Listeners judged the coherence and expressivity of the retrograde versions of each piece as on a par with that of the originals.

Now, clearly such experiments, which concern the causal relevance of large-scale musical form, do not show that such form is *never* registered by listeners at any level, nor that such form is *incapable* of having aesthetic effects via such registration. Most likely experiments with a more restricted class of subjects, or ones in which subjects are primed to attend to features of large-scale form, would turn up more evidence

[13] Nicholas Cook, "The Perception of Large-Scale Tonal Closure," *Music Perception* 5 (1987), 197–206.

[14] E. West-Marvin and A. Brinkman, "The Effect of Modulation and Formal Manipulation on Perception of Tonal Closure," *Music Perception* 16 (1999), 389–408.

[15] V. J. Konečni, "Elusive Effects of Artists' 'Messages'," in *Cognitive Processes in the Perception of Art* (Amsterdam: North-Holland, 1994); H. Gottlieb and V. J. Konečni, "The Effects of Instrumentation, Playing Style, and Structure in the Goldberg Variations by Johann Sebastian Bach," *Music Perception* 3 (1985), 207–13; and M. Karno and V. J. Konečni, "The Effects of Structural Intervention in the First Movement of Mozart's Symphony in G minor on Aesthetic Preference," *Music Perception* 10 (1992), 63–72.

[16] Barbara Tillmann and Emmanuel Bigand, "Does Formal Musical Structure Affect Perception of Musical Expressiveness?" *Psychology of Music* 24 (1996), 3–17.

of such registration and its impact on musical experience. But the difficulty of evincing clear sign of even the *causal* relevance of large-scale form should make us more sympathetic to the idea that the *appreciative* relevance of large-scale form cannot be what traditional theorists of musical appreciation, such as Kivy, have made it out to be. For that which practiced subjects appear to be largely either incapable of noting, or else indifferent to even while noting, despite having appreciative experiences of richness and depth, cannot plausibly be thought to constitute a major focus of musical appreciation.

6. In a public forum on *Music in the Moment* in the year it was published the musicologist Justin London remarked that concatenationism could appear to be friendly to the idea that a musical composition from which parts were freely excised might very well not be much the worse for the operation. I hope that one can see, in light of the distinction between the *causal* and the *appreciative* relevance of large-scale form, that that is not the case. Concatenationism in no way entails the eliminability-without-consequence of some portion of a piece's parts, even though the empirical research just reviewed indeed suggests that listeners may not in fact be particularly sensitive to alterations or perturbations of large-scale structure. Still, from a concatenationist perspective on music a given part of a piece can only be guaranteed to have its proper effect when heard in light of the parts that precede it, attended to in moment-to-moment fashion, and in perhaps subliminal anticipation of parts to come, for a listener already familiar with the piece in question. Whether or not the succession of musical parts constituting a piece of music is focused on as a whole or contemplated synoptically, the entire succession still needs to be heard attentively if a listener's aesthetic response to each part is to be what it should be.

So concatentionism does not imply the causal irrelevance of large-scale form. The extent of that relevance or irrelevance is for empirical research to establish. What concatenationism helps explain, though, is why detached passages of music retain a great deal, if not all, of their sense and appeal when heard out of context—in contrast with isolated portions of works of visual art, what are usually called "details," which though having a certain interest for us, have an interest that is quite secondary to our interest in the work as a whole and its overall design.

A few square inches of the sleeve of a duke in a portrait by Titian, for instance, may attract our gaze and cause us to marvel at the painter's

skill, but it is the way the achievement of those few square inches fits with the rest of the canvas that is the primary focus of appreciation. The main theme of the opening movement of Schubert's "Unfinished" Symphony, however, is no mere detail, and retains an extraordinary value even when the rest of the movement is put to the side, because its value is not, in anywhere the same degree as with static works of visual art, tied to its architectonic relationship to the rest of the composition.

I remark in closing the opposing sentiment of Theodor Adorno regarding the value of isolatable passages of music, in his perverse rant against the popular music of his day, *On the Fetish Character in Music and the Regression in Listening*: "The man who in the subway triumphantly whistles loudly the theme of the finale of Brahms's First Symphony is already primarily involved with its debris." If that majestic theme is to be regarded, as Adorno contemptuously suggests, as mere debris, then all I can say in response is, let us have more such debris.[17]

[17] The version of this essay given here is somewhat different from that published in *Revue internationale de philosophie* in 2006, and derives from a light revision of the text undertaken in 2011 prior to its publication in French translation in 2013. The final section here, in particular, represents an addition to the 2006 version.

4

Indication, Abstraction, and Individuation

I

Roughly thirty years ago, as part of an exploration of the ontology of art, I suggested that musical works were not *pure abstract structures*, like geometrical forms, but rather, *impure indicated structures*.[1] But what exactly does that mean? In this chapter I propose to revisit that old idea of mine in the hope of clarifying it, before then using it as a springboard to discussion of *artistic* indication as a singular psychological act, of the individuation of indicated objects that results from such indication, and finally, of the relation between artistic indication and neighboring sorts of action, in particular, actions of *simple* indication.

It is necessary, before we start, to briefly explain why it is that musical works—and by the same token, literary works—cannot be considered to be pure tonal or verbal structures. For instance, why it is that Shelley's famous poem *Ozymandias* cannot be reduced to the sequence of words: "I" "met" "a" "traveler" "from" "an" "antique" "land" . . . , and why it is that Chopin's Mazurka in A minor, Op. 17, No. 4 cannot be reduced to a complex sequence of notes starting with an altered F major triad. Here are the most important reasons why such works cannot be reduced to pure structures. First, pure structures of elements, which are similar to mathematical objects, cannot be created, since they exist at all times, but works of art, and that includes musical and literary works, surely are created, by specific artists working in specific historical contexts.[2]

[1] Levinson (1980). See also Levinson (1990b).
[2] More cautiously, if such structures are not eternal they at least exist as soon as a musical system or linguistic system is in place, and thus well before the works that are composed employing elements of such a system.

Second, works of art have a number of important aesthetic and artistic properties that they could not have were they pure structures existing atemporally, with no essential links to creative artists, preceding art-works, preceding artistic movements, and more generally, surrounding cultural environments.

All this was shown, quite conclusively I think, in Jorge Luis Borges's brilliant short story "Pierre Menard, author of the *Quixote*" and, in the philosophy of art, through a number of writings by Ernst Gombrich, Richard Wollheim, Kendall Walton, Arthur Danto, Gregory Currie, and Jacques Morizot, to cite but a few authors.[3] A musical or literary work, though it is partly defined by its tonal or verbal structure, is nonetheless, like a pictorial or sculptural work, a particular human creation; it came into being at a certain time; it may be destroyed in the future if the conditions for its existence cease to obtain; and it gets its meaning and produces its effects on us not simply in virtue of its abstract perceptible form, but in virtue of its status as a *statement, expression,* or *utterance* arising in or emerging from a singular generative context. A Beethoven sonata would not say the same things, musically speaking, if we thought it to be a work by Brahms, a Jane Austen novel would not communicate the same message if we considered it to be a heavily ironic Woody Allen production, and an expressionistic painting by the young Mondrian would certainly look much different if we saw it as a work painted sixty years later by a mature Jackson Pollock.

This is roughly why musical and literary works cannot be pure or eternal structures, but must rather be considered as impure, historically conditioned, temporally anchored, structures. I suggested that such works are really what I call "indicated structures", which are partly abstract sorts of objects, the result of the interaction between a person and an entirely abstract structure, such as a sequence or series of words or notes. The interaction in question is precisely an act of indicating, and it is this action that creates the link between the abstract structure and the concrete individual human that lies at the heart of such an artwork. A paradigmatic musical work, for instance, Beethoven's Fifth Symphony, is therefore a tonal-structure-as-indicated-by-a-specific-composer-in-a-specific-historical-context; similarly, a paradigmatic literary

[3] See Gombrich (1963); Wollheim (1968); Walton (1970); Danto (1981); Currie (1989); and Morizot (1999).

work, such as Flaubert's *Madame Bovary*, is a verbal-structure-as-indicated-by-a-specific-author-in-a-specific-historical-context.

Of course a standard musical work in the Western tradition arguably has as its core not simply a *tonal* structure, but rather, a *tonal-instrumental* structure. I here leave that complication aside, because my focus in this chapter is narrowly the role of indication, in a special sense, in the generation of certain sorts of artworks, and not the debate between sonicists and instrumentalists as to whether performing means are essential to standard musical works. A similar complication might also be observed in the case of standard literary works in the Western tradition, whether poems or novels. Their core structure is not simply a *verbal* one, if that be understood as merely a sequence of words or sentences, but such a sequence as segmented into lines, stanzas, paragraphs, chapters, and the like. Such a core structure might perhaps be labeled a "verbal segmental" structure. I will likewise ignore that complication in what follows.

The hyphens employed in the formulations above are not idle. They are meant to draw attention to the particular sort of entity that comes into existence through the structure-indicating actions in question. So for instance, it is not the case that what it is to be Beethoven's Fifth Symphony is to simply be a tonal structure S that is indicated by a specific composer C in a specific historical context H. Rather, what it is to be Beethoven's Fifth Symphony is to be the *indicated structure* S-C-H, an object distinct from any tonal structure *simpliciter*, though an object into which a specific tonal structure enters essentially.

I know that to describe the act through which an artist creates a work of art in music and literature as an act of *indication* might seem odd. I must therefore say a few words about the kind of indication I mean. Of course, when composers or writers are creating works, they probably don't take themselves to be indicating, and probably they don't take their acts of creation to be fundamentally acts of indication. More likely they would be tempted to describe what they are doing as making, as expressing, as formulating, as narrating, and there are no reasons to deny that these do apply here as well, at least generally. But it remains true that what these symphonists and poets are doing, at least most saliently, is indicating, from among all those available in a given language or tonal system, the notes or words that will, arranged in a certain order, constitute the symphony or poem that is theirs.

Naturally, the kind of indication I am discussing here, which we can label "artistic indication", and through which musical and literary works come to be, should be distinguished from more ordinary kinds of indication, which we can label "simple indication". For example, if I notice something of interest in the street while on a bus, I may point to it so my traveling companion will attend to it. This is quite a common type of indication, but not the sort of indication that creates artworks. Or if in the midst of a conversation I make reference to this or that person, there is a sense in which I indicate him or her, yet I surely do not create either of the people I indicated, nor do I even create a partly abstract object of which they would be constituents. Or, if I find myself facing a waitress in a restaurant and I nod my head at the blackboard special that I want to order, again, I indicate, but I do not thereby bring something new into existence merely in virtue of my act of indication.[4] The same can be said for any usual everyday action whose purpose it is to draw someone's attention to some thing or other. In all such cases, the indication in play is not plausibly one that thereby brings into existence some thing that didn't exist before.

So the specific nature of the indication that lies at the heart of the creating act, whether in music or in literature, needs to be identified. Let us, then, compare the indication in operation in the creating of a musical work, say Chopin's Mazurka in A minor, Op. 17, No. 4, and a perfectly ordinary act of indication, say that of drawing my friend's attention to a strange passerby on the street. We'll start with this second indication: I notice the strange person walking along; I then point my finger toward him so my friend will turn her gaze in his direction. In other words, I indicate, or point to, this unknown individual, singling him out as something worthy of attention. If my friend does indeed look at him as a result of my pointing gesture, then my act of indication has succeeded; if my friend doesn't look, then my act of indication has failed, which is not to say that it never occurred. The action is purely transitory; it is tightly bound up with a fleeting situation, one that dissolves almost as soon as it comes to be. The action exhausts itself in the moment, and

[4] The qualification "merely *in virtue of* my act of indication" is important, since an act of ordinary indication can clearly bring another event into existence in a straightforward *causal* way. For instance, my indicating something of interest to my companion can bring about the event of her being aware of the thing in question.

doesn't aim at anything permanent. My goal is simply to draw my friend's attention, here and now, to the passing phenomenon, and there is no goal beyond that. I am not engaged in an activity that is future-oriented, I have no intention to establish or to build anything, I have no desire to leave any traces, however small, on the sands of time. At any rate, such unconcern about what might follow or issue from my act of indication is characteristic of indication in the ordinary, non-artistic sense.

Something quite different goes on in artistic indication. What is Chopin doing, by contrast, when he composes the short but magnificent and heart-rending Mazurka in A minor? There is a sense in which he too—using his fingers, whether he inks the notes or plays them on the piano—is engaged in indication. And what he indicates, in a particular order, are certain individuals of the tonal realm that existed before the act of composition. In this case, there is indeed an act, or rather many acts, of simple indication by which Chopin draws our attention ultimately to a certain tonal configuration that was there before, hidden in the tonal domain as a field of possible sounds. But Chopin does more than that when he is composing, because his intention is indeed to leave a mark of some sort on the world, to insert something new into the musical culture that precedes and surrounds him.

So what exactly does Chopin do above and beyond simple indication when he creates his mazurka? We can start by noticing that he *chooses* or *selects* notes—here including pitches, rhythms, timbres, and dynamics, and from both vertical and horizontal perspectives—he doesn't merely *draw attention* to them. That is to say, Chopin has a certain attitude—in part approval, in part appropriation—toward those particular notes. He doesn't in effect merely say: "here are some sounds" but rather, "here are some sounds, they are now specifically mine, I embrace them, and in this exact sequence." When we simply indicate, say by physically pointing or by referring in conversation, we do not take that perspective with regard to the object targeted; we don't choose it, we don't select it, we don't designate it as something that henceforth has an enduring relation to ourselves.

But in creating his mazurka Chopin doesn't *just* choose or select a sequence of notes which he thus puts in a special relationship with himself. If he were simply improvising, that might suffice as a description of his activity. However, as a composer of a work for *performance*, or possible future instantiation, he aims in addition to *establish* something by that very choice or selection; what he establishes is a *rule*,

a *norm*, a miniature *practice*, whereby pianists play a piece *by Chopin* and not just any piece of music when they play *that* sequence of notes chosen by Chopin, and do so precisely *because* that sequence was chosen by Chopin. That's what makes the Mazurka in A minor exist *as* a work by Chopin. To indicate, as a composer, a particular sequence of notes consists precisely in establishing a rule to reproduce the sounds in a certain way following the indications of a particular, historically situated musical mind. And it is as such an indicated structure that we can identify a classical musical work.

This idea of compositional indication as an action of establishing a rule was well expressed by Nicholas Wolterstorff in a 1987 essay:

> A work of music, then, involves a complex interplay among three sorts of entities: a performance-kind, a set of correctness and completeness rules, and a set of sounds and ways of making them such that the rules specify those as the ones to be exemplified... Once we see the contribution of rules to the constitution of music, it becomes apparent that the three-phase model of composition... [invention, evaluation, and selection]... is deficient when it comes to music. Invention is of course still involved, as is evaluation. So too is selection. But the process of selection is now ancillary to the distinct action of *ordaining* rules for correctness and completeness. In light of his evaluation, the composer selects a set of sounds and ways of making those sounds; but he does this in the course of ordaining a rule to the effect that exemplifying those sounds and those actions is necessary for a complete and correct performance.[5]

The key idea in the above formulation is that of *ordaining* a rule to be followed by performers wishing to instantiate or perform a given work, but clearly this is just a more forceful, more ritualistic variant of the idea, already mentioned, of *establishing* such a rule. And such establishing or ordaining is an essential aspect of artistic indication, one that serves to distinguish it from indication of the mundane sort.

Let us take stock. Artistic indication, unlike simple indication, normally involves all the following: deliberate *choice*, an act of *appropriation*, an attitude of *approval*, and the *establishment* of a rule. But now it is time to explore the way in which artistic indication creates a link between the abstract tonal or verbal world and a concrete individual human being, in other words, to explore how this act serves to individuate the tones or words that it recruits for its creative and expressive ends.

[5] Wolterstorff (1994: 120).

We often say, pre-theoretically, that a sonata is composed of tones, and that a poem is composed of words, albeit ordered in a certain way, and indeed there is some rough truth to these claims. But to be more accurate, the flatted F major triad that opens the Mazurka, Op. 17, No. 4, or the word "traveler" in the first line of *Ozymandias,* aren't components of these works that serve to identify them as such, components that would distinguish them from possible works that resemble them, at least superficially, to the point of being perceptually indiscernible from them. The story of Pierre Menard and "his" *Quixote* clearly shows that works that are perceptually indiscernible are not necessarily identical; in fact, such works can be dramatically different in meaning, significance, or content. Therefore, even a given series or configuration of notes or words, however complex it may be, is not sufficient to fix or uniquely individuate the musical or literary work in question. This individuation must rather rest on the unique identity of the artist who, in the interests of self-expression, combines these brute elements—abstract notes or words—in a specific creative context, and who then ends up combined with them, so to speak, in the resulting work.

It is for this reason that the true identifying elements of such works aren't really the purely abstract tones and words that the artist uses or appropriates in fashioning his or her work but, as it were, those tones and words *as-indicated-by-this-artist-in-his-or-her-singular-artistic-situation.* The elements of the work so understood in effect guarantee that the work really is the work of *that* artist, and it is by indicating, in the sense I have been trying to make clear, the abstract elements of a given language or system, that the artist brings into being these half-abstract and half-concrete entities that I call "indicated structures". The indicated structures are more individual, more personalized, we might say, than the pure structures that can, unlike indicated structures, be part of any work of any artist. Again, only the indicated structure, not the pure structure, can be created by the artist. Only that structure, and not the purely abstract one whose existence predates that of the artist himself or herself, can have the aesthetic, expressive, and semantic properties proper to the work of art as such.

Having somewhat clarified, at least in a contrastive manner, the nature of the indication involved in the creation of indicated structures, I must now take note of a difficulty concerning the *type status* of such entities. Is an indicated structure, that is, a structural-type-as-indicated-in-a-context, itself strictly speaking a *type*? Well, odd as it may seem, perhaps not, and

for the following reason. If, as many philosophers maintain, types are wholly defined in terms of essential properties, ones that must be possessed by any token of the type, and if in addition such properties, even when relational, are held to be eternal, and so not subject to creation, then types will also be eternal, and equally not subject to creation.[6] But that is precisely the opposite of what indicated structures and initiated types are supposed to be, and so insisting that they are types would undermine one of the main motivations for introducing them. Thus, perhaps the act of artistic indication that operates on a preexisting structural type, and which yields an indicated structure or initiated type, should not be conceived as having as output a type *tout court.*[7]

But if initiated types are not, *sensu strictu*, types after all, then what are they? One possibility would be to assimilate them to *qua* objects, items such as Obama-as-President, or Venus-as-seen-from-Earth.[8] However, that is not an altogether happy suggestion, for at least two reasons. The first is that conceiving initiated types as *qua* objects makes them rather too insubstantial and aspectual, and thus poor candidates for creation in a robust sense. The second is that the *qua* object model seems inadequate to capture the intuition that in creating a musical work of the standard sort one is engaged in *constituting it from,* or *making it out of,* some preexistent sound structure.[9]

So where does that leave us? Well, if initiated types are then neither types as classically defined, nor *qua* objects, they are nonetheless recognizably what Wollheim called "generic entities". That is to say, they are things that can have instances and that can be exemplified in a concrete manner. In the case of musical initiated types, such instantiation occurs

[6] An argument of this sort has been offered in Dodd (2000, 2002). For discussion and partial defusing of the argument, see Howell (2002). What I call "indicated types" Howell there calls "types-in-use", and the reservations aired here as to whether indicated types are finally properly thought of as types would apply equally well to Howell's types-in-use.

[7] For a judicious review of the pros and cons of conceiving musical works as types of some sort, see Davies (2011: ch. 2).

[8] A theory of *qua* objects is worked out in detail in Fine (1982).

[9] This is convincingly argued in Evnine (2009). Evnine also articulates an attractive positive conception of what the work of making a musical work involves, a conception not far removed from that of artistic indication as elaborated in the present chapter: "The labour, in the case of composition, is not transformative of the sound structure out of which the work is made. But in some looser sense it is work on that sound structure. It is the work of locating it within the saturated sound space and distinguishing it from other sound structures" (Evnine, 2009: 215).

through musical performance, and in the case of literary initiated types, such instantiation occurs through the printing of copies.

One difficulty, though, surely remains, and it is that of saying what it is to instantiate the *historical-cultural aspect* of an initiated type such as a musical indicated structure. The instantiation of the structural aspect—the sound/performance means structure at the core of such an initiated type—by a concrete performance is a familiar and relatively unproblematic idea, but instantiation of the other aspect arguably is not. Perhaps all one can say is that to produce a performance that complies with the structural aspect of a musical work in a way that is *mindful of and conformant with* the historical-cultural aspect is thus to instantiate that aspect as well.

Let us return once more to the question of whether initiated types are, strictly speaking, types. That there is perhaps, at bottom, not that much of an issue here is suggested by Robert Stecker in a recent essay on the methodology of ontological reflection about art:

Some believe that types are by definition eternal and unchanging (Rohrbaugh, Dodd), while others think that at least some types are created and are subject to change and can cease to exist (Levinson, Howell, Thomasson). On this latter issue it seems that there is no real dispute other than a dispute over which entities should be called "types." As long as one can give a consistent, intelligible description of a kind of entity, it is not important what we call it.[10]

II

In the remainder of this chapter I briefly address three further questions, ones concerning the sorts of indication *effected* by works of art, as opposed to the sort of indication with which we have so far been concerned, the sort that operates to *create* works of art, at least in certain art forms.

First question: how does a work indicate *that it is a work of art*, and is thus to be appreciated as such? A brief answer is this. On the view of

[10] Stecker (2009: 385). One might still insist that a reasonable methodological concern remains, namely that the extent to which the kind of entity one posits resists being classified according to the standard metaphysical taxonomy is the extent to which the kind of entity posited can seem *sui generis* or ad hoc. But in response to that I would point out that it would be surprising if new metaphysical insights or proposals did not often require such posits.

arthood that I have proposed and defended over the years, a work of art is such—that is, is a work of art—because it, or the object or event or structure it contains, has been projected by an artist with a specific intention, that of making it the case that the work be taken or treated or regarded or engaged with more or less as some works of art have been taken or treated or regarded or engaged with in the past.[11] It follows immediately that anything can be, or at least can become, a work of art, if it is simply sincerely and seriously projected in such a manner, and thus that there are no foolproof external signs that something presented for our consideration is a work of art.

That said, some features serve as reliable, if not infallible, signs that what we are presented with is a work of art. For instance, and confining ourselves here for simplicity to the visual arts, features such as extraordinary beauty; striking form; enigmatic appearance; ostensible reference to earlier artworks; employment of a traditional artistic medium; a tag or label attaching to the object; an autograph or signature on the object itself; or finally, location in an art gallery or exhibition space. In many instances, these are some of the ways that a visual artwork indicates or signals to us that it is indeed a work of art.

Second question: what does a work of art indicate *in the world beyond it*? A brief answer is that it indicates as much as can be indicated by any other symbolic vehicle and, in some respects, rather more. Works of art can indicate worldly objects in many ways: by representing them, by expressing them, by exemplifying them, by evoking them, by alluding to them, by serving as metaphors for them, and so on. Works of art sometimes go beyond these general ways of referring in ways that are more evaluatively loaded, as with homage, pastiche, parody, satire, burlesque, or caricature. Of course, the question of what exactly works of art indicate about the world outside them, in how many registers or modes, and with what import for their overall meaning, cannot adequately be answered short of a study in effect summarizing the whole of art criticism and meta-criticism.

Third question: what things do works of art enable us to glimpse or discern *without explicitly indicating them*? In other words, what do artworks indicate *indirectly*, without being meant to, without expressly drawing our attention to them, and so to speak, in spite of themselves?

[11] See the relevant essays in Levinson (1990a, 1996b, and 2006).

A brief answer is that they so indicate many things, and possibly more than they directly indicate. In some sense, artworks indicate indirectly whatever one can reasonably conjecture, given the work and the artistic context in which it was created, about the creator and the process of creation. That is to say, works generally reveal or betray, without aiming to do so, a range of things about their creators and the processes by which they were created.

For instance, the way in which a novel was written can tell us much about the neuroses of its author even if the novel doesn't depict a neurotic narrator and doesn't directly address neurosis. Something of that sort might be true of Kafka's *The Trial*. A symphony, merely by being excessively long, can convey the difficulty faced by the composer when trying to finish the composition, even if the symphony does not directly exemplify this difficulty. Bruckner's Fifth Symphony is perhaps an example of such a work. The violence of a painting's *facture* and the savage character of its forms can suggest a feeling of self-loathing that the artist himself might not be aware of, without the painting actually expressing, representing, or symbolizing that feeling. I am thinking here of some of Willem De Kooning's paintings from his *Woman* series.

In short, works of art do not only indicate what their creators meant to convey or communicate, and which in successful cases we understand above all in engaging with them; they can also indicate much about their creators and their creative processes that was never meant to be conveyed or communicated.[12]

If we label the sort of indication I have been concerned with in this section "work indication", the question can be raised of how work indication relates to the sort of indication of principal concern in this essay, namely, "artistic indication", that involved in the creation of literary and musical works of art. We might ask, in particular, if work indication is *figurative* indication, while artistic indication is *literal* indication. I think not. My view is that both are literal, though of course there are salient differences between them. First, their *agents* are different, artists in the one case, and artworks in the other case. Second, the *agency* involved is different, being immediate in one case, and mediated in the other. That is

[12] For related reflections on what artworks indicate directly and indirectly, see Levinson (1996b).

to say, the author or composer directly performs actions that constitute the selectings, fixings, and ordainings identified earlier as central to literary and musical art-making, the artist's agency not being dependent on that of other agents, whereas their artworks perform (or "perform") actions only in virtue of having been constituted as artifacts of a certain sort by their creators. Finally, the action involved in work indication, if not quite figurative, is admittedly action in a *weaker* sense than that involved in artistic indication, one that does not imply will, intentionality, or goal-directedness, and amounting, more or less, to bringing about an effect or result.[13]

In conclusion, the work of art, and more specifically, the musical or literary work of art, can be considered a site where several kinds of indication intersect. There is, on the one hand, the kind of indication performed *by the artist*, which makes the work what it is, through transforming an ensemble of abstract tonal or verbal elements into an individualized such ensemble, one tied essentially to the artist himself or herself. On the other hand, there is the kind of indication performed *by the work*, which encompasses all of what the work signifies, in a wide sense, about the world and the artist, directly or indirectly, for better or for worse. And these two sorts of indication, though different in nature, are of course intimately related: *what* a work, once constituted, variously indicates, depends in significant measure, and in numerous ways, on the indication by which it is constituted *as* a work.

References

Currie, Gregory (1989). *An Ontology of Art.* London: Macmillan.

Danto, Arthur (1981). *The Transfiguration of the Commonplace.* Cambridge, MA: Harvard University Press.

Davies, David (2011). *Philosophy of the Performing Arts.* Oxford: Blackwell.

Dodd, Julian (2000). "Musical Works As Eternal Types." *British Journal of Aesthetics* 40: 424–40.

Dodd, Julian (2002). "Defending Musical Platonism." *British Journal of Aesthetics* 42: 380–402.

[13] It is in that respect similar to the sort of action invoked when speaking of the gravitational action of one mass on another, or of the action of sulfuric acid on certain metals.

Evnine, Simon (2009). "Constitution and Qua Objects in the Ontology of Music." *British Journal of Aesthetics* 49: 203–17.

Fine, Kit (1982). "Acts, Events, and Things." In *Sprache und Ontologie*. Vienna: Holder-Pichler-Tempsky.

Gombrich, Ernst (1963). *Meditations on a Hobby Horse*. London: Phaidon Press.

Howell, Robert (2002). "Types, Indicated and Initiated." *British Journal of Aesthetics* 42: 105–27.

Levinson, Jerrold (1990a). *Music, Art, and Metaphysics*. Ithaca, NY: Cornell UP.

Levinson, Jerrold (1990b). "What a Musical Work Is, Again." In Levinson (1990a).

Levinson, Jerrold (1996a). *The Pleasures of Aesthetics*. Ithaca, NY: Cornell UP.

Levinson, Jerrold (1996b). "Messages in Art." In Levinson (1996a).

Levinson, Jerrold (1980). "What a Musical Work is," *Journal of Philosophy* 77: 5–28.

Levinson, Jerrold (2006). *Contemplating Art*. Oxford: Oxford University Press.

Morizot, Jacques (1999). *Sur le problème de Borges*. Paris: Kime.

Stecker, Robert (2009). "Methodological Questions about the Ontology of Music." *Journal of Aesthetics and Art Criticism* 67: 375–86.

Walton, Kendall (1970). "Categories of Art," *Philosophical Review* 79: 334–67.

Wollheim, Richard (1968). *Art and Its Objects*. Cambridge: Cambridge University Press.

Wolterstorff, Nicholas (1994). "The Work of Making a Work of Music." In P. Alperson (ed.), *What Is Music?* 2nd edn, University Park: Penn State UP.

5

Musical Beauty

1. Much good music is beautiful, and perhaps all beautiful music is good, but much good music is not, in the sense I am concerned with, beautiful. My objective in this chapter is to identify and characterize the specificity of musical beauty in the *narrow*, though perfectly familiar, sense in which beautiful music is a category of good music, but not coincident with good or valuable music *tout court*. *Narrowly* beautiful music, or as I will sometimes call it, *unequivocally* beautiful music, is thus to be distinguished from *broadly* beautiful music, where this is tantamount to good or valuable music as a whole, but also from clearly *non-beautiful* yet valuable music, including music we might label *sublime* in the nineteenth-century sense, and from music we would judge merely *pretty*.

For simplicity I here focus exclusively on Western tonal or quasi-tonal music. My examples will be drawn almost entirely from the classical repertoire, with one example drawn from theatre music and one from film music. But this focus on Western tonal music should in no way be taken to suggest that there is not beauty, in the sense I am aiming at, to be found in virtually every genre of music.

My target is musical beauty as a *specific sort* of musical excellence, one distinct from musical power, sublimity, expressiveness, profundity, inventiveness, ingenuity, dramaticness, and so on. Some earmarks of musical beauty are features such as sweetness, harmoniousness, fluidity, tenderness, and rhapsodicity. Musical beauty is, above all, disarming and enchanting, at the opposite pole from music that is threatening, disturbing, arousing, or anxiety-producing. Of course, the boundary between music that is narrowly beautiful and music that, while musically good or valuable, is not beautiful in the sense in question, remains irredeemably vague. Furthermore, at least some music that is narrowly beautiful is also passionate, poignant, or profound, properties compatible with such

beauty, unlike sublimity, dramaticness, or monumentality, which are probably incompatible with musical beauty narrowly understood.

2. It will help, before proceeding further with the examination of musical beauty, to state what I take the common denominator of all beauty, in whatever mode, whether free or dependent, in whatever medium, whether visual or verbal or sonic, in whatever domain, whether that of art or nature or persons: it is the affording of pleasure in the perceiving or beholding of the item in question, in the appearance of the item to our senses and our imaginations.[1] In the case of music, the mark of musical beauty is thus pleasure in apprehending by ear music's sensuous appearance as it presents itself in time. Put otherwise, the touchstone of narrowly beautiful music is an immediate, unmitigated, and unmixed pleasure in how the music sounds and unfolds, a pleasure in which tension and discord have at most a minor place.

Beautiful music, then, is music that seduces, charms, and gently conquers us—rather than, say, exciting, confronting, or challenging us. As such, beautiful music in the narrow sense verges perilously on what the music industry calls "easy listening" music, or music "for relaxation." The music so labeled is in effect the degenerate form of beautiful music, the devolution of beautiful music into something vapid and spineless, rather than simply effortlessly disarming and enchanting.

But truly beautiful music is also distinct from music that is simply pretty or decorative. The difference between beautiful and merely pretty music might be illustrated by the contrast between the music of Chopin and that of the nineteenth-century Irish composer John Field, whose nocturnes for piano are said to have provided the model for Chopin's ventures in that direction. For almost nothing that Field composed rises above the merely pretty, and a good deal of it even falls below, through a rather persistent tendency toward dullness. Whereas almost everything composed by Chopin is outstandingly beautiful, or else musically good in another fashion.

Again, only some good music is beautiful; and some music that is beautiful is not, more broadly viewed, especially good; and much great

[1] Compare this definition from a recent philosophical dictionary: "Bellezza. Caratteristica di tutto quanto viene percepito con un'approvazione e un piacere immediate, disgiunti da ogni scopo esterno all percezione stessa." [Beauty. Characteristic of anything that is perceived with immediate approbation and pleasure, apart from any external aim or interest.] Ermanno Bencivenga, *Parole che contano* (Milan: Mondadori, 2004), 24.

music is not, in the sense I am targeting, beautiful, though of course it is beautiful in the sense of artistically excellent. Much music that would be described as sublime is not beautiful. Music that is tense or unsettling or overwhelming is not beautiful in the sense I am after. By the term "musical beauty" it is useful to mean something more specific than musical goodness or excellence. Musical beauty implies a *particular sort* of audible appearance, that which is displayed by some, but not all, good music, an appearance that is in some way analogous to that displayed by paradigm examples of visual beauty.[2]

One reason to decline to identify all musical excellence as musical beauty is that many composers explicitly *deny* that they are aiming to compose or have in fact composed beautiful music. Such composers claim instead to be pursuing other goals, such as emotional expression, formal invention, timbral exploration, spiritual transcendence, or the out-and-out blowing of minds by sonic means—goals that a marked degree of musical beauty would not advance, and might even hinder. It is not hard to imagine composers such as Stravinsky, Schoenberg, Varèse, Ives, Ligeti, Gerard Grisey, and a host of others as issuing such denials. So it would be best, all told, to recognize a sense of musical beauty that does not make such denials on the part of accomplished composers almost nonsensical.

3. I now offer an assortment of specific examples, so as to put some flesh on the bones of the sketch of musical beauty I have given. Here is an arbitrarily assembled but nonetheless representative list of narrowly beautiful pieces of music from the classical repertoire: Ravel: *Pavane pour une infante défunte*; Debussy: *Prélude à l'après-midi d'un faune*; Schumann: *Larghetto* from Symphony No. 1; Mahler: *Adagietto* from Symphony No. 5; Mahler: *Andante* from Symphony No. 6; Massenet: 'Méditation' from *Thaïs*; Bach: Fourth "Brandenburg" Concerto; Mozart: *Andante* from Piano Concerto No. 21; Beethoven: *Allegro* from Violin Sonata No. 5, "Spring"; Haydn: *Allegro* from String Quartet, Op. 76, No. 4, "Sunrise"; Fauré: *Allegro* from Violin Sonata No. 1; Poulenc: Flute Sonata; Brahms: *Allegro* from First String Sextet in B♭; Tchaikovsky: Serenade for Strings; Schubert: *Adagio* from String Quintet in C; Ravel: *Introduction and Allegro* for Harp, Flute, Clarinet, and String Quartet;

[2] For further discussion of beauty in general, see my "Beauty Is Not One: The Irreducible Variety of Visual Beauty," in E. Schellekens and P. Goldie (eds.), *The Aesthetic Mind* (Oxford: OUP, 2012).

Smetana: "The Moldau" from *Má Vlast*; Falla, *Nights in the Garden of Spain*; Barber, *Adagio for Strings*; and Toru Takemitsu, *Water Music*.

Now, some great music that is *not* narrowly beautiful, but instead powerful, disturbing, restless, or sublime: the outer movements of Beethoven's "Appassionata" Piano Sonata; the outer movements of Schubert's String Quartet No. 14, "Death and the Maiden"; the Scherzo of Beethoven's Ninth Symphony; Brahms's Piano Trio in C minor; the opening movement of Mahler's Second Symphony; the "Dies Irae" of Mozart's Requiem; "Siegfrieds Trauermarsch" from Wagner's *Götterdämmerung*; Bartók's Fourth String Quartet; Schoenberg's *Erwartung*; and Richard Strauss's opera *Elektra*. And finally, some great music that is perhaps even *ugly*: Beethoven's *Grosse Fuge*, the third of Berg's *Three Pieces for Orchestra*, Xenakis's *Pithoprakta*, and Penderecki's *Threnody for the Victims of Hiroshima*.

It will bring into clearer relief what I mean by narrow *musical* beauty if we compare this to *painterly* beauty narrowly understood, that is, as not equivalent to painterly excellence generally. The sense of musical beauty I am after is parallel to that which suggests itself in regard to paintings, where it is not unnatural to divide artistically successful paintings into those which are *beautiful* and those which, having artistic goals of other sorts, are rather *un*beautiful, or at any rate, not *clearly* beautiful.

This is the sense in which the paintings of Perugino, Tiepolo, Vermeer, Corot, Degas, Monet, Vuillard, Matisse, Klimt, Klee, and Kandinsky are generally *beautiful*, while those of Bosch, Ensor, Kirchner, Nolde, Picasso, Francis Bacon, Franz Kline, Robert Motherwell, Chaim Soutine, and Anselm Kiefer, in general are *not*—and not because they are merely *pretty*, like many of the paintings of, say, Renoir or Dufy or Boucher. Artists such as Manet, Seurat, Mondrian, Rothko, and Barnett Newman might be said to occupy a somewhat intermediate position on this admittedly vague spectrum, in that typical canvases of these painters strike us neither as beautiful nor as unbeautiful, but as compelling in another manner somewhat orthogonal to those two poles.

4. Beautiful music is not just distinct from unbeautiful yet powerfully expressive music. Music that is unequivocally beautiful is also other than and more than music that is merely pleasant or diverting. As examples of the latter we might cite Mozart's early C major piano sonata, known to every beginning student of the piano, Boccherini's Minuet in G, from one of his string quintets, or even Bach's "Sheep may Safely Graze." The

"musically beautiful", to borrow Hanslick's famous phrase in one of its standard English translations, differs from the musically pretty in more than *degree* of unmixed pleasure or diversion afforded. The difference seems rather to lie in whether such music actually *moves* or *touches* us, apart from merely being pleasant or diverting. One of the most distinctive marks of narrowly beautiful music is a feeling of melting on hearing such music, a sensation of being gratifyingly disarmed and overcome. Perhaps an equivalent way of putting this would be just to affirm that beautiful music is music that is in some manner notably *expressive*, as well as being wholly and straightforwardly pleasurable.

Note that even if you do not agree with my sorting of musical examples as between the beautiful and the merely pretty or diverting, and would thus sort them somewhat differently, you may nonetheless agree that the beautiful is distinct from the merely pretty or diverting in virtue of its moving or touching us emotionally in some manner, beyond the pleasure afforded us in following its effortless unfolding.

5. Assuming that we now have the category of the narrowly musically beautiful clearly enough in our sights, it will be useful to recognize a distinction, within that category, between *sensual* musical beauty and *intellectual* musical beauty. A distinction of this sort is suggested in Thomas Mann's last novel, *Doktor Faustus*, about a demonically possessed composer named Adrian Leverkuhn.

At one point in the novel the company assembled at a social evening in Munich are listening to a phonograph recording of Dalila's D♭ major aria, "Mon cœur s'ouvre à ta voix," from Saint-Saëns's opera *Samson et Dalila*. The novel's narrator remarks that the mezzo-soprano's singing

was marvelous in its warmth and tenderness, in its dark lament for happiness—as was the melody itself, whose two stanzas are constructed alike, with the passage of fullest beauty beginning first toward the middle before reaching its stunning conclusion, especially the second time, when the violin, now quite sonorous, joins in, basking in the voluptuous melodic line, and repeats its final figure in a plaintively tender postlude.

Leverkuhn, the novel's protagonist, then comments as follows:

Well then! Now you understand how a serious man can be capable of worshipping such a number. Its beauty is not intellectual, but exemplarily sensual. And ultimately, one ought not fear or be embarrassed by what is sensual.[3]

[3] Thomas Mann, *Doctor Faustus* (New York: Vintage Books, 1997), 434.

If this aria of Saint-Saëns's can thus serve us as a paradigm of sensual musical beauty—along with, say, Debussy's *Prélude à l'après-midi d'un faune* and the "love theme" from Tchaikovsky's *Romeo and Juliet*—then as paradigms of intellectual musical beauty we might offer Ockeghem's *Missa Fors Seulement*, Bach's "Goldberg" Variations, and Haydn's Andante and Variations in F minor. Such pieces captivate us through their melodic-harmonic form alone, without any notable assist from tone color or emotional coloration. From what Mann tells us in *Doktor Faustus* many of the compositions of Leverkuhn also exemplified intellectual musical beauty, but unfortunately those remain unavailable.

It is instructive to compare Saint-Saëns's "Mon cœur s'ouvre a ta voix" with an equally fine piece of music for voice, Schumann's "Ich grolle nicht" from his song cycle *Dichterliebe*. Confining ourselves to the music apart from the words, we may note that both songs are suffused with romantic feeling and undisguised passion. But while it is natural to call the Saint-Saëns beautiful, it is somewhat less natural to call the Schumann beautiful. Why is that? I wager it is because the Schumann conveys a measure of tension and unease, of psychic conflict and unsatisfied yearning, whereas the Saint-Saëns is flowing acceptance throughout, caressing and tender, from which all opposition has been banished. What we require of music that we are comfortable labeling unequivocally beautiful, it seems, is a reduction, not a heightening, of stress, a soothing of the animal spirits rather than a rousing of them, a promise of peace and tranquility rather than struggle and strife. One thinks of Baudelaire's formula for the earthly paradise: "luxe, calme, et volupté."

6. This brings us to the question of the underlying basis of musical beauty. In particular, what structural features of music *conduce to*, and which *militate against*, the achievement of musical beauty in the narrow sense? Among the features that seem to conduce to such beauty are these: moderate tempo, even dynamic level, legato articulation, limited dissonance, major mode, symmetrical phrasing, and slow harmonic rhythm. That list of structural features conducive to musical beauty could no doubt be extended. But even were the list to be further filled out the ensemble of features so comprised could still be found in reams of unbeautiful music. Such structural features are plainly insufficient for musical beauty.

What seems necessary for musical beauty to emerge, I suggest, beyond the presence of features such as those just noted, is some degree of

novelty or *unexpectedness* in the music's evolution. It is that which serves to impart a distinctive expressive profile to the music, stamping it with the individuality of a person, and that which also largely accounts for the power of beautiful music to touch or move us emotionally, remarked on earlier as essential to its being beautiful. Of course in invoking a feature like novelty or unexpectedness we have perhaps gone beyond the bounds of what one would normally consider a structural feature of music.

Consider now the sort of features, whether structural or more-than-structural, that militate against, rather than conduce to, the emergence of the narrowly musically beautiful. There seem to be a number of clear defeaters of musical beauty, by which I mean features whose presence either precludes or makes highly unlikely that a piece will turn out to be narrowly musically beautiful. Such defeaters include: abrupt shifts of meter (as in Stravinsky's *Sacre du printemps*); jagged rhythms (as in the scherzo of Schubert's "Death and the Maiden" Quartet); breathless tempo (as in the finale of Beethoven's Third "Rasumovsky" Quartet); fearfulness or pessimism (as in the opening of Mahler's Second Symphony); anguish or unrest (as in the outer movements of Brahms's First String Quartet); humor or sarcasm (as in parts of Bartók's *Concerto for Orchestra*); aggression or martiality (as in the opening of Mahler's Sixth Symphony); weirdness or uncertainty (as in Berg's Piano Sonata); and angularity or discontinuity (as in Beethoven's *Grosse Fuge*).

On the other hand, the narrowly musically beautiful is compatible with the following features which might seem at first blush to work against such beauty: liveliness (as in the opening movements of Mendelssohn's "Italian" Symphony and Tchaikovsky's Violin Concerto); melancholy (as in the third movement of Brahms's Third Symphony and many of Chopin's mazurkas); unusual instrumentation (as in the *Lento* of Falla's Harpsichord Concerto); and certain sorts of unprepared modulations. A striking example of this last is provided by David Raksin's song "Laura," the theme music for the 1944 film of that name, whose melody turns downright improbable and almost unsingable around its twelfth measure, and whose harmony already shifts surprisingly at the beginning of the song's second eight-bar period.

It is worth observing, finally, that the concept of narrow musical beauty that we have been examining very likely has a *prototype* structure, with certain examples being closer to the center of the concept and others closer to its periphery, rather than a character that might be

captured by a set of necessary or quasi-necessary conditions. Paradigms or prototypes of musical beauty, such as those offered in Section 3, probably serve to anchor the meaning and deployment of the concept of musical beauty rather more than do the conducing and defeating features that we have latterly been examining.[4]

7. Before concluding I must try to say something about the special *value* of narrowly beautiful music in the sense I have targeted in this essay. What does such music *do* for us that good but not narrowly beautiful music does *not* do? Perhaps equivalently, why do we *need* such music, over and above good music generally, some of it ultimately more valuable than the narrowly beautiful music on which I have here focused? Why do we require Debussy's *Faune*, Massenet's "Méditation," Puccini's "Un bel dì," Poulenc's Flute Sonata, and so on, when we have arguably greater but less narrowly beautiful music, such as Bach's Passacaglia and Fugue in C minor, Beethoven's "Hammerklavier" Sonata, Mozart's "Jupiter" Symphony, Brahms's Piano Quintet, Mahler's Ninth Symphony, Verdi's Requiem, Stravinsky's *Sacre du printemps*, Bartók's Second Piano Concerto, Shostakovich's Eighth String Quartet, and Berg's *Wozzeck*?

At least part of the answer, I think, is this. Human life, even in our relatively privileged and comfortable Western societies, isn't always easy. Even if life in affluent and enlightened modern democracies is not as "nasty, brutish, and short" as, according to Hobbes, it was in the state of nature, it is still not invariably a piece of cake, a thing of joy, an unmitigated delight. It is, in fact, often full of anxiety, stress, uncertainty, and disappointment. Narrowly beautiful music provides some compensation for that—provides an antidote, if a temporary one, to the annoyances and compromises of the quotidian, and a rejoinder of sorts to the oppressive greyness of existence.

In a world where people and nature were in complete harmony with one another, where interpersonal conflict was unknown, where our spirits and emotions were invariably in equilibrium, where we found ourselves always attuned to our surroundings, where our projects always came to fruition, where our expectations were always marvelously fulfilled—in such a world we would probably have little or no need for

[4] See Eleanor Rosch, "Principles of Categorization," in E. Margolis and S. Laurence (eds.), *Concepts: Core Readings* (Cambridge, MA: MIT Press, 1999).

narrowly beautiful music. Narrowly beautiful music provides a sonic vision of an ideal world, one in perfect balance, wholly lucid and luminous, where "luxe, calme, et volupté" reign, and which vision consoles us, if only momentarily, for the harshness, imperfection, and haphazardness of this world. As Friedrich Nietzsche famously, if rather hyperbolically, observed, without music human life would be a mistake. But without narrowly beautiful music, we might add, human life would be, if not an outright mistake, at least a damned sight harder to bear.

6

Values of Music

1. Introduction

In this chapter I survey the kinds of value that music can possess, or perhaps equivalently, the variety of ways in which music is sensibly valued. For that music is multiply valuable is the central theme of this chapter. (On the general subject of musical value, see Budd, 1995; Davies, 2007; Goldman, 1995, 2011; Kivy, 2002; Levinson, 2006b; Ridley, 2004; Scruton, 1997; Sharpe, 2004; and Storr, 1992.)

It is not uncommon for those who reflect on the value of the arts, from the perspective of either art makers or art appreciators, to propose that art is useless, and that it is precisely in being useless, or not satisfying any practical objective, that it is both most true to its nature and of greatest worth. It is not hard to understand the motivation of such an attitude toward art, sometimes described as "aestheticist" or "art for art's sake." At bottom is the concern that art not be viewed in utilitarian terms, that it not be bound to the marketplace, that it not be rudely harnessed to social or political goals. For to treat art in such fashion would be at odds with the formal and expressive freedom that art must arguably be accorded if it is to achieve all that it might in artistic terms.

But regarded soberly, the claim that art is useless is hyperbolic. It is true only in the limited sense in which usefulness is equated with the achieving of narrowly practical ends. But the arts, and music among them, are certainly not, in the broad sense, useless. The arts answer to certain interests we possess, certain goals we entertain, and certain purposes that we embrace. They answer, perhaps, even to certain needs that we have, in the sense of goods without which our lives cannot fully flourish, even if we are not likely to actually perish without those goods.

Consider in this connection the well-known remark of Friedrich Nietzsche: "Without music, life would be a mistake" (*Twilight of the Idols*,

1888). This can, of course, like the claim that art is useless, seem somewhat exaggerated. For if Nietzsche's affirmation is valid, then why not, "Without flowers, life would be a mistake"? Or "Without tennis, life would be a mistake"? Or even, "Without Coca-Cola, life would be a mistake"? Clearly, music, flowers, tennis, and carbonated beverages are all, in their different ways, good things, but is there really something special about music, such that its absence from our lives would be almost tragic, whereas that would perhaps not be so were those other good things to be absent? I return to that question throughout this chapter.

2. Preliminary Distinctions

Certain preliminary distinctions regarding the value of music are in order at the outset of our inquiry. First, we can distinguish the *intrinsic* value of music from the *instrumental* value of music, where the former can be understood as the value of engagement with music for its own sake, without any further end, while the latter can be understood as the value of music as a means to some good other than that residing in the engagement with music for its own sake. Second, we can distinguish the *artistic* value of music, which includes music's intrinsic value but also some of its instrumental value, from its *non-artistic* value, which is entirely instrumental. Third, we can distinguish the *artistic* value of music from its *aesthetic* value, where the former has as its core the latter but is not exhausted by that.

Fourth, we can distinguish the value of music for an *individual* from the value of music for a given *community*, or even more broadly, for all of *humankind*. Fifth, as regards the value of music for an individual we can distinguish between its value for someone as a *listener*, its value for someone as a *performer*, and its value for someone as a *composer*. (See Sessions, 1950; and Levinson, 2006b.) Sixth and last, we can distinguish between the value of music or the practice of music *as a whole*, and the value of *individual pieces or occasions* of music.

Corresponding to the last distinction are two questions that might naturally be posed about musical value. One, what makes music or the practice of music as a whole good, or something that contributes to human flourishing? Two, what makes a given piece or occasion of music

good, or good compared to other such pieces or occasions of music? Let us dwell on these questions for a moment.

Could music as a whole be valuable if no individual pieces or occasions of music were valuable? That is hard to envisage, for the value of music as a whole seems to depend on the value of at least some such individual pieces or occasions. Could an individual piece or occasion of music be valuable even though music as a whole was not? That seems slightly easier to envisage, if still highly improbable, for the existence of even one valuable instance of music would surely point the way to others.

To frame the question somewhat differently: is music in general valuable because specific instances of music are valuable, or are specific instances of music valuable because music in general is valuable? At this point we may begin to suspect that there is something unhappy about the very question, but if forced to choose it looks as if the first option is the better one, holding that the value of music in general must somehow derive from the value of specific instances of music.

Perhaps the best thing to say is this: music *as a whole* is valuable insofar as it is *possible* for there to be valuable instances of music or occasions of music-making, where such instances or occasions may be valuable in different ways, and a given *genre* of music will be valuable to the degree that valuable instances of music or occasions of music-making are possible *within* that genre.

At any rate, I will here be primarily concerned with the value attaching to music or the practice of music *generally*, rather than with the value of *individual* pieces of music or genres of music. That means that my discussion of the values of music will often situate itself at a fairly abstract level, seeking those musical values that are to be found, though of course to varying degrees, in music of just about any sort.

The *social* value of music provides a clear example of the divergence between the value of music in general and the value, inherently comparative, of an individual piece of music. Let us understand the social value of music as consisting centrally in the opportunity that music affords to bring people together in a public context for shared experience, interaction, coordination, and mutual affirmation. So understood, social value does not serve to any extent as a differentiating value of individual pieces or occasions of music, since it is possessed by virtually all pieces or occasions of music, and yet remains a

value of music generally. (See Higgins, 1991; McNeil, 1995; and Bigand, 2011.)

3. Music's Value for Listener, Performer, and Composer

It is helpful at this point to distinguish music's value to listeners from music's value to performers from music's value to composers. These are, of course, different in theory, so it is hardly surprising that in practice they only partly overlap. (See Sessions, 1950.)

Music can be more rewarding to listen to than it is to perform—perhaps it is technically too easy to challenge a player and yet manages to be melodically ravishing. An example that comes to mind is the Rodgers and Hart standard "You Are Too Beautiful." Music can be more rewarding to compose than it is to listen to—perhaps involving ingenious solutions to problems in counterpoint that are difficult to relish audibly. An example might be Ferruccio Busoni's gigantic work for piano, *Fantasia contrappuntistica*. And music might be more rewarding to perform than it is either to listen to or to compose—perhaps interestingly challenging the performer without either calling forth anything new from the composer or especially captivating the listener. An example might be Max Bruch's *Scottish Fantasy* for violin and orchestra, which despite many virtuosic turns for the soloist, features thematic material that is far from enthralling, and works its folksy closing theme to death. (See Levinson, 2011b.)

So a given piece of music can differ in value according to the role in the musical situation that is focused on—whether that of listener, performer, or composer. Still, it seems as if the first of those, that of the listener, appropriately takes priority over the others. Why? The reason is that making music the heard experience of which is rewarding is the fundamental *raison d'être* of the musical enterprise, that by which success in composing and success in performing is ultimately to be judged. Basically, someone composes well if they compose music that rewards listening, and performs well if they perform in a manner that rewards listening, whatever satisfactions may or may not accrue to the composer or the performer in the activities of composing and performing themselves.

Another reason, often noted, is that composers and performers are always perforce listeners as well as composers and performers, and that their listening responses, at least in imagination, are integral to the successful pursuit of their composing and performing activities. The satisfaction that a performer takes in performing or that a composer takes in composing may be, in part, a matter of challenges met or problems solved in their respective arts, but in virtually all cases spelling out what that amounts to will acknowledge the goal of a *good-sounding* performance or composition, that is, one that appeals above all to the ear of the listener, and not only the mind of the composer or the body of the performer.

4. Manners of Musical Value

It will be useful now to distinguish different *manners* in which music can be valuable in regard to a given desirable end. Doing so is essential if we hope to justify in some measure Nietzsche's rather hyperbolic pronouncement about music's importance.

The different manners that I have in mind are as follows. First, music might be valuable *as one among many* other things conducive to some desirable end. Second, music might be *particularly* conducive to a desirable end, despite there being a number of other things conducive to that end as well. Third, music might be valuable as *distinctively* conducive to some desirable end, unlike almost anything else. And fourth, music might be valuable as *uniquely* conducive to some desirable end, unlike anything else at all.

Clearly, the more values of music we can identify that are valuable in the second, third, and fourth ways of being valuable, the better position we will be in to justify the judgment that a world without music would be a vastly regrettable thing, which in more sober guise is the force of Nietzsche's remark. I will be particularly attentive in what follows to values in the third and fourth categories sketched above, that is, ones that are arguably either distinctive of music or else unique to music. But even those values of music that fall under the first and second of the above categories may enter into that justification, if substantial enough.

5. The Centrality of Music in Human Life

In a recent survey of the philosophy of music Peter Kivy nicely poses a version of Nietzsche's remark, though in the form of a question: "Does music strike deep enough into human bedrock that it can be seen as partly defining our lives?" (Kivy, 2002: 8.) Kivy is pretty sure that it does, going on to observe that there has never been, anywhere, a culture without music.

The fact that music is ubiquitous in human societies is a striking one, and indeed suggests that music answers to some deep need or interest that we have, apart from those for food, drink, sex, shelter, companionship, and the like. But noting music's ubiquity does not of itself tell us what that need or interest is. Moreover, music is not only ubiquitous, but appears to play an irreplaceable role in the lives of most of us. It pervades our existence to such an extent that its disappearance would be immediately remarked, and with considerable consternation. But the irreplaceability of music, like its ubiquity, is again at best a symptom of music's importance, and neither an explanation of, nor a reason for, that importance.

We could do worse at this point than quickly pass in review some well-known proposals regarding music's special value that have been offered in the course of the last two centuries of philosophical reflection on that noble art. I have in mind those associated with the names of Eduard Hanslick, Edmund Gurney, Arthur Schopenhauer, Susanne Langer, James Sullivan, and Leonard Meyer.

The idea of a specifically musical beauty championed by Hanslick, that of a deep-rooted and non-rule-governed musical impressiveness emphasized by Gurney, that of music as a supremely revealing mirror of emotional life advanced by Schopenhauer and Langer, that of music as a discloser of unprecedented states of mind proposed by Sullivan, and that of music as a potential developer of personal character offered by Meyer, are all of substantial merit. (See the Appendix for elaboration.)

Those ideas no doubt point to values that are either distinctive of or even unique to music. But instead of pursuing those ideas further here I am going to explore, in my own fashion, a number of other suggestions regarding the special value of music, though ones in which can surely be heard echoes of the ideas just canvassed.

6. The Aesthetic Value of Music: First Pass

As stated at the outset, the central theme of this chapter is how many and how various the values are that music possesses or that music can have for us. But that is not to say that those values are all on a par. There are, rather, priorities and asymmetries among them. Some musical values are more important than others, and some musical values presuppose and depend on others.

Among the values that music possesses, pride of place must be given to what one can label music's *musical* value, or the value of music *as music*. Since music is, in the primary sense, an art, the musical value of a piece of music is thus a species of *artistic* value. Now what exactly artistic value comprises is a difficult question, which I will pursue in Section 7. Nonetheless, it will probably be agreed at the outset that a major part of music's artistic value is what we can label music's *aesthetic* value, or the value that music has as an object of aesthetic appreciation.

But what is *aesthetic appreciation*? Let us say that an aesthetic appreciation of an object is a perceptual-imaginative engagement with it in which its manifest properties, including formal and aesthetic ones, and the relations among them, including relations of dependence between lower-level and higher-level properties, are registered and savored in their full individuality, and for their own sake. The aesthetic value of music would then be the value that it affords a listener when attended to in that way, that is to say, when appreciated aesthetically. (See Levinson, 2009.)

I have just characterized the engagement involved in aesthetic appreciation of an object, whether an artwork or not, as *perceptual-imaginative*, rather than simply *perceptual*, and there are at least two reasons for that. A first reason is that grasp of most aesthetic properties recruits the imagination in one way or another, often through a kind of metaphorical seeing or hearing or construing. Our typical aesthetic interactions with absolute music, abstract paintings, rock formations, and passing clouds are clear illustrations of this, as it is unlikely we could find such things airy, cheerful, anguished, desolate, elegant, or oppressive if no imaginative or metaphorical processes were in play. A second, closely related reason, is that the prospect of emotional or empathic response to objects, and especially artworks, would seem to require an imaginative involvement

with their expressive aspects that goes beyond the mere perceptual recognition of such aspects. And a third reason is that in the case of verbal art forms such as that of the novel, the purely perceptual element of the interaction, namely, visual apprehension of the sentences of the text, is only a means to the aesthetic experience the novel provides on an imaginative, contemplative, and emotional plane.

So much for the general characterization of aesthetic appreciation, aimed at being adequate to such appreciation whether focused on works of art or objects of other sorts, such as persons or portions of nature. We can be somewhat more specific in characterizing the aesthetic appreciation of *music* if we allow ourselves an assumption about what listening to music with understanding centrally involves, namely, a kind of close tracking of music as it evolves in time, what we often call *following* music. Then we can say that the aesthetic *value* of a piece of music is given roughly by the value of the perceptual-imaginative experience that the piece is capable of affording a prepared listener when the listener tracks or follows the music attentively and responds appropriately to its formal and expressive features. (See Levinson, 1997, 2006a, and 2006b. For contrasting perspectives, see Kivy, 1991; and Davies, 2011.)

So conceived, the aesthetic value of a piece of music is thus inescapably a kind of *experiential* value. Moreover, since the idea of appreciation implies finding something experientially *rewarding*, and since this often, if not always, amounts to *enjoying* that something, it is only a small step from that to affirm that music's aesthetic value is typically, if not exclusively, reflected in the *pleasure* that it gives us when we attend to it aesthetically. Or in other words, that the aesthetic value of music is not only an experiential value but often, quite plainly, a *hedonic* value.

Music is perhaps above all something designed to give pleasure, although of a special sort, to those who engage with it aesthetically. And that has been taken as a reason, by those adhering to an "art for art's sake" perspective on music, for declaring music, in company with all the other arts, to be in effect useless, or of no practical utility. But something that is a source of non-injurious, non-ruinous, and highly repeatable pleasure cannot reasonably be thought of as useless. If one adds further that music, in the course of giving us harmless pleasure, profitably exercises our perceptual, cognitive, affective, and imaginative faculties, the charge of music's uselessness appears even less well founded.

Exactly what psychological benefits accrue to individuals who actively engage with music, especially though not exclusively in virtue of learning to sing or play music, is currently a lively area of research in the cognitive psychology of music, but it is clear that there are some such benefits, consisting most likely in the enlivening and sharpening of various of our mental faculties, such as those involved in spatial reasoning, arithmetical calculation, anticipating the future, remembering the past, coordinating motor activity, and empathizing with others. (See Bigand, 2010; and Huron, 2006.) There also appears to be synergy between regular engagement in musical activity and ease of foreign language acquisition, and between such engagement and the forestalling of various dementias. However, instrumental benefits of an engagement with music such as those just mentioned are mostly of a delayed and indirect sort, not something that one occurrently enjoys or realizes. By contrast, the psychological benefits of musical engagement that I highlight later on are for the most part quite different, involving manifest and immediately experienced positive goods.

Finally, the case can also be made that engaging in musical activity proved directly adaptive for humankind in its prehistory, most notably by facilitating collective action, apart from any benefits that accrue to individuals now through such engagement. (See Hauser & McDermott, 2003; Huron, 2006; and Levitin, 2006.) But apart from the fact that the jury is still out on the validity of evolutionary explanations of music's origins, whether or not such explanations are valid is orthogonal to the concerns of this essay, restricted to values that music incontestably possesses for us here and now.

7. The Artistic Value of Music

I return to the issue of the *artistic* value of music, or the value of music *as art*, which of course includes music's aesthetic value, but goes beyond that. So how might the artistic value of music be delimited? Even if music's artistic value outruns its aesthetic value, not *all* the value that engagement with music can have for us is properly regarded as part of its artistic value—its value as art—and detachable psychological benefits of the sort invoked above perhaps furnish a clear example of undeniable yet non-artistic values of music.

We must first put in evidence some values that music as art can possess and which are thus *artistic* values of music, but which do not belong to its *aesthetic* value. Some plausible candidates are these: the *accomplishment* in a medium to which a piece of music can lay claim, the *originality* of invention that a piece of music can display, and the positive *influence* on the course of future composition that a piece of music can exert. (See Levinson, 2006b.) These seem clearly to be *artistic* values of music, ones internal to the musical enterprise, and not simply external fruits or side benefits of musical activity, such as a possible improvement in memory capacity. And yet they are not *aesthetic* values in the sense earlier specified, since they are not as such *experiential* values, whereby music is of aesthetic value insofar as it affords a listener who properly attends to the music an intrinsically rewarding perceptual-imaginative experience. The values of artistic originality, artistic accomplishment, and artistic influence—what we might collectively label "achievement" values—do not primarily reside in the experience of those things. And that is so even if, as I argue elsewhere, they must themselves ultimately be *grounded* in valuable appreciative experiences that they make possible. (See Levinson, forthcoming.)

Grant that music's artistic value has as its core music's aesthetic value but is not exhausted by that, as the example of achievement values serves to illustrate. The question still remains of how to circumscribe music's artistic value *generally*. One way would be to conceive such value as residing in the capacity that music has to fulfill objectives or answer to purposes that are proper to music *as an art*. But what objectives or purposes are those?

We might be tempted at this point to offer a historical answer. That is, we might simply look to the objectives or purposes that music, practiced as an art, has traditionally aimed to fulfill. These would surely include objectives such as the exploration of form, the expression of emotion, the exercise of imagination, the creation of tonal beauty, the elevation of the soul, the embodiment of ideas in sensuous form, the heightening of a sense of occasion, and so on.

The historical answer is good as far as it goes, but it seems both possible and desirable to supply another, more principled one. The issue, recall, is what is to count as an *artistic* objective or purpose of music. Why do the objectives just mentioned qualify as artistic— exploration of form, expression of emotion, attainment of tonal

beauty—whereas other objectives, such as the production of economic worth, the obtaining of medical benefit, the acquisition of prestige, and so on, which might well result from musical activity, seem not to qualify?

A short answer is that something is an artistic objective or purpose of music when accessing the associated value requires an *adequate* engagement with the music as music, that is, an engagement in which the music is *understood*, its distinctive forms, qualities, and meanings grasped and appreciated for what they are. (See Budd, 1995.) A musical work's aesthetic value, most obviously, but also its influence value, originality value, and accomplishment value, is inaccessible to someone who lacks an understanding engagement with the work, whereas its economic or medicinal or prestige value, by contrast, are plausibly accessible without such engagement. In other words, it may suffice to harvest the economic value to just own the rights to some music; to receive the medical value just to audit it without closely attending to it; and to reap the prestige value simply to have sponsored its composition. In short, something is arguably a non-artistic value of music if it can be accessed without an understanding engagement with the music as art.

8. The Aesthetic Value of Music: Second Pass

I now return to the most important of music's *artistic* values, namely, music's *aesthetic* value. This, arguably the fundamental value of music as such, is the value of experiencing music's forms and qualities for their own sakes, a value accessed when we appreciate a piece of music for the distinct individual it is, formally and expressively, and for the fusion of form and expression that it represents. (See Levinson, 2009.)

Schematically, we might say that with any music there is, first, how it very concretely *goes*—how sound follows sound, note follows note, chord follows chord, phrase follows phrase, and so on; then second, what it variously *conveys*—movements, gestures, attitudes, and emotions; and third, what it conveys *in relation to* and *as embodied in* how it precisely goes. It is that third thing, that specific complex of motion and meaning, that is likely most distinctive of a piece of music, and that it is perhaps most rewarding to focus attention on. (See Levinson, 2006b.)

Great music, especially, stands as an exemplar of the most complete and indissoluble union of form and content, something marvelous in its

unparaphrasability—more unparaphrasable even than great poetry, where poem and paraphrase are at least in the same medium. I recall here Mendelssohn's celebrated remark that what music conveys, in its own fashion, is not too vague for words, but too specific for them; and Beethoven's response to a listener who, having just heard him perform one of his piano sonatas, asked him what it meant, his response being to simply play the piece again. This, of course, is not far from what both Hanslick and Gurney proposed as most distinctively valuable about music.

The music theorist William Benjamin has offered a conjecture about the distinctive pleasure listeners take in following the unfolding of music that goes beyond what I have said so far, where the emphasis was put on the indissoluble union of form and content in music and the consequent unparaphrasability of what it conveys. Benjamin's conjecture is as follows: "We find intensely pleasurable a power that we experience, the power to remember the sound of small sections of music and to reproduce them in our imaginations . . . because as we engage that power, we feel as if the music is emerging from within us, as if we were its virtual source." (Benjamin, 2006.)

Elaborating on Benjamin's conjecture we might suggest that part of the distinctive value of music is the ease with which it is internalized by us, so that we in effect possess it in auditing it attentively. Music enters into us and pervades us like no other artistic offering, whether film, novel, painting, or sculpture, which always remain to some extent outside us and at a distance from us. Music is in effect recreated within us each time we listen, by seconding its movement, for the most part without conscious intent, in our aural imaginations, often anticipating each gesture of the music as if it were our own, as if coming from within us instead of from without.

9. Music's Extra-Artistic Value

So much for music's aesthetic value and, more encompassingly, its artistic value. It is time to state squarely that music has considerable value beyond its artistic value. Most patently, as recalled above in passing, music clearly also has *economic* value, whether as a commodity, a service, or a skill. Many people earn their living in whole or in part from music, and from many angles: some from composing it, some from performing it, some

from publicizing it, some from marketing it, some from promoting it, some from criticizing it, some from engineering it, some from recording it, some from teaching it, some from analyzing it, and some, even, from theorizing and lecturing about it.

More generally, music has various sorts of *practical* value. Notable among them, in addition to economic value, would be social value, entertainment value, distraction value, relaxation value, therapeutic value, memory-improvement value, mobility-enhancing value, seduction-facilitating value, and so on. Music's practical values constitute a fairly open-ended set, and I am hardly the first to attempt to catalog them. The practical uses and virtues of music have been systematically surveyed since at least the beginning of the Renaissance, as the treatises of Johannes Tinctoris (1435–1511), Giulio Caccini (1551–1618), Marin Mersenne (1588–1648), and others clearly attest.

There are some further sorts of value which music may possess that are perhaps not purely practical, such as *cognitive* value and *moral* value. The former would consist in the potential of music to convey *knowledge* about important aspects of human life, while the latter would consist in the potential of music to *morally* improve those who engage with it. If music can have cognitive or moral value so conceived then such value would perhaps count as artistic, since presumably requiring an understanding of the music in order to be accessed. But skepticism about whether music can in fact have such value is surely appropriate, given music's evident limitations to convey thought or express propositions. (The existence and status of moral and cognitive values in art generally is currently a lively topic of debate in aesthetics. See Savile, 1993; Gaut, 2003; Kieran, 2003; Levinson, 2006b; and Kivy, 2008.)

In what follows I highlight some distinctive values of music deserving of special notice. Some are clearly artistic values, in that they presuppose an engagement with music in which the music is understood and not simply registered, and some are clearly non-artistic values, because not presupposing such understanding. And some are perhaps not easily characterized as either artistic or non-artistic values. They nevertheless all seem to be real and important values of music.

10. Music's Symbolic Value

I here draw attention to the way in which music may be said to model in audible form myriad ways of being, of moving, of developing, of unfolding, of progressing, which modeling would seem to qualify as an artistic value of music. (See Beardsley, 1981.) Music's unusual capacity to model aspects of life as lived is clearly rooted in its being a temporal art, but unlike, say, dance or film, which are equally temporal in nature, the abstractness of music imparts to such modeling a reach and a power beyond what those other arts can attain. Music, through the virtual movement that it delineates and the real movement that it induces, introduces us to possibilities of movement that would otherwise have remained closed to us, and to ways of inhabiting our bodies that we may never have suspected. Music provides, in its sounding form, a paragon and practicum of how to move, how to grow, how to evolve—of how to go on. It's not clear that anything else does that for us, or at least not so powerfully. (See Levinson, 2006b.)

The medium of music is unparalleled for the virtually unlimited possibilities that it exemplifies, and that on at least three levels. First, in a purely formal sense, presenting a limitless variety of ways that sounds can be combined in time; second, in terms of how many kinds of virtual movement and virtual gesture are generated by those sonic combinations; and third, in how many emotions, moods, attitudes, and other states of mind or spirit are mirrored in those limitless sonic combinations and the manifold musical gestures they generate.

That third level, of course, constitutes music's *expressive* dimension, the most important part of its symbolic content. Furthermore, recognizing and inhabiting those musical gestures in imagination when attending closely to expressive music can allow us to enter into and grasp those states of mind or spirit more fully or more vividly than we are able to in our extramusical lives. (See Levinson, 2011a; and Bicknell, 2009.) This recalls, in some measure, what Langer and Sullivan thought worth underlining about the special value of music.

11. Music's Self-Affirmation Value

Music has manifest value as a reflector of self and a definer of identity, a value that seems likely to also qualify as artistic. This works differently, of

course, for composers than for performers, for performers than for listeners, but it does work for them all, in one way or another. One's involvement with music has the potential to be almost as absorbing and challenging as a relationship, amorous or otherwise, with another person, often leading to the same sorts of constructive self-questioning. Musical works arguably help to crystallize or constitute the self that attends to them, internalizes them, and identifies with them.

Moreover, the musical tastes of a listener are often taken to be a clear barometer of his or her personality, the sensibility of a performer is manifest not only in how he or she performs but in what he or she chooses to perform, and composers are often said to live in and through their music. One has the sense of Gustav Mahler the person, for example, more fully and vividly through his ten symphonies and five song cycles than through the most detailed biography that might be devoted to him, and one suspects that the sense of the personality of Sviatoslav Richter emanating from his performances—one of massive strength, solidity, and self-reliance—is truer than what might be gleaned from newspaper or radio interviews with him. Moreover, there is probably no surer indicator of spiritual kinship between two persons than their sharing musical preferences and predilections.

That last point reminds us that music serves as a powerful source of group, and not just individual, identity. What music you favor often allies you with a given group, affirming your identification with it. As we all know, the musically inclined are not simply generic music lovers, but aficionados, variously, of Beethoven, the Stones, Bob Dylan, Baroque opera, Swedish fiddling, Arvo Pärt, punk rock, bebop, heavy metal, hip-hop, Javanese gamelan, and so on. Almost every genre of music spawns a community of appreciators of it who find in its sounds a special charm that makes that music—and by extension, them—stand out from the usual run of musics and persons.

12. Music's Social Value

I come back now to music's *social* value, probably the most important of its non-artistic values. Music is of undeniable value as a sort of social glue and agent of solidarity, helping to create, maintain, and strengthen a sense of community. Music is notably more effective in this regard than

almost any other art form. But why is that the case? Comparing music with literature, painting, and film will bring out part of the reason.

The experience of a concert, of publicly performed music, is an especially communal one, with many people intently focused on and enjoying the same thing, in full awareness of the participation of others. Concert attending is rather unlike film viewing, which is communal but solitary and isolating, or painting viewing, which does not lend itself to doing communally, or most obviously, the consumption of literature, normally a wholly private activity. Even a theatrical performance, though as communal an event as a concert, seems not quite as effective as a binder of persons as a musical performance, though that may just be due to the fact that in our culture audience response is normally a smaller part of theatre events than it is of musical events. And if we shift our focus from the context of the modern concert, whether of rock, jazz, or classical music, to how music manifests itself in tribal and traditional cultures, the social affirmation-interaction aspect of music is all the more salient. We should also not fail to note, as part of music's social value, occasions of public music as facilitators of human intercourse in the most ordinary sense, the conversing, gesturing, acknowledging, and exchanging that are the very fabric of social life.

A more specific aspect of music's social value, and one which perhaps deserves its own designation, ecumenical power, is the ability of music to transcend cultural barriers, to disarm prejudices, to unite people simply as human beings, regardless of linguistic, religious, or ethnic affiliation. Of course its power to do this is not unlimited, and may be greater for some genres than others, but it is noticeably greater than that of other artistic manifestations, which often struggle to export themselves outside of their culture of origin. This no doubt owes in part to the abstract, non-verbal nature of music, but perhaps also to its greater capacity to enter into us, to take hold of us, to set our bodies and souls in motion, almost without the participation of our wills. (See Bicknell, 2009.)

13. Music's Idiosyncratic Value

I here acknowledge what one could call the *idiosyncratic* value of music. Music can have value for a given listener that need not be shared, or even

shareable, with others. Music's idiosyncratic value is a matter of the way some music speaks to someone in a completely individual way, resonating with his or her specific memories, associations, history, and physiology. Of course what I'm calling idiosyncratic value, which is a cousin of sentimental value though not identical to it, can attach to anything—a dilapidated wall in one's neighborhood, a piece of bottle glass found on the beach, the way one's sister shakes her head—but music seems to have a particularly strong propensity to take on such value for us. This is the phenomenon of "just something about it" or "je ne sais quoi," that strange appeal that resists explanation. Think of the ineffable charm that the "little phrase" in Vinteuil's sonata in Proust's *Remembrance of Things Past* has for Charles Swann, whose model was probably Gabriel Fauré's Violin Sonata in A major, whose soaring main theme, consisting of a series of five-note motifs, squares well with Proust's description of the Vinteuil. I suspect that music's unusual capacity to take on idiosyncratic value of this sort has something to do with music so often striking us as a sort of veiled speech or utterance, in which something is being said, something of significance, but which one nevertheless cannot quite make out or pin down.

14. Music's Mood-Enhancement Value

Consider next music's undeniable value as an improver of mood and lifter of spirits. When one is down, there is almost nothing that works as well to bring one up again, or at least part of the way, as suitably chosen music. Even if the cheering effect of such music is transient, and cannot alone transmute unhappiness into its opposite, the effect, however temporary, is undeniably real.

Mood-enhancement value is a value of music in general, a marked potential that music possesses for quickly bringing about a lightening of spirits. But of course not *all* music exhibits that potential. However, contrary to what one might at first think, it is not only music that is expressive of *positive* emotion that can serve to brighten one's mood or alter one's outlook for the better. For to hear one's sadness mirrored exquisitely in sad music can be psychologically beneficial, affording the sense of being intimately understood and virtually empathized with that such music can impart. (See Levinson, 2011a; and Bicknell, 2009.)

On the other hand, the possible effect of truly depressive music should not be overlooked, especially when coupled with a suitably pessimistic text. According to urban legend a song recorded by Billie Holiday in 1941 called "Gloomy Sunday," based on a Hungarian original entitled "The End of the World," was so convincingly despairing that it was credited with prompting hundreds of suicides, and earned the song the nickname "the Hungarian suicide song." It was also banned from broadcast by the BBC for sixty years.

15. Music's Accompaniment Value

I lastly underline music's familiar yet crucial value as an accompaniment to and facilitator of other activities, such as religious ritual, military parade, factory work, aerobic exercise, and most obviously, dance in all its forms. With regard in particular to the last, music is valuable for the spur and guide it affords to bodily movement of an organized, rhythmic, and fluid sort, the sort of movement that is experienced by almost everyone as unusually liberating, even those whose talent for dance is rather modest.

Music is, in fact, supremely fitted to accompany almost all the activities of life, rendering them more pleasant, more fruitful, more engaging, or just, in some cases, more bearable or tolerable. The range of such activities is vast: not only marching and dancing and wooing, but dining, cooking, gardening, raking, washing, socializing, strolling, giving birth, making love, and so on. The products of other arts, such as painting, poetry, sculpture, and film, do not lend themselves so well, if at all, to the accompanying role that music so effortlessly plays, for reasons too obvious to underline.

But music is not only an ideal accompaniment to so many life activities, and in the case of some, an alleviator of the discomfort or distress involved in such activities. It is in addition, for many of us, a kind of companion to life itself, without which we would often feel more isolated, more at odds with our surroundings, more shuttered within ourselves. Yet music does more even than accompany so well so many of our daily activities, and more even than offer companionship of a sort in what may sometimes seem an indifferent world. Music also energizes

our lives and renders them more beautiful, investing them, if only in passing, with vitality, depth, and significance.

Appendix: Some Notable Proposals on the Special Value of Music

Eduard Hanslick, nineteenth-century Austrian music critic: music presents tonally moving forms ("tonend bewegte Formen") in which its beauty consists, apart from any emotional quality or representational content that such forms may possess. So music's special value resides in its offering us a kind of beauty irreducible to any other, and unrelated to ordinary life. (See Hanslick, 1986.)

Edmund Gurney, nineteenth-century British psychologist and musician: music presents an absolute specificity of content, whereby every satisfying musical passage possesses a melodic quality inseparable from its individual form, so that even the slightest change in that form, whether in pitch or rhythm, is liable to yield a wholly different, and usually inferior, melodic quality. Music's special value, then, in a spirit not too far removed from Hanslick, is for Gurney to be found in its ultimately inexplicable *impressiveness*, Gurney's term for musical beauty. (See Gurney, 1966.)

Arthur Schopenhauer, nineteenth-century German romantic philosopher: music transparently mirrors the inmost nature of the world, revealing it to be fundamentally *will*, a kind of blind striving, which manifests itself in a multitude of phenomenal forms, of which music is the most direct and most affecting. Music's special value thus lies in its metaphysical significance, the fact that it speaks to us of the underlying irrational nature of things, distressing as that nature might be to acknowledge. (See Schopenhauer, 1966.)

Susanne Langer, twentieth-century American philosopher and student of Ernst Cassirer: music, through its temporal form, mirrors and reveals the inner nature of emotions, their shape, rhythm, and tempo. Music thus provides a uniquely faithful, as well as particularly lucid, image of the inner life. (See Langer, 1942.)

J. W. N. Sullivan, early twentieth-century British journalist and critic: music is capable of expressing emotions, attitudes, and states of mind that are not encountered in ordinary life, and thus contributes to the

enlargement of human experience. This is the greatest and most distinctive contribution music can make to our lives, and is singularly exemplified in the music of Beethoven's late period, his last piano sonatas and string quartets. (See Sullivan, 1960.)

Leonard Meyer, twentieth-century American music theorist: classical music presents a rich field for the play of expectations, in which fulfillment and frustration alternate in complex ways, allowing suitably constructed music to serve as a beneficial shaper of character through the challenges that its appreciation presents. (See Meyer, 1967.)

References

Beardsley, Monroe (1981). "Understanding Music." In K. Price (ed.), *On Criticizing Music*. Baltimore, MD: Johns Hopkins University Press.

Benjamin, William (2006). "Music Through a Narrow Aperture: A Partial Defense of Concatenationism." *Revue internationale de philosophie* 60: 515–22.

Bicknell, Jeanette (2009). *Why Music Moves Us*. New York: Palgrave Macmillan.

Bigand, Emmanuel (2010). "La Musique rend-elle intelligent?" *L'Essentiel cerveau & psycho* 4 (November): 38–42.

Bigand, Emmanuel (2011). "Musique, empathie, et cohésion sociale." Laboratoire d'étude de l'apprentissage et du développement, Université de Bourgogne, <http://leadserv.u-bourgogne.fr/en/members/emmanuel-bigand/pages/musique-empathie-et-cohesion-sociale>.

Budd, Malcolm (1995). *Values of Art*. London: Penguin.

Davies, Stephen (2007). "The Evaluation of Music." In *Themes in the Philosophy of Music*. Oxford: OUP [orig. pub. 1987].

Davies, Stephen (2011). "Musical Understandings." In *Musical Understandings and Other Essays on the Philosophy of Music*. Oxford: OUP.

Gaut, Berys (2003). "Art and Knowledge." In *Oxford Handbook of Aesthetics*. Oxford: OUP.

Goldman, Alan (1995). *Aesthetic Value*. Boulder, CO: Westview Press.

Goldman, Alan (2011). "Value." In T. Gracyk and A. Kania (eds.), *Routledge Companion to Philosophy and Music*. London and New York: Routledge.

Gurney, Edmund (1966). *The Power of Sound*. New York: Basic Books [orig. pub. 1880].

Hanslick, Eduard (1986). *On the Musically Beautiful*. Indianapolis: Hackett Publishing [orig. pub., in German, 1854].

Hauser, Mark & McDermott, Josh (2003). "The Evolution of the Music Faculty: A Comparative Perspective." *Nature Neuroscience* 6: 663–8.

Higgins, Kathleen (1991). *The Music of Our Lives*. Philadelphia: Temple University Press.

Huron, David (2006). "Is Music an Evolutionary Adaptation?" *Annals of the New York Academy of Sciences* 930: 43–61.

Kieran, Matthew (2003). "Art and Morality." In *Oxford Handbook of Aesthetics*. Oxford: OUP.

Kivy, Peter (1991). *Music Alone*. Ithaca, NY: Cornell University Press.

Kivy, Peter (2002). *Introduction to a Philosophy of Music*. Oxford: OUP.

Kivy, Peter (2008). "Musical Morality." *Revue internationale de philosophie* 62: 397–412.

Langer, Suzanne (1942). *Philosophy in a New Key*. Cambridge, MA: Harvard University Press.

Levinson, Jerrold (1997). *Music in the Moment*. Ithaca, NY: Cornell University Press.

Levinson, Jerrold (2006a). "Concatenationism, Architectonicism, and the Appreciation of Music." *Revue internationale de philosophie* 60: 505–14.

Levinson, Jerrold (2006b). "Evaluating Music." In *Contemplating Art*, Oxford: OUP [orig. pub. 1998].

Levinson, Jerrold (2009). "The Aesthetic Appreciation of Music." *British Journal of Aesthetics* 49: 415–25.

Levinson, Jerrold (2011a). "Music and Negative Emotion." In *Music, Art, and Metaphysics*. 2nd edn, Oxford: OUP [orig. pub. 1982].

Levinson, Jerrold (2011b). "Evaluating Musical Performance." In *Music, Art, and Metaphysics*, 2nd edn, Oxford: OUP [orig. pub. 1987].

Levinson, Jerrold (forthcoming). "Artistic Achievement, Aesthetic Experience, and Artistic Value." In *Aesthetic Pursuits*, Oxford: OUP.

Levitin, Daniel (2006). *This Is Your Brain On Music*. New York: Penguin.

McNeil, William (1995). *Keeping Together in Time: Dance and Drill in Human History*. Cambridge, MA: Harvard University Press.

Meyer, Leonard (1967). "Some Remarks on Value and Greatness in Music." In *Music, the Arts, and Ideas*. Chicago: University of Chicago Press.

Ridley, Aaron (2004). *The Philosophy of Music*. Edinburgh: Edinburgh UP.

Savile, Anthony (1993). *Kantian Aesthetics Pursued*. Edinburgh: Edinburgh UP.

Schopenhauer, Arthur (1966). *The World as Will and Representation*, vols. i and ii. New York: Dover Publications [orig. pub., in German, in 1844].

Scruton, Roger (1997). *The Aesthetics of Music*. Oxford: OUP.

Sessions, Roger (1950). *The Musical Experience of Composer, Performer, Listener*. Princeton: Princeton UP.

Sharpe, Robert (2004). *Philosophy of Music: An Introduction*. Chesham: Acumen.

Storr, Anthony (1992). *Music and the Mind*. New York: Macmillan.

Sullivan, J. W. N. (1960). *Beethoven: His Spiritual Development*. New York: Vintage [orig. pub. 1927].

7

Shame in General and Shame in Music

I. Shame versus Other Emotions

1. Shame, guilt, embarrassment, regret, blame: five related emotions, attitudes, affects, or states. How exactly are these emotions related? I begin with the question of what these emotions or attitudes have in common, of what ties them together. First, they all display past-regarding-ness, that is, they are all retrospective, or refer to past events—though in some cases, events that are only just past.[1] Second, they are all negatively-valenced or negatively-toned, that is, they have an unpleasant or undesirable character, or involve negative affect. Three of these attitudes—shame, guilt, and embarrassment—are in addition self-regarding, that is, they necessarily concern oneself, what one has been or what one has done. But not the other two attitudes, regret and blame, which can be entirely other-directed: one can surely regret events in which one had no part, and one can clearly blame other persons, and ones with whom one has no relationship.

I will now leave aside blame, which is more a stance adopted than a sentiment felt, and turn to regret. Shame and guilt often, if not invariably, involve regret, though in different fashions. When one feels guilty one normally also feels regret for the bad thing one has done. One wishes, at least in part, not to have done it. But when one feels shame one's regret is

[1] Whether shame is necessarily past-regarding can be questioned. Consider being ashamed of one's body, or being ashamed of being out of shape. These seem, at first glance, to be present-focused rather than past-focused. But on second glance it may seem otherwise, since there is invariably an implicit comparison with an earlier state of one's body or one's shape with which one was more content. Still, it is at least conceivable that someone has always been, at least since the advent of self-consciousness, ashamed of his or her body, or indeed of having a body at all. So perhaps the truth is that shame is preponderantly, though not quite necessarily, past-regarding.

usually more global, and settles more on the agent than the action. One wishes, at least in part, not to be the person one is.

2. One of the most fundamental distinctions between shame and guilt seems to be this: whereas shame requires self-consciousness, guilt does not. This seems to be reflected in the fact that it is natural for someone to say "I'm ashamed of myself" [I feel shame about myself], but not "I'm guilty of myself" [I feel guilty about myself].

The difference between shame and embarrassment, however, which both involve self-consciousness, lies elsewhere. While the former can be experienced privately, the latter requires a public; and while the former involves a negative self-judgment, the latter involves awareness of a negative judgment of oneself by others, but not necessarily by oneself.

As an illustration of the difference between shame and embarrassment I can draw on my own experience in drafting this chapter a few years ago. In preparing to present it for the first time in a lecture series whose specified theme that year was shame, I was keenly conscious of the fact that if I did not both manage to come up with interesting things to say and to give my presentation a decent shape, then I would be embarrassed when I found myself standing before my audience. But even if that had happened—which fortunately it did not—then although I would have been embarrassed, I would not have been ashamed. Why not? Because although I would have been somewhat disappointed in myself I would not have judged my self negatively to any degree, knowing that a mild recent indisposition and my unfamiliarity with the topic had operated to keep me from performing at my best. In other words, my public failing in the circumstances, though no doubt embarrassing, would not have affected my self-image, and would not have caused me chagrin at the disparity between my actual and my ideal self.

Here are two helpful characterizations of the difference between guilt and shame drawn from the Wikipedia article on our subject—and no, I am not particularly ashamed to put them before you. One is this: "The experience of shame is directly about the self, which is the focus of evaluation. In guilt, the self is not the central object of evaluation, but rather the thing done." And the other is this: "While guilt is a painful feeling of regret and responsibility for one's actions, shame is a painful feeling about oneself as a person." The first observation seems correct, in identifying a difference in primary focus between the two emotions—in the one case, the self as such; in the other case, a particular

action of the self. But the latter observation goes deeper, suggesting that shame is in a way the more far-reaching sentiment, in that it relates to something enduring, one's fundamental character, whereas guilt is more limited in scope, and can attach to isolated actions, without reflecting on self more generally.

Shame involves a feeling that one's behavior is unworthy of one as a human being, that it reflects badly on one's character; whereas guilt involves a feeling that one's behavior was wrong, harmful, regrettable, and so on, but not necessarily that it was unworthy of one or reflects badly on one's character. For instance, one might very well feel *guilt* for knocking over a lamp belonging to someone else during an argument, but one would be unlikely to feel *shame* for having done so.

The core of shame is consciousness of the discrepancy between the image of oneself that one would like to maintain and one's actual thought and behavior, a consciousness characterized by painful or distressing feeling, sometimes of singular intensity. Bernard Williams, in his book *Shame and Necessity*,[2] underlines that shame is not simply distress about what others might say or think about us, it is more centrally unease for failing to live up to our own self-images. Shame is a peculiarly self-regarding emotion.

3. The terms "shameless" and "shameful," we may note, both denote negative properties. It is thus curious that both an excess and a deficiency of the same thing—namely, shame—turn out to be equally undesirable. The case is not quite similar to those treated by Aristotle in his doctrine of virtues as personal qualities occupying the "golden mean" between extremes. Take the example of courage as the virtue that stands between cowardliness and foolhardiness, where the former connotes a deficiency in the inclination to face danger to achieve some end, while the latter connotes an excess of that inclination. For the inclination to face rather than evade danger with which one is confronted is as such a morally neutral property, and only acquires a moral charge, either positive or negative, depending on the degree to which it is present.

But shame, unlike the inclination to face danger, seems at first glance not to be morally neutral, but instead morally negative, which would explain why "shameful," that is, "something of which one should be

[2] (Berkeley and Los Angeles: University of California Press, 1993).

ashamed," is a negative characterization. But what about "shameless," which one might think a positive characterization, since it implies the absence of shame, a negative property, yet which is, like "shameful," a negative characterization?

The solution to this little linguistic conundrum is not far to seek. The term "shameful" normally applies to actions, and designates, as just noted, those which merit shame, and thus is not primarily a personal quality. The term "shameless," by contrast, normally applies to individuals, and thus is a personal quality, one implying the incapacity or disinclination to feel shame when it would be appropriate. So shameful actions are bad ones that merit shame, a negative feeling, and shameless persons are bad ones in that they are deficient in shame when in fact it should be felt.

4. So is shame a good or a bad thing? Well, it is bad to behave in ways that cause one to be ashamed, but it is good to feel shame when one's behavior merits that. So shame as an emotion is typically a good thing, since it exerts a chastening or at least restraining influence on one's future actions, even if it is a sign of something wrong in one's past actions, at least in the subject's own estimation. But sometimes the subject's self-estimation is awry, and the shame that results from the negative evaluation of self is misplaced, inappropriate, and unjustified.

In general the emotion of shame would seem to be a force acting toward improvement of the self, and thus indirectly, the world, since those who feel shame are usually prompted to behave otherwise in future so as to avoid such an uncomfortable feeling, and are sometimes even spurred to try to redress any damage resulting from their shameful behavior. But what is true in general is not true in every case, as the example of someone who feels shame inappropriately because of excessive self-criticism or unrealistically high self-expectations. Whether shame is a good thing also depends, in a way, on whether a subject's self-image is a salubrious or insalubrious one.

Take, for example, the serial murderer in the grip of some perverted Nietzschean notion of self-affirmation through homicide, but who is also ashamed of his hesitations to take the life of innocent others. Should such shame work its way on him, dampening those hesitations, his murders would be more numerous and perhaps less likely to be intercepted and prevented. In such a case we surely feel that the

murderer should be, as it were, ashamed of his shame on this matter, as well as, of course, ashamed of his murderous dispositions.

An example like the last one also brings out something else about shame which it shares with many, though not every, emotion. Namely, that shame lends itself readily to *iteration*, so that one can easily envision being ashamed of being ashamed, as one can being afraid of being afraid, or being hopeful of being hopeful, or being regretful of being regretful. Whereas disgust and startle and rage, by contrast, are not easily iterated; we are not readily disgusted at being disgusted, or startled at being startled, or enraged at being enraged. This might suggest that *only* cognitively higher emotions lend themselves to iteration, which may be so. But then *not all* cognitively higher ones so lend themselves: for instance, it's hard to imagine being jealous of being jealous, or being envious of being envious.

5. I turn now to some examples of guilt and shame from William Styron's well-known novel *Sophie's Choice*,[3] at the center of which is the doomed love triangle of Sophie, the beautiful Polish concentration camp survivor, Nathan, the flamboyant and schizophrenic Jewish laboratory worker, and Stingo, the young Southern writer who narrates the story and serves as Styron's surrogate in the novel.

As a first example there is Stingo's shame over fondling the naked breast of Sophie, the woman he is madly in love with, while she is soundly asleep, after an evening of serious drinking and soul-searching revelations (562). Stingo speculates, following this shameful incident, that shame is different from guilt in that it involves a feeling of being ignoble or despicable, a feeling that guilt does not necessarily involve. This is illustrated in a second example of how shame differs from guilt. Sophie doesn't feel guilty about the anti-Semitic pamphlet that her father, a Polish pro-Nazi sympathizer, had authored before the German invasion, and which does not prevent his being rounded up and executed with other Polish intellectuals once the Germans arrive. And why should Sophie feel guilty for that pamphlet? After all, she had no responsibility in bringing it about, and no knowledge of its existence until much later. Nevertheless, she feels ashamed about her father's vile action, since it reflects badly on her family and so, indirectly, on her; the action of

[3] London: Vintage Books, 2004. Page references to the novel will be given in paretheses in the text.

penning that pamphlet soils the family of which she is a part, and makes her feel less worthy as a person (572).

But let us now come to Sophie's choice itself—her horrible, infamous, eponymous choice, revealed only towards the end of Styron's harrowing tale, which has her choosing to send her daughter rather than her son to the gas chamber, since she is permitted to save only one of them from that fate. This leaves her with a crushing, soul-destroying guilt, since she was, in a way, partly responsible for her daughter's death. Yet her fateful choice could not reasonably have occasioned shame, since no other choice would have reflected better on her character, on her as a human being, no other choice would have been more in keeping with her ideal image of herself. She could feel guilty towards her daughter, for having ultimately preferred to save her brother rather than her, but feeling shame for such a preference or decision, given the circumstances, would make no sense. This celebrated, albeit fictional, situation offers an excellent illustration of the fundamental difference between guilt and shame, since it allows all too understandably for the former, while precluding any reasonable manifestation of the latter.

6. After those wrenching examples from Styron's novel it may be salutary to consider a much less extreme example of shame from everyday life. To that end I will again put in evidence something from my own experience. Some years ago a francophone friend had written me that she had "founded" another solution to a problem that she was then facing. Always happy to provide correction to those wishing to improve their language skills, I pointed out that what she should have written was that she had "found" another solution. But I couldn't leave it at that, I had to go on to say, in a teasing spirit, that there was no such word as "founded" in English. Now that excess of philological zeal was, of course, misplaced, since there is indeed in English the word "founded," only it is the past tense of "to found," meaning to establish, not the past tense of "to find."

Realizing my error right after sending my message I was ashamed of my teasing remark, in part because it was in fact incorrect, but in greater part because of the personal fault that it clearly evinced, namely, a tendency toward pedantry and intellectual showing-off. That was a minor, and thankfully transient, experience of shame, because the fault in question is not a particularly serious one. At least, not in my own, perhaps too generous, assessment.

7. What, finally, might we make of the fact that we often feel that others *should* be ashamed of attitudes/actions/thoughts/behaviors of which they—unaccountably, by our lights—are *not* ashamed? Why are we particularly inclined, so to speak, towards pointing the finger in cases of shame? Why aren't we content to let everyone experience the shame that he or she regards as deserved—even those individuals who seem to be, as we say, really shameless, or incapable of registering shame, however appropriate? I am unsure how to answer, except to note that this fact is clearly reflective of how very *social* the emotion of shame is, of how much the shame of others seems to concern *us*, almost as much as it concerns the shameful *themselves*.

I leave the topic of shame in general with two further observations. First, it is possible to be ashamed of *not* being ashamed in a given situation, that is, to feel shame for *not* feeling shame about one of your actions or attitudes. Second, it is possible to be ashamed, with some justification, of *almost* anything; for example, of having a lot of money, of owning a modest home, of driving a mid-sized car, of preferring slim women to buxom ones, or of collecting pennies.[4]

II. Musical Shame

1. Is there ample scope for shame in regard to music? Indeed there is, and I will shortly offer a rough taxonomy of musical shames. But is there anything philosophically interesting in the varieties of musical shame, or anything that musical shame might illuminate for us as regards shame in general? That remains to be seen.

Musical shames can be divided into at least the following types: formative shame, performative shame, creative shame, and appreciative shame.

2. *Formative shame.* By "formative shame" I mean shame having to do with deficiencies in one's musical education. A common example of formative shame would be shame for lacking the patience or discipline to learn to play an instrument, even though one was provided that opportunity in one's youth. A somewhat less common, but related, example

[4] For extensive reflections on the nature of shame, and especially its moral dimension, see the recent wide-ranging study by Julien Deonna, Raffaele Rodogno, and Fabrice Teroni, *In Defense of Shame: The Faces of an Emotion* (Oxford: OUP, 2012).

would be shame for one's parents at not having provided such an opportunity even though they were in a position, financially and otherwise, to do so; in such a case, shame *for* one's parents is admixed with blame *of* one's parents. Yet another example of formative shame is shame about not having exposed oneself to a broader range of music in one's formative years, especially music that is more challenging, or that otherwise requires a significant apprenticeship in listening. And a fourth sort of formative shame would be shame for never having mastered the basics of music theory. As it happens I don't believe that such mastery is particularly crucial to adequate appreciation of music, even difficult music, but since a prevalent view in the music community is that it is, it is not uncommon to experience shame, misguided in my opinion, on this count.

3. *Performative shame.* By "performative shame" I mean shame having to do with one's performance of music, including one's actual performings, one's performative aspirations, and one's performative attempts. The most common example would be shame at not performing well, most often, at not properly executing a work given by a written score. Shame of this sort, of course, is rightly proportional to one's performing level, running from rank beginner, to relative tyro, to seasoned amateur, to professional, to world-class virtuoso. It is reasonable to strive to perform to the best of one's abilities, or near enough, but not to perform at a level that is simply beyond one, and accordingly, only appropriate to feel performative shame at falling rather short of one's own level. Much the same proportionality rightly applies to the performative shames that I note next.

Apart from performative shame at not performing well in the executive sense there is also: shame for not offering an insightful interpretation of a work; shame for not sufficiently practicing one's instrument; shame for being otherwise inadequately prepared for a concert or engagement; shame for timid or conventional choice of performing repertoire; and shame for hamminess or exhibitionism in performing.

4. *Creative shame.* By "creative shame" I mean shame having to do with the creation of music, most often through the activity of composing, whether through defining a score, manipulating elements on tape, sampling tracks from recordings, or devising a computer program for the generation of sounds, but also in virtue of performative improvisation. Creative shame can encompass shame for creating music unworthy of

one's talents, whether through composing or improvising; shame for creating music unworthy of one's audience; shame for pandering to the public or selling out commercially in the music one composes; shame for derogating better composers out of envy or spite; shame for borrowing too freely from the work of other composers.

5. *Appreciative shame.* By "appreciative shame" I mean shame having to do with one's appreciative practices, habits, or tendencies. This would include: shame for unadventurous musical choices; shame for lazy listening habits; shame for misusing or disrespecting music of substance, for instance, by not paying it the attention it deserves but instead multitasking or simultaneously focusing on other matters.

Possibly the most interesting species of *appreciative shame* is the shame of not liking, of not investigating, or of not endeavoring to appreciate music that one believes, or at least has reason to believe, is better than the music that one currently consumes. Such shame can, I believe, serve a good purpose, spurring one to the effort to come to terms with and appreciate better music. It is, in any case, of note that in regard to music, as equally in regard to art, film, literature, and other spheres where we exercise and display our tastes, we can be ashamed of what we actually like, and also ashamed of what we believe worthy of appreciation but which we do not succeed in liking. Thus some people are ashamed of liking popular music as much as they in fact do, while others are ashamed of not liking classical music or serious jazz as much as they would have wanted to.

6. I must now ask what of philosophical interest, if anything, is suggested by this cursory survey of musical shames, understood as shames that might attach to musical agents.

One thing, perhaps, is that only matters of *substantial importance* to us are liable to generate shame when we fall short in respect of them. Hence, where our musical or literary habits, athletic or sexual abilities, cognitive or analytical capacities are concerned, shame is a real possibility. By contrast, possessing mediocre penmanship, having modest baking talent, favoring dullish clothes, or forgetting to keep an ample supply of napkins on hand, are none of them likely to occasion shame. Music, books, sports, sex, and the acquisition of knowledge are central to most people's lives; penmanship, pastry, shirts, and setting the table are not.

A second thing, perhaps, is that only where the *moral stakes* are relatively high is the risk of shame very great. Hence even though, as

we have seen, there are many kinds of shame that one can experience in connection with music, very few instances of musical shame count as shame of a deep sort. And that is because, although music is indeed of substantial importance to most of us, musical situations—unlike, say, sexual or political or military ones—are not usually very highly morally charged.

7. But there is, of course, another sort of musical shame, one which, unlike those just canvassed, has actually been the subject of some discussion in the aesthetics literature.[5] And that is shame in the sense of a *property* of music, shame as something that a passage of instrumental music might *express*. I don't think that such expressiveness can be excluded a priori, though there are well-known considerations that make the expression of highly specific and cognitively complex emotions such as shame relatively unlikely. On the view of musical expressiveness I have defended in a number of places, a passage would be expressive of shame, roughly, if it were such as to be readily and spontaneously *heard as* the expression of shame by attentive and suitably backgrounded listeners.

Given such a requirement, I am not sure I know of any passages of music that unequivocally meet it. But consider a somewhat weaker condition, namely this: that a suitably backgrounded listener who attends closely to the music can *comfortably* or *without forcing* hear the passage as the expression of shame, even if such a listener does not *readily* or *spontaneously* so hear it.

Passages of music that might meet that weaker condition do come to mind. I am thinking of passages in two pieces of late Romantic music, Richard Strauss's study for strings *Metamorphosen* and Schoenberg's string sextet *Verklärte Nacht* ("Transfigured Night"). The passages in question are, for the Strauss, the opening eighty measures or so, and for the Schoenberg, measures 201–20, beginning with the marking *schwer betonent*, or "heavily accented." It is not hard to hear in these passages, with their descending melodic lines, minor harmonies, and prominent stressed notes, musical individuals whose halting progress is burdened

[5] See, for instance, my "Hope in 'The Hebrides'," in *Music, Art, and Metaphysics* (2nd edn, Oxford: OUP, 2010); Stephen Davies, *Musical Meaning and Expression* (Ithaca, NY: Cornell UP, 1994); and Daniel Putman, "Why Instrumental Music Has No Shame," *British Journal of Aesthetics* (*BJA*) 27 (1987), 55–61.

by painful recollection of a past of which said individuals are not proud. In other words, there is something in the sonic and gestural profile of these passages that lends itself to being heard as expressing shame, even if such hearing is hardly forced upon us.

Moreover, if these compositions are appreciated in their full contexts, then the passages in question may in fact be expressive of shame without qualification, because readily and spontaneously inducing such hearing-as. The respective contexts are as follows. In the case of the Strauss, the historical backdrop of being composed in April 1945 in Garmisch-Partenkirchen at the end of World War II, in light of the failure of the Nazi regime's genocidal ambitions, the collapse of Germany as a country, and the destruction of many German cities. In the case of the Schoenberg, the poem by Richard Dehmel that actually forms an integral part of Schoenberg's composition, and which recounts a woman's difficult admission of carrying the child of a man other than the one to whom she is now attached, and to whom she makes this painful confession, the child having been conceived before knowing him. Thus, unlikely as that may seem, there may very well be shame in music, since the passages by Strauss and Schoenberg to which I have called attention arguably succeed in expressing that cognitively complex and all-too-familiar emotion.[6]

[6] If this tentative conclusion be admitted, it is clear that the Strauss makes a stronger case for the conclusion than the Schoenberg, since if Dehmel's poem is considered fully part of Schoenberg's work, then *Verklärte Nacht* becomes a piece of program music in a rather strong sense. On the other hand, the gestural force of the music in the passage highlighted is so pronounced that it is not too farfetched to think it would regularly lead listeners to hear the expression of shame in it even apart from its associated poem or program.

8

Jazz Vocal Interpretation
A Philosophical Analysis

1. I begin with the most straightforward question that one could frame on this topic, namely, what is it for a singer to *interpret* a song in a jazz context? Clearly, it is for the singer to *sing* it, rather than, say, to *discourse* on it. But just as clearly, it is to do so in a particular way, with a range of freedoms to depart from the chart or score of the song. Moreover, if the singer fails to avail herself of any of those freedoms, it is arguably not a jazz interpretation at all.

The freedom of a singer in a jazz context to modify the standard chosen for interpretation is much greater than that afforded singers of songs in the classical repertoire, such as German lieder or French *mélodies*. These freedoms include, but are not restricted to, changes of meter; substitutions of melodic notes; substitutions of words; rearrangement of stanzas; alteration of rhythms; recasting of style, such as from ballad to swing or bossa; shifts of styles mid-song; variations in tempo; and whether or not to sing the introductory, usually *parlando*, verse that many of these standards contain in their original form. Moreover, such freedoms are engaged in to a degree greater than is generally found in versions, sometimes called "covers," that pop and rock musicians do of each other's songs.

Singing a song in a jazz manner, characterized in part by a high degree of the freedoms just noted, is an instance of what can usefully be labeled *performative* as opposed to *critical* interpretation of a song.[1] The singer of a jazz standard performatively interprets that standard precisely in

[1] For more on this distinction, see my "Performative versus Critical Interpretation in Music," in *The Pleasures of Aesthetics* (Ithaca, NY: Cornell University Press, 1996).

singing it a particular way, a way that she normally hopes is distinctively hers.

2. What, then, are the most obvious *dimensions* of jazz vocal interpretation, understood as the performative interpretation of vocal standards in a jazz manner? Clearly, all the following: basic musical style; vocal timbre; tempo and change of tempo; metrical recasting and change of meter; rhythmic alteration; melodic alteration; textual modification, including excisions, additions, interpolations, and elaborations; placement of accent; playing with the time, including "laying back" or singing behind the beat, and "pushing forward" or singing ahead of the beat; scatting and other non-verbal vocalizing. And that is not an exhaustive list.

3. But in addition to these dimensions of vocal interpretation, we need to take note of various *background factors* that an audience needs to take into account in order to grasp the content of a particular performative interpretation. What are these factors? Well, apart from the singer's particular way of singing the song, at least these three things seem crucial: (a) the song in its straight version, or as originally composed; (b) the usual ways of singing the song in a jazz context; and (c) the singer's public persona, including the singer's gender, age, race, ethnicity, sexual orientation, physical appearance, as well as certain publically known features of the singer's personal history.[2]

As regards the first of these factors, its relevance is obvious. Someone unfamiliar with the original composition has little way of gauging what the singer is doing with the song, that is, what the singer is adding to, subtracting from, or altering in, the song as written or as standardly taken.[3] As regards the second of these factors, the usual ways of performing a given vocal standard also serve as crucial context to a given singer's interpretation, and need to be kept in mind by a listener seeking to correctly interpret the given interpretation. An obvious example is where an interpretation is a *homage* to an earlier famous

[2] See Jeanette Bicknell, "Just a Song? Exploring the Aesthetics of Popular Song Performance," *Journal of Aesthetics and Art Criticism* 63 (2005), 261–70, for some observations on the relevance of the last-mentioned factors.

[3] Of course someone unfamiliar with a given song may form a reasonable conjecture as to a singer's departure from the song as written, especially if it is in a familiar style, but that will fall short of *knowledge* of what is or isn't a feature of the song in its official or standard version.

rendition of a song, and should thus be understood with reference to that earlier rendition—as respectfully acknowledging it, but neither aping nor affecting oblivion of it. The same goes for an interpretation that is a *parody* of an earlier famous rendition. A homage might be either slavish or creative, and a parody either appreciative or dismissive, but in either case proper understanding on the part of a listener requires awareness of what is either being honored or made fun of. More generally, in assessing what a given interpretation might convey about how a singer regards a song, it clearly matters whether we refer the interpretation only to the straight version of the song as represented in a standard chart, or also to existing performative renditions with which the singer can be assumed to have been acquainted.

As regards the third of these factors, the singer's public persona or publicly available face, an obvious example of its relevance is provided by a song such as Cole Porter's "My Heart Belongs to Daddy," in which the singer affirms and embraces her status as the kept woman of an affluent older man.[4] It clearly matters whether the singer is a young woman, so that her persona is roughly a match for that internal to the song, rather than, say, a straight middle-aged man. For sung by the latter, the song inevitably takes on in performance a campy or ironic character. And sung by a gay man the song no doubt acquires yet another character in performance. These differences in what is conveyed, moreover, would manifest themselves even if—what is admittedly a highly unlikely state of affairs—the audible musical features of each singer's rendition, that is, the key and all the subtle inflections of melody, rhythm, accent, and timbre brought to the basic tune, were precisely the same, so that the renditions were aurally indiscernible. In terms that will make more sense as discussion proceeds, what one can say is that a singer's way of singing a song is not reducible to or wholly contained in the purely sonic profile of what the singer produces, even confining ourselves to what can be heard, as opposed to seen.[5]

4. Consider next how jazz *vocal* interpretation of a given standard is importantly different from jazz *instrumental* interpretation of the same

[4] The same point could be made using another Cole Porter song, "Love for Sale," whose protagonist is implied to be a young female prostitute.
[5] I address the issue of non-audible dimensions of a singer's interpretation of a standard at the end of Section 8.

standard. The most salient difference is that jazz vocal interpretation invariably involves *some* acknowledgment of the song's text and textual meaning, whereas jazz instrumental interpretation may dispense with *any* such acknowledgment.[6] Though the vocal treatment of a jazz standard is importantly different from the reciting of a poem, it remains at least a relative of that activity, in that it involves putting across a text with an articulate content, and not just an exploration in musical sound.

Almost as salient is the fact that jazz vocal interpretation only rarely strays very far from a song's melody, and never so far as to be unrecognizable as that song, whereas jazz instrumental interpretation notoriously often does so, cleaving only to a song's chord progressions or changes, and sometimes altering even those. For jazz vocal interpretation, the melody of a standard is not sacrosanct, but it must be clearly in evidence, whatever modifications the vocalist subjects it to.

It is significant that a number of standards often played by jazz instrumentalists, though in fact they are songs with words, are not especially rewarding for singers. This is possibly because they lack sufficient melodic, verbal, thematic, or emotional interest, despite containing chord progressions capable of inspiring instrumental improvisers. Examples might be "Cherokee," "I've Got Rhythm," "Lady Be Good," "Sweet Georgia Brown," and "Take the A Train." Of course some of the preceding have been successfully interpreted by some vocalists, such as Ella Fitzgerald, but then she could probably make something musically rewarding out of a page from the phone book.

5. In this section I begin to consider claims about the content of jazz vocal interpretations, formulating these claims in terms of what such performative interpretations *convey*, rather than what they *communicate*. That is because conveying can arguably occur without being intended by a singer, whereas communicating arguably cannot. For instance, what may be conveyed about a singer by her interpretation includes what her manner of performing *tells* us or allows us to *infer* about the singer, but not necessarily what she *intends* us to learn about her. What is conveyed by a performance, unlike what is communicated, at least as I propose to use the terms here, is a matter of what is revealed in or manifested by the performance, and need not be brought about purposely.

[6] This is not to deny that the best instrumental jazz players often *do* keep the text and its meaning in mind and, moreover, claim that their improvisations indeed *reflect* that.

Let me now ask what a given jazz vocal interpretation of a standard might convey about *the song* that is its subject. Can such a performative interpretation, in other words, do more than simply make the song available for appreciation, and if desired, critical interpretation?

The most minimal position regarding what a jazz vocal interpretation conveys about a standard, I suppose, is just that it *can* be sung in that manner, or that it is musically *effective* to sing it in that manner, or perhaps, going just a bit further, that the singer implicitly *endorses* that manner of singing it. On such a position it is largely futile, or at least misguided, to ask what a singer might be conveying about a song by singing it a given way. The departures from the straight version of the song, on this perspective, or from the usual ways of doing the song, are there simply for musical variety. They are just meant to answer to the listener's interest in hearing something different, while also serving, of course, as a display of the singer's skill, ingenuity, and taste.

Though there is something to be said for taking the minimalist position on what performative interpretation of a standard can convey—it has at least the virtue of cautiousness—I'm inclined to think that one can advance beyond that position to a certain degree. But before I do so, I respond to two further questions and then offer a preliminary caution.

First, can one sing a jazz standard *without* interpreting it? Might one convey *nothing* about a song, or about one's view of a song, through how one sings it? This strikes me as unlikely. For consider what would seem to be the only way to achieve that somewhat dubious goal, namely, singing the song in a way that hewed as closely as possible to the song as originally conceived. Rather than conveying nothing about the singer's view of the song, in a jazz context this would likely convey either the singer's overwhelming admiration or respect for the original composition, inducing her to present it as purely as possible, or else her intimidation by or insecurity about the composition, causing her to venture no alterations in it.

Second, does a singer *convey something about a song* in virtue of features of her singing voice that she cannot control, such as her basic timbre or basic range? Perhaps not. But a singer will nevertheless still *impart a character to the song in performance* in virtue of her timbre and range. A character imparted to a song *through* concrete performance

aspects does not automatically amount to something conveyed *about* the song through such performance aspects. For it is only imparting a character to a song in performance *through dimensions under the signer's control* that can play a role in the singer's conveying something about a song by singing it as she does. None of that is to deny, however, that a singer might convey something about a song through how she *manages* or *deploys* her basic timbre or range, through how she works with or against her basic vocal endowment.

Finally, when I say that a jazz vocal interpretation might convey thoughts or propositions about the song being interpreted I do not mean to say, of course, that a listener who grasps such an interpretation necessarily, or even normally, *articulates* to himself such thoughts or propositions. What I mean, at most, is that such a listener registers the interpretation in such manner as to be disposed to consent to such propositions as what is conveyed by the performance *were* those propositions to be articulated to him.

6. Consider what might be conveyed by a singer's elongation, accentuation, or salient modification of particular words in a song, clearly an important part of what we mean by the singer's interpreting the song. Does doing so convey that the singer regards those words as especially *important* thematically? Though it seems reasonable in general to take it that emphasis placed by a singer on a given word suggests that the singer views that word as particularly significant thematically, and that lack of emphasis suggests the reverse, an interpretive rule of that sort can be no more than a rule of thumb, and would certainly lead one astray if regarded as universally valid. I illustrate this with a somewhat unusual example, the standard "My One and Only Love," perhaps best known in the version of vocalist Johnny Hartman and saxophonist John Coltrane.

The text of this song plausibly contains a slight infelicity, in that the word "give" occurs twice in close succession in the last stanza: the line "every kiss you give sets my soul on fire" is followed immediately by the line "I give myself in sweet surrender." Accordingly, in interpreting those lines a sensitive singer should not dwell on either occurrence of "give" and should call as little attention as possible to the repetition, which betrays, I suggest, a small failure of inspiration on the lyricist's part. However, insofar as he does so the singer clearly

should *not* be understood to be slighting the idea of "giving" as it figures in the song's message.[7]

7. In general, we may say that in singing a song a particular way, employing particular inflections of rhythm, pitch, phrasing, pronunciation, and so on, a singer conveys her *feeling* about the song, or expresses her *attitude* toward the song, or presents the song in a certain *light*. These are fairly obvious and commonsense observations, though nonetheless true for all that.

Deserving perhaps more notice, though if anything an even more familiar phenomenon, is the fact that a singer's way of singing a song on a given occasion may manifest or reflect, not how the singer *feels about* the song, but more simply, how the singer is *feeling*. In other words, a singer's interpretation of a standard can sometimes be a window into the singer's emotional state at that time, whatever the basic tenor or thrust of the standard in question. Thus, a singer in the grip of profound melancholy might make even "The Sunny Side of the Street" sound sad, and a singer in a highly elated condition might succeed in making even "Angel Eyes" seem full of cheer.

But I am more interested in a further thing that seems to be communicated by a singer's interpretation of a standard, something that operates when the singer's emotional state may be presumed to be in its normal range, and that testifies to something about the singer that is both less transient than occurrent emotion and more characteristic of the singer as an artist. And that is the singer's *personality*, at least as it manifests itself in performance. For a singer, through her particular way of singing a song, invariably displays her *personality*, coming across as, say, cool, or excitable, or seductive, or insouciant, or vulnerable, or matronly, or earthy, or aristocratic.

8. And so I come now to the question about jazz vocal interpretation that most interests me, namely, how can one distinguish between what a singer, in interpreting a given song, is conveying *about the song*, and what the singer is conveying *about herself*? The former might be glossed, along hypotheticist lines, as the view of a *song* that an appropriately

[7] In a jazz club in Washington I once heard this song performed by a singer who must have been sensitive to this problem in the text. His solution was to alter, perhaps unthinkingly, the first occurrence of "give" to "bring," so that the line went "Every kiss you bring, sets my soul on fire."

informed listener would be most justified in attributing to the singer on the basis of the specific interpretation offered. The latter might be glossed, along similar lines, as the view of a *singer's personality* that an appropriately informed listener would be most justified in adopting on the basis of the specific interpretation offered.[8]

The former sort of conveying seems akin to the phenomenon of *conversational implicature* identified by the philosopher Paul Grice. In Gricean terms, a particular singer's way of singing a given standard may be said to conversationally implicate certain beliefs about a song if it affords strong evidence that the singer held such beliefs, or alternatively, if the holding of such beliefs would best account for why the singer sings the song as she does. By contrast the latter sort of conveying, as regards the singer's personality, does not seem a matter of conversational implicature, since not likely operating through a plausible conjecture as to the singer's beliefs.

In any event, whatever the differences in the mechanism of conveying involved, I suspect it may often be *indeterminate* whether to interpret a distinctive feature of a singer's interpretation of a song as conveying something about the song or as conveying something about the singer, because often either hypothesis would make good sense of the singer's particular way of treating the song. And in some cases it may be that something is conveyed *both* about the song *and* about the singer, precisely because a hypothesis of double import makes most sense of the features of the interpretation taken as a whole. Still, my hunch is that in most cases a jazz singer's interpretation of a standard conveys more about the *singer* than it does about the *song*, putting aside the minimal implication of any successful performative interpretation, to the effect that the song *can* effectively be sung that way.

Most likely, each musical choice or inflection in a jazz vocal interpretation is heard or received by a listener in two ways, or from two perspectives. The first is embodied in the question, What does that choice or inflection suggest about the *song*?, and the second is embodied in the question, What does that choice or inflection suggest about the *singer*? The answers with respect to the first question will be more or

[8] See my "Performative versus Critical Interpretation in Music."

less constant, having the force that, so sung, the song sounds good or is musically satisfying. But the answers with respect to the second question will vary, spanning the gamut of personality traits that can be exhibited through the sort of behavior that performing involves.

Furthermore, in many cases, a singer's phrasing may convey something about the singer *through* conveying something about the song. For example, when Ella Fitzgerald scats lengthily and inventively on her famous recording of "How High the Moon," she demonstrates the almost infinite potential of that song's straightforward melody and uncomplicated changes. But she also reveals, and precisely through that musical demonstration, her warm persona and impeccable taste. Or when Diane Schuur exploits to the maximum the manic potential of the large leaps and insistent chromaticism of "Invitation" in her recording of that standard, she also provides a window into her wild musical persona and incredible vocal virtuosity.

I should note that in the foregoing discussion I abstracted entirely from what may be conveyed by a jazz vocal interpretation in a *live venue*, such as a club or theater, where the singer is physically present to the audience, and where the singer's visual appearance, hand gestures, facial expressions, and body language can play an important role in her interpretation of a song. In other words, for reasons of simplicity I have treated the singer's performative interpretation of a standard narrowly as something *heard*, as what a good sound recording of the performance in question will preserve. Clearly, if one takes those other factors, accessible in the live setting, into account, the process of inferring a performing personality or grasping aspects of conveyed content from the interpretation on offer becomes a more complicated affair, though given how much more one has to work with, one that is likely to yield more definite results.

9. As these examples show, some of what is suggested about a singer by her performance will be narrowly musical traits, those which make up what we can label the performer's *musical personality*, such as a tendency toward metrical alteration, or timbral modulation, or harmonically adventurous melodic substitutions, and some will be non-musical traits that enter into what we can label, more broadly, the performer's *performing personality*, roughly, the personality as it exhibits itself in performing, which includes the performer's musical personality but is not restricted to that.

But what, though, of personality without qualification? Might a performance of a standard be said to express the performer's *real personality*? Suppose, by analogy with a plausible analysis of the behavioral expression of emotion, that for a jazz vocal performance to express a performer's real personality: (a) the performance must be such as to *ground a reasonable inference* on the part of listeners that the performer has personality P; (b) the performer must actually *have* personality P; and (c) the performance must have the distinctive features it does partly *because* the performer has personality P. If that is so, then although a given performance certainly *might* express, or perceptibly manifest, the performer's real personality, we won't be in a position to affirm that unless we know the performer outside the performing context, and hence know whether he or she *in fact* has personality P, and thus whether condition (b) is satisfied and condition (c) at least possibly satisfied.

In light of that, we are on safer ground affirming that a given performance of a standard expresses a singer's *performing personality*, since that is more or less analytic, a singer's performing personality being, again, roughly the singer's personality as it comes across in and through a given way of singing. Of course the singer's performing personality may not be particularly representative of the singer's real personality as it exists outside the context of performance, but that is generally of little concern to us as listeners. For our aesthetic interest in jazz vocal performance is in the *projection* of personality by a manner of performing, and not in the singer's personality as a matter of fact.

As already noted, a singer reveals how she regards a song by her way of singing it. But she also shows how the song can be used to express her *personality*, or more cautiously, how the song can be used to exhibit her *performing personality*, both musical and non-musical.

10. It seems that there are generally two basic approaches to interpreting a vocal standard: (1) treating the song as an intimate communication—for example, as a whispered confession, a heartfelt plea, or an avowal of love—directed to one other person; and (2) treating the song as a public pronouncement, meant for anyone and everyone to hear, even if textually addressed to a particular individual. Which of these approaches a singer adopts may itself be an expression of her personality or, more cautiously, contribute to the emergence of the singer's *performing* personality. But apart from that, it seems

important to grasp which of these contrasting global approaches is in effect in order to adequately gauge both the aptness and the import of what the singer is doing on the small-scale level of specific inflections of rhythm, melody, timbre, and so on.

Of course, not every standard lends itself easily or naturally to both of these approaches, which we may label, respectively, *intimist* and *publicist*. Some standards would seem to work only one way, for instance, the intimist approach for "My Funny Valentine" or "Darn That Dream" or "One for My Baby," the publicist approach for "My Way" or "I've Got the World on a String" or "The Lady Is a Tramp." Certain songs seem to demand one approach but not the other; those that cry out for publicist treatment, in particular, are often songs that seem to have the idea of an audience of many built into them, that are conceived as having a message for all the world to hear, and not just one special person. Of course it is not always evident at first blush which approach works best for a given song, if in fact it is amenable to both. For example, one might think that the standard "You Don't Know What Love Is",[9] probably the most poignant and wrenching in the whole canon of jazz ballads, must, in virtue of that character, call for an intimist approach on the part of the singer. But it would, in fact, be odd to think of the song as directed toward the person who has ostensibly broken the heart of the song's despairing protagonist. A more natural take on the song, rather, is that its gloomy heartbreak is something the singer wants, even needs, others to hear and to acknowledge, so as to afford the amorous sufferer a measure of consoling sympathy.

11. So far I have said little about whether in singing a jazz standard a particular way the singer can communicate something, not about *herself*, nor about the *content* of the song, but about the *music* of the song narrowly construed, something going beyond the minimal suggestion that the song is musically effective when so sung. I suppose that, as with classical performance, some ways of phrasing a song in jazz context will make its melodic, rhythmic, thematic, or implied harmonic structure clearer than others, or will draw attention more than others to unifying structural features.

[9] Some of the character of this song can be gleaned from how it ends: "until you've faced each dawn with sleepless eyes, you don't know what love is," but of course much of the sad import is also carried by the music apart from the lyrics.

As an example, consider Cole Porter's "All of You." This short song is cleverly constructed out of motivic cells, namely, pairs of repeated notes and rising seconds, and the repeating verbal motto "of you," which permeate the song and give it a singular coherence.[10] A singer might very well sing this song so as to underline this fact of its construction, though he would have to take care not to overdo it in order to avoid falling into didacticism.

Such an interpretation might thus perhaps be said to *affirm* a song's having the structural features it does. But note that a jazz reading of a song might achieve that sort of effect, of affirming a song's structure, not by *emphasizing* the features in question, but instead by deliberately *downplaying* them, so that listeners familiar with the song were made more conscious of those features through their having been made less prominent in the reading at hand.

12. Consider, finally, a question about interpretation on the listener's rather than the performer's part. To what extent is the audience of a jazz vocal interpretation engaged in *interpreting* the singer's interpretation? If we allow that appreciating such an interpretation requires interpreting it in turn, what does such appreciative interpreting amount to? Is there anything special about the appreciative interpreting that is involved when one seeks to understand a performative *interpretation* of a song, as opposed to seeking to understand the song *itself*, apart from particular performances, by critically interpreting it? Such appreciative interpreting is clearly not a species of *performative* interpreting—one doesn't *sing* the singer's rendition of a song in understanding or appreciating it—but neither does it seem entirely assimilable to *critical* interpreting, with its plausible hypotheses of intent to convey articulate meanings.

So exactly what sort of interpreting is it? Despite my leaning earlier on an *inferential* model of what a performer's interpretation of a standard might be said to convey, the listener's interpretation of a singer's interpretation seems, on reflection, more akin to finely backgrounded *perceiving* of a performance than it does to explicit *hypothesizing* about the performance on the basis of evidence. The truth may be that it is a perceiving pervaded and inflected by subconscious or deeply

[10] This motto occurs no less than nine times in the song's scant eight lines.

backgrounded hypothesizing, which hypothesizing may, however, be brought to light in subsequent reflection on one's perception, in an attempt to justify the rightness of that perception.

13. To illustrate in more detail some of my observations I now take a close look at a particular standard, Cole Porter's "You'd Be So Nice To Come Home To." This song has a straightforward 32-bar form, consisting of two 16-bar strains, the second being a simple variant of the first.

Though tempo choice is always a crucial factor in a singer's rendition of a standard, with this song, choice of tempo is of more than usual significance. Taken at a fast swing tempo, a singer of this song can readily convey an impression of hipness and cool, while taken at a slow swing tempo, a singer of the song can readily convey an impression of warmth and vulnerability. As suggested earlier, such impressions might be referred by the listener either to the *song*, in which case they would be understood as indicative of different potentials the song affords for convincing realization; or else to the *singer*, in which case they would be understood as indicative of the singer's performing personality; or they might be understood in *both* ways.

Consider next some instances of small-scale performative interpretive choices a singer might make in singing this song. (i) In the very opening, measures 1–4, syncopating the phrase by putting a strong accent on "be," holding "be," "so," and "nice" for two beats each, could be said to impart a punchy, masculine character to the phrase, as does a similar treatment of "au," "gust," and "moon" in measure 21. It also serves, in that opening phrase, to emphasize the thematically unimportant word "be," which could be said to put some distance between the singer and the song's sentiment, or at least to suggest a view of that sentiment that's more on the "outside" than the "inside." (ii) By contrast, in that same opening phrase, holding "so" for six beats boosts the amplificatory force of the adverb, imparting a sort of swoony tenderness to the phrase. (iii) In the second phrase, measures 4–8, entering two beats late, or "laying back," conveys something like nonchalance or languorousness. (iv) And in the fifth phrase, measures 16–19, interpolating the words "that were" before "chilled," in addition to producing more musical motion, conveys a touch of confidence, of someone at ease with what he has to say and willing to depart from his script.

It is instructive to note the divergent characters that different singers impart to this song in performance through both the individual musical

choices they make and the basic features of their voices, and to witness the performing personalities that emerge as a result.[11] Helen Merrill, for instance, in her reading of this standard, regularly lays back, beginning phrases after the beat, and stretching out long notes; together with her singular timbre, this produces the image of a warm, confident, and sincere personality. Anita O'Day's rendition, by contrast, a product of her distinctive voice quality and singular diction, is seductive, flirty, devil-may-care, suggesting a woman on the verge of inebriation, only just suppressing a wicked laugh. Sarah Vaughan's traversal of the song, from a live performance, unmistakably exudes confidence, but also a romantic vulnerability, due in part to her extended vibrato at the ends of many phrases. Diane Schuur's interpretation is rather complex, her opening and closing choruses exhibiting a marked contrast: the persona of the first is honest and straight-talking, the kind of woman who could never deceive you, while that of the second is rather more volatile, capable of flights of fancy, as suggested by the singer's exploitation of her powerful upper register. Finally, Cheryl Bentyne's performance, the most recent of the five, with its fast tempo, smooth, slightly clipped delivery, and seamlessly integrated bits of scat, gives the impression of a cool, professional, unflappable personality.

In many modes of artmaking it may be possible for the artist to more or less hide from his or her audience. That is, it may be possible for viewers or listeners to understand and appreciate what is offered artistically, and yet form little idea of the personality, or at any rate the persona, of the artist. But jazz singing, I venture to suggest, is not one of those modes.

14. In conclusion, a few further observations.

First, it should be underlined that the performing personality manifested in a vocalist's interpretation of a *given* standard will not necessarily be that which is manifested in her performance of *another* standard, nor even that manifested in her performance of the

[11] Details on the recordings commented on are as follows: Helen Merrill, New York, 1954, with C. Brown, J. Jones, B. Galbraith, M. Hinton, O. Johnson [EmArcy 814 643-2]; Anita O'Day, New York, 1959, with Billy May and His Orchestra [Verve 849 266-2]; Sarah Vaughan, Chicago, 1958, with W. Culley, T. Jones, F. Wess, R. Bright, R. Davis, R. Haynes [Verve 314 516986-2]; Diane Schuur, Los Angeles, 1999, with N. Tempo, E. Richards, A. Broadbent, C. Borghofer, L. Marable [Atlantic 83150-2]; and Cheryl Bentyne, New York, 2002, with K. Barron, L. Nash, J. Patitucci [Telarc 83583].

same standard on a different *occasion*. The manifesting of performing personality on which I have focused attention is a performance-and-occasion-specific phenomenon. That said, it would be surprising if the performing personality that manifested itself through one perform-ance of a given singer did not bear a significant resemblance to that manifested through another such performance.

Second, jazz singers in their interpretations of standards often quite naturally assume a role, in effect impersonating the protagonist internal to the standard in question, a protagonist who may very well not square with the singer's real personality or situation. In such cases, our sense of the personality that the singer projects through her interpretation—our sense of what I have labeled the singer's "performing personality" as conveyed by her interpretation—is mediated by the way the singer inhabits and presents the song's internal persona. This was illustrated earlier in my discussion of "My Heart Belongs to Daddy," a song that has a clearly defined protagonist, one that as it happens will not match up with any male singer.[12]

Third, in considering what is conveyed about her performing personality by a vocalist's interpretation of a song, I have focused entirely on the vocalist's *vocal* interpretation of the song, that is to say, her manner of *singing* it. But, of course, a vocalist's interpretation of a song is not necessarily confined to that. To the extent that the singer has exerted control over, or influence upon, the total musical arrangement, that might also be said to enter into her interpretation of a given standard in a *broad* sense, if not into her narrowly *vocal* interpretation of it. But whereas the singer's *vocal* interpretation is immediately accessible to a listener passably familiar with the standard in question, a singer's *broad* interpretation of a standard, in the sense just sketched, remains largely opaque to listeners, since it is not generally evident to what extent the

[12] Thus, in such cases there are at least three sorts of "personality" in play: (a) the singer's *real*, or at least publically accessible, personality; (b) the singer's *performing* personality as manifested on that occasion; and (c) the *persona* internal to a standard that the singer must assume in performing that standard. As I have already indicated, there may sometimes be significant tension between (a) and (c), whose relationship is a crucial factor in the generation of (b). Unsurprisingly, such tension may sometimes issue in an unsatisfactory interpretation, one that fails to hold up or hang together. But other times it may issue in comic or poignant effects, or simply impart an ironic or knowing cast to the singer's interpretation of the song.

singer has chosen or endorsed the non-vocal aspects of the version of a song she presents.

Fourth, until now I have not taken any note of that aspect of a singer's interpretation of a standard which resides in how she *reacts to* and *interacts with* the other members of the ensemble—that is, her sidemen—an aspect in which her musical sensitivity and improvisational skill are very much to the fore. And the way in which the singer shows awareness of and responds musically to what her sidemen are doing can certainly manifest something of her performing personality in the sense I have been underlining. Still, although the singer's interaction with her sidemen during their solos—through overlaid phrases, echoed figures, superimposed scatting, and the like—as well as any reflections of their solos in her later choruses, is naturally an important part of her overall jazz *performance*, it is not, I think, a central part of her *interpretation* of the standard as such. That is to say, it is normally not a primary vehicle of how she views or feels the standard, of how it speaks to her or how it strikes her. Hence my justification for having mostly neglected that aspect of jazz singing in the present study.[13]

[13] Thanks to audiences in Prague, Paris, Chicoutimi, Nancy, Amherst, Baltimore, Ithaca, and Hong Kong, and to Jeanette Bicknell and John Fisher, the editors of the special issue of the *Journal of Aesthetics and Art Criticism* where this article was originally published, for valuable comments at various stages of its development.

9

Popular Song as Moral Microcosm
Life Lessons from Jazz Standards

I

In a recent paper devoted to my topic, music and morality, my fellow philosopher of music Peter Kivy makes a helpful tripartite distinction among ways in which music could be said to have moral force.[1] The first is by embodying and conveying moral insight; Kivy labels that *epistemic* moral force. The second is by having a positive moral effect on behavior; Kivy labels that *behavioral* moral force. And the third is by impacting positively on character so as to make someone a better human being; Kivy labels that *character-building* moral force.

Kivy is decidedly skeptical about the prospects of pure instrumental music, or what he calls "music alone," to possess the first or second sort of moral force, and only slightly less so for its prospects to possess the third sort. But he rightly points out that that third sort of moral force—what might alternatively be described as music's power to shape for the better, albeit in subtle ways, what kind of person one is—is largely, if not wholly, independent of the first two sorts, the epistemic and the behavioral, and might be manifest where they are absent.

Before returning to Kivy's three sorts of moral force, however, I want to underline a fourth way in which music can be moral. This fourth way is through music's having moral *quality*, whether or not it possesses, in consequence, moral *force*. What I mean by moral quality is a matter of

[1] Peter Kivy, "Musical Morality," *Revue internationale de philosophie*, 62/246 (2008), 397–412.

the mind or spirit reflected in the music, and most particularly, in the nature of its expression, both *what* it expresses and *how* it expresses that. Moral quality in music is not a function simply of what emotions, attitudes, or states of mind are expressed, but of how they are expressed—with what fineness, subtlety, depth, honesty, originality and so on. Music can surely display moral quality whether it is optimistic—as for instance, the first movement of Dvořák's "American" Quartet—or pessimistic—as for instance, the first movement of Mahler's "Resurrection" Symphony. What matters is the nature of the mind or spirit that shows itself through such expression, and more generally, through its management of all aspects of the musical medium, expressive, formal, and aesthetic.

The fundamental criterion of musical moral quality, perhaps too crudely framed, is whether the mind or spirit displayed in the music is such as to elicit admiration and to induce emulation, or instead such as to elicit distaste and to induce avoidance. If the former, the music has positive moral quality; if the latter, the music has negative moral quality; if neither, then the music is simply morally neutral.

But why, one may ask, does such a property of music deserve the label of *moral* quality, and not simply *aesthetic* quality? Before answering let me relabel the property in question as *ethical*, rather than *moral*, quality, appealing to a broad sense of "ethical" that is familiar to us from Aristotle and the Stoics, comprising all aspects of character relevant to living a good life, and not only those corresponding to the moral virtues narrowly understood. With that relabeling in place, I see no way to avoid replying, to the question of why the display of an admirable mind or spirit makes for ethical quality in music, that it is simply because some minds or spirits are ethically *superior* to others, in the sense that they are such as to conduce to living a good life or to living as one should. Music can thus have ethical value in the sense of presenting exemplars of admirable states of mind that are conducive to, perhaps even partly constitutive of, living well, even if no demonstrable effect on character is forthcoming. And ethical value of this sort, one may add, in general makes music that possesses it *artistically* more valuable as well, artistic value being a broader notion than aesthetic value, plausibly covering rewards afforded by a work that are not directly manifested in experience of it.

So music might, in principle, have ethical quality without that resulting in moral force of either the behavioral or the character-building sort.

But in fact it is difficult to believe that repeated exposure to music that is ethically superior, in the sense I have indicated, should have as a rule *no* effect on character at all. And that is because of the plausibility of a contagion-cum-modeling picture of what is likely to result from such exposure. Just as spending time with certain sorts of friends invariably impacts on character, if perhaps in a transitory manner—this is what parents have in mind in classifying their children's pals as on the whole either "good influences" or "bad influences"—so does keeping company with certain music rather than other music.[2] It seems manifestly better, for one's psychological and spiritual well-being, to spend time with music of sincerity, subtlety, honesty, depth, and the like, than with music of pretension, shallowness, or vulgarity.[3]

As noted earlier, Kivy does not entirely discount the notion that purely instrumental music might have moral force, at least of the character-building sort, but the possibility that he is willing to grant is slender indeed. Here is what he says:

> One might argue that, at least in some sense or other, great music uplifts us; makes us, for the period of the listening experience, feel a kind of exaltation . . . And even though this experience has no lasting beneficial effect on our characters . . . it would not be wrong to say that during the experience, at least, we are better people . . . Thus absolute music shares with many other human activities the propensity to produce in human beings a kind of ecstasy that might seem appropriate to describe as character-enhancing, consciousness-raising, and, therefore, in some vague, attenuated sense, morally improving, *while it lasts.*[4]

I have a few comments on this. First, as regards the feeling of uplift or exaltation that Kivy acknowledges can be the result of listening absorbedly to certain music, music in which one seems to be in the presence of a great mind or spirit—surely this effect normally endures for some time *after* the listening experience, and does not cease as soon as listening ends. Second, it is necessary to insist, *pace* Kivy, that any ethical benefit of music, if it is to be deserving of that name, must involve an effect on character that *endures* to some extent—that is, which outlives the

[2] I here echo the claim made by Wayne Booth on behalf of great literature in his well-known book *The Company We Keep* (Berkeley and Los Angeles: University of California Press, 1988).

[3] For further reflections in this vein, see my "Evaluating Music," in *Contemplating Art* (Oxford: OUP, 2006).

[4] "Musical Morality," 411–12.

occasion itself. Music that is only "morally improving" while one is listening to it is not, to my mind, really morally improving, but rather only music that provides a temporary if pleasant *illusion* of moral improvement. But third, the mechanism of music's possible character-building force strikes me as both less obscure and more robust than it does Kivy. I have already touched on this, in mentioning the likelihood of contagion and modeling effects, but I now elaborate further.

Though they are not sentient, musical works are somewhat like *persons*. They possess a character, exhibit something like behavior, unfold or develop over time, and display emotional and attitudinal qualities which we can access through being induced to imagine, as we listen to them, personae that embody those qualities.[5] In short, musical works are person-like in psychological ways. If so, then it hardly seems implausible that music regularly frequented will have moral effects on one, just as will being in the company of, and spending time with, real persons. This may transpire through the mere contagion or rubbing off of mental dispositions; or through a conscious desire to model oneself, in thought and action, on impressive individuals in one's environment; or through a less conscious identification with and internalization of attractive personalities with which one has contact. Why should something similar not generally occur through exposure to a given range of minds and spirits in music?

Let me be more concrete. Judging from the mind or spirit that comes across from their respective musics, Haydn would, I think, be a good choice of companion on a desert island, Tchaikovsky rather less so. It would perhaps here be fair to specify a *particular* Tchaikovsky, say that of the Piano Trio or the Fourth Symphony; these do not correspond to individuals I would care to be marooned with. On the other hand, I would willingly share my desert island with the Tchaikovsky of the String Sextet "Souvenir de Florence" or the Third Symphony. And what goes for Haydn and Tchaikovsky as imagined desert island companions holds as well for the proportion of time one would be well advised, on ethical grounds, to allow Tchaikovsky's music, or at least certain stretches of it, to occupy one's ears as opposed to Haydn's music.

[5] See my "Sound, Gesture, Space, and the Expression of Emotion in Music" and "Musical Expressiveness as Hearability-as-Expression," in *Contemplating Art*.

Mention of Haydn naturally raises the issue of the ethical value of *humorous* music, especially skillfully and wittily humorous music of the sort Haydn produced in abundance, and of the intimate connection between *humor* and *good humor*. It is surely significant that most *humorous* music is also *good-humored* music: that it is, on the one hand, funny or amusing, and on the other hand, mood-improving and spirits-lifting. This observation provides a basis, perhaps, for affirming the inherently positive ethical worth of humorous music, but its development will have to wait for another occasion.

II

Leaving music aside for the moment, let us remind ourselves briefly of ways in which the other arts, most notably those of literature, theatre, and cinema, can contribute to moral education. Novels, plays, and films can offer imaginative acquaintance with concrete moral situations, represented in specific ways and from particular perspectives, and embodying concrete moral perceptions of them, engagement with which can aid us to better understand ourselves and others, and so to better conduct our lives. Such artworks, it should be stressed, need not *prescribe* moral stances in order to facilitate our efforts to define ourselves and to appreciate the selves of others; they need only *present* morally relevant situations sensitively and believably, allowing us a valuable exercise of our moral faculties. Such artworks generally serve to enlarge our moral imaginations, making us more capable of adopting the points of view of others and of empathizing with them. Even if an increased awareness of the subjectivity of others does not itself constitute moral improvement, it is clearly a prerequisite to it, in that without such awareness we are less able to take the interests of others into account and so to treat them as ends rather than means.

The foregoing should all be roughly familiar as a defense of the moral relevance of arts such as literature, theatre, and film. But as the ancient Greeks were keen to emphasize, music arguably also has a place in moral education, the production and reception of some music serving to make us more fully human, despite representing no concrete individuals, scenarios, or situations. And that is largely because of the person-like character of music, remarked on before, whereby music can embody personal qualities, and thus affect one in somewhat the same way that

persons do. Music, through its form and expression, audibly manifests attitudes, emotions, and other states of mind, and these states of mind, to which we are exposed when attending to music, can clearly be of greater or lesser moral worth. Thus, on the one hand there is music that exudes maturity, strength, courage, resignation, vitality, and determination; on the other hand there is music that exudes immaturity, cowardice, fecklessness, megalomania, hypocrisy, and superficiality. Some music reflects a process of thought that compels admiration and uplifts us; other music reflects a process of thought that inspires dismay and depresses us. Can it make no difference in what sort of musical atmosphere, ethically speaking, one chooses regularly to bask?

So much for the ethical dimension of instrumental music. I turn now to my main subject today, the ethical import of song, and the role in such import of both the articulate component—the words—and the purely musical component—the notes.

III

As regards song, or texted music generally, claims of moral insight, which correspond to the first sort of moral force recognized by Kivy, and claims of character-building potential, which correspond to the third sort of moral force recognized by Kivy, are generally held to be less extravagant, and to have a more solid basis, than comparable claims for textless music. And the same goes for claims of what I characterized above as ethical *quality*, as distinct from moral force in any of Kivy's senses.

Still, the contribution of the musical element per se to whatever moral force or ethical quality a song ends up possessing surely remains crucial, and presents an enduring puzzle. Put bluntly, how is it that music can reinforce, amplify, or almost create single-handedly, the moral force or ethical quality of a text that would otherwise not seem particularly notable in that respect? I will return to this question towards the end of this essay, after having looked at an array of specific examples.

One of my purposes in examining a number of songs from the jazz standard repertoire—which to a large extent overlaps with what is called the Great American Songbook—is to underline that the ethical dimension of art is not something that is only of issue in regard to unconventional performance art, transgressive theatre, propaganda films in the

mode of Leni Riefenstahl, homoerotic photographs in the mode of Robert Mapplethorpe, or intentionally provocative novels in the mode of Michel Houellebecq. That is to say, of art that, whether self-consciously or not, is in forthright opposition to prevailing mores. The ethical is, I suggest, a dimension in one way or another present in virtually all art, even the declaredly amoral literary art of an Oscar Wilde or Vladimir Nabokov, the purely abstract visual art of a Piet Mondrian or Mark Rothko, and the abstruse musical art of a Pierre Boulez or Milton Babbitt.[6]

IV

I begin by contrasting the Rube Bloom and Johny Mercer song "Day In, Day Out" with two somewhat similar songs, "You Go to My Head" and "Night and Day." These three songs all have more or less the same theme, namely, the unparalleled effect of the beloved on the one who loves, and how the sway of the beloved over the lover amounts to a kind of possession, calling possibly for eventual exorcism. And all three songs exhibit, of course, a measure of ethical quality in virtue of their musical excellence and taste and the mind that such excellence and taste manifests. "Night and Day" and "You Go to My Head" are as fine, or perhaps even finer, from the musical and lyrical point of view, as "Day In, Day Out."[7] But I suggest that they embody less, if anything, in the way of moral insight, and that their ethical quality is thus less than that of "Day In, Day Out."

"Day In, Day Out" offers, first of all, a picture of amorous absorption even more revealing than that offered by the other two, turning on the figure of the beloved as a recurring tattoo, coursing through one's blood and permeating one's being, and the idea that the presence, the sight, the touch of the loved one utterly transforms the world, whatever the

[6] Nor do I mean to suggest that ethical quality is the exclusive prerogative of songs in the repertoire from which I draw my examples. Many songs from the rock, folk, and blues genres also exhibit such quality. Consider Leonard Cohen's "Everybody Knows," whose poetic cynicism, smooth transitions from global to personal concerns, jewel-like mandolin accompaniment, and rich background vocals all contribute to its ethical impact.

[7] To note just one respect in which the music of "You Go to My Head" is not only beguiling on its own terms, but incredibly well fitted to the sentiment of its lyric, the octave leaps at the beginning of the vocal line at each of three stanzas of the chorus are a perfect sonic emblem of the intoxicating effect of which the lyric so eloquently speaks.

weather may happen to be.[8] But what probably most distinguishes "Day In, Day Out" from the other two songs is its quasi-narrative aspect, which makes the phenomenology of love it conveys even more vivid and affecting. This is most noticeable in the bridge, which sketches a paradigm scenario in the lover's daily existence: "Day out, day in, I needn't tell you how my days begin. When I awake I awaken with a tingle, one possibility in view, that possibility of maybe seeing you." And the narrative momentum of the bridge is continued in the chorus that follows, "Come rain, come shine, I meet you and to me the day is fine, then I kiss your lips, and the pounding becomes, the ocean's roar, a thousand drums," leading sweepingly to the emotional climax and vocal high point of the song, "Can't you see it's love, can there be any doubt."

With "Day In, Day Out" one doesn't just *grasp* the nature of the lover's possession by the beloved through a series of original and poetically arresting images of intoxication, as in "You Go to My Head," or through a sequence of alternatingly besotted and bemoaning apostrophes to the beloved, as in "Night and Day." One rather *lives* that possession itself, albeit vicariously, in virtue of the narrative, albeit fragmentary, that the song contains. And it is most of all in that illuminating vicarious experience that the surplus ethical quality of "Day In, Day Out" resides.[9]

It should not, of course, be surprising that a narrative dimension, even if it is not essential to a song's having ethical import, can nevertheless contribute to its having such import. For a song is then able to draw, although to a limited degree, on the same resources possessed by novels and plays for evoking complex emotional responses to concrete situations and facilitating ethical insight into them.

Consider next the song "As Long As I Live." One thing that makes this song special is its uncommonly bluesy feel, of which Harold Arlen was, among the great American song composers, the past master. But another thing, and one more germane to our theme, is the genius of the lyricist,

[8] Another song that foregrounds that idea is Gershwin's "A Foggy Day."

[9] Alec Wilder, an authority on American popular song, offered this encomium of "Day In, Day Out," one that responds to its special quality from a somewhat different, yet entirely compatible, angle: "I was astounded by both the melody and the lyric ... It was unlike any song in the pop field I'd ever seen ... fifty-six measures long. The melodic line soared and moved across the page like a lovely brush stroke. It never knotted itself up in cleverness or pretentiousness. And it had, remarkable for any pop song, passion." (Quoted in Philip Furia, *The Poets of Tin Pan Alley* (Oxford: OUP, 1992), 122.)

Ted Koehler, in following the line "Maybe I can't live to love you as long as I want to" with the seemingly throwaway explanatory remark "life isn't long enough." For that is an unexpected and beautifully colloquial way of telegraphing how love, in effect, always aspires to forever, knowing all along that it is bound to finitude and must necessarily come to an end. The repeated amorous pledges of the speaker to love for all time are all the more poignant because they invariably raise in our minds the question of whether loving someone is something that one can reasonably *promise* to do. More likely, it is only something that one can promise to *try* to do, or that one can earnestly *hope* to do, for only as long as one lives.

V

Let us now look at the other side of the coin, turning our attention to some songs that deal not with the thrill and exhilaration of love, but with the ache and desperation of its loss or absence. Pride of place here must go to Don Raye and Gene De Paul's "You Don't Know What Love Is." Probably no song conveys better the pain of loving hopelessly, long after love has flown.[10] First, the despairing and soul-sick lyric is perfectly matched by, and fitted to, music of precisely the same character. But second, the idea that fully appreciating the value of love requires losing it or going without it for some time is one that rings completely true, at least to this listener. Naturally one might easily *understand* that truth in the abstract—say, in the manner in which Tolstoy's Ivan Ilych, before his fatal accident, had always grasped the syllogism "All men are mortal; Caius is a man; Hence Caius is mortal," not seeing that it had any particular relevance to him—but a song like "You Don't Know What Love Is" makes you *feel* its truth, in the most concrete fashion. And therein lies its not inconsiderable ethical value.

In a less wrenching, though perhaps no less moving, vein is the Rodgers and Hart standard "It Never Entered My Mind." This song, imbued with wistful regret and rueful musing, brings home as few others do how fragile love is, how often underappreciated, how often taken for granted, its inevitable departure from some oppressive notion of

[10] A strong second-place showing, however, must be accorded at least three other songs from this repertoire, "Angel Eyes," "Estate," and "When Your Lover Has Gone."

perfection being allowed to get in the way of estimating it at its proper value. The sublime rightness of the bittersweet images of life after love—ordering orange juice for one, being uneasy in one's easy chair, wishing that the other might get into one's hair again—have rarely, if ever, been equaled in the annals of song. The song's jilted lover seems, as one commentator puts it, "almost bemused by her own heartache and understatedly characterizes it as mild discomfort." But we see and hear through that, and have no trouble suffering along with her empathically.

Consider now another love song—it hardly needs mentioning that love is the overriding subject of the songs in this repertoire, accounting for perhaps ninety percent of them—but one that stresses neither the joy nor the sorrow of love, but instead the mystery that so often triggers and sustains it, namely, the perception of the other as beautiful. "You Are Too Beautiful," another gem we owe to the team of Rodgers and Hart, straightforwardly conveys in its text the irrational power of human beauty, its dominion over the will, and its capacity to short-circuit, or even wholly disarm, moral assessment. The text is perfectly seconded, and its truth effectively illustrated, by the song's utterly beautiful, wholly unfussy, melody, one that is almost entirely diatonic, not needing any chromaticism for chromaticism's sake in order to lend it interest. There is ethical quality here as well, and not all of it resides in the luminous beauty and simplicity of the music itself; some of it resides in the wisdom of the sentiment conveyed by the words.

A more complex song, "Sophisticated Lady," is full of sympathy for the woman of the title, though a sympathy qualified by criticism of the choices she has made, which the song regards as reflecting a basically evasive adaptation to the reality of disappointed love. The music of this standard is as sophisticated as the lady it helps to portray, and perhaps in a way that is similarly a bit forced, the bridge being almost unsingable in its unbridled chromaticism and unusual harmonic relation to the chorus that precedes it.[11]

Its ethical dimension aside, "Sophisticated Lady" is a particularly interesting song from one point of view: it is an example of a strikingly

[11] The main key of the song is Ab major, while the bridge is in G major, only a half-tone down but harmonically quite remote from Ab. What is especially hard to negotiate for a singer is the transition from the last note of the main section to the first note of the bridge, separated by the bedeviling interval of a tritone.

successful joint creation,[12] the conjunction of an original instrumental by Duke Ellington and lyrics added subsequently by Mitchell Parish, where the composer and lyricist harbored rather different conceptions of the subject, that is, the sophisticated lady, in fashioning their respective contributions. Parish's sophisticated lady, as is evident from the song, is a blasé and jaded creature of the night, vainly attempting to escape the emptiness in her soul; but the sophisticated ladies that Ellington had in mind were the proper, well-dressed, middle-class, cultivated African-American schoolteachers of his Washington youth.

VI

For the sake of contrast I now draw attention to a standard that seems to me not just of *lesser* ethical value than those I have been discussing, but possibly of slight ethical *disvalue*. For if songs can have positive ethical value on the grounds I have been sketching, then presumably they can have negative ethical value, or ethical disvalue, as well. At the least the song is of dubious ethical quality, even though it is, as regards both its lyrics and its music, of a high order.

The standard in question is called "Everything Happens to Me," by Tom Adair and Matt Dennis, and represents, in a vein of apparent endorsement, an attitude of mind that is arguably not worthy of admiration, emulation, or sympathy, an attitude one might describe as one of self-indulgence and self-pity. The attitude represented comes through clearly in the opening stanza: "I make a date for golf, and you can bet your life it rains. I try to give a party, and the guy upstairs complains. I guess I'll go thru life, just catching colds and missing trains. Everything happens to me." The second stanza of the song delivers more of the same.

Plainly, one would do well not to dwell in the company of a persona as self-absorbed as that which such sentiments reflect, someone who feels that the ordinary small annoyances and inconveniences of life have somehow singled him out for special and unfair treatment. One wants to take this whiner by his lapels and ask, what will you do if you ever confront a real problem or experience a serious setback? To be fair, the closing stanza of "Everything Happens to Me," which reflects bemoaning

[12] I note here the rather unsympathetic, and in my opinion obtuse, view of this song taken by Philip Furia. (See *The Poets of Tin Pan Alley*, 257–8.)

more worthy of sympathetic response, turning as it does on misfortune in love, somewhat offsets the initial impression of outsized self-pity.[13] And both the song's harmonically surprising bridge and some nice chromatic touches in the song's main melody add an undeniable poignancy to the protagonist's complaint. Nonetheless, in the final analysis the song leaves something to be desired, ethically speaking.

This prompts me to a more general reflection concerning songs of equivocal ethical quality, such as "Everything Happens to Me." The crucial issue is whether a song not only *expresses* or *portrays* undesirable character traits, but in addition, does so in a way that amounts to *endorsing* or *condoning* them. Only if the latter is true will they clearly count as bad company for a listener on ethical grounds. And a song might conceivably also be ethically bad company if the implied author, while not endorsing or condoning the undesirable traits displayed, fails to clearly *reject* or *distance* himself from the undesirable traits or obnoxious attitudes expressed or portrayed.

Still, mightn't the displayed character of the imagined speaker of the song be bad company *even if* the implied author is critical of the song's imagined speaker? Perhaps. That is to say, the mind of the song's persona might be a bad thing to spend too much time exposing oneself to, even if the implied author is blameless because implicitly criticizing or distancing himself from the persona depicted. Yet clearly, it is worse if the implied author appears to view the persona in a sympathetic or even just neutral light.

VII

If any of the songs I have chosen for examination manages to achieve the ethical quality I am claiming for them, then surely the song "What's New?" by Bob Haggart and Johnny Burke does so. Like "Sophisticated Lady," "What's New?" is one of those vocal standards that began life as

[13] "I've telegraphed and phoned, and sent an air mail special too. Your answer was goodbye, and there was even postage due. I fell in love just once, and then it had to be with you. Everything happens to me." Furthermore, when sung a certain way "Everything Happens to Me" can be redeemed in performance, if the singer manages to neutralize what's unappealing about the song's persona by inhabiting it in a wistful yet knowing manner. The performance by Chet Baker comes closest, of those I have heard, to achieving that.

an instrumental, and then achieved a new identity once words had been attached to it by someone other than the composer. With the text in place "What's New?" emerges as a musical dramatic monologue, one half of a conversation between ex-lovers, the other half of which is only implied, yet all-too-readily imagined.

Note first that the song achieves a satisfying unity between its opening and its closing couplet: the phrase "you haven't changed" in the former becomes "I haven't changed" in the latter. This is a small change, grammatically speaking, but one that adds to the song's very special poignancy: the first phrase is a remark directed to outer appearance in a vein of polite compliment; the second phrase is a naked confession of inner sorrow. And the falsely cheery "adieu"—preferably pronounced *à l'américaine* as "adyoo"—at the end of the bridge serves as a perfect hinge to the heartbreak of the final chorus, with its almost unuttered "I still love you so."

"What's New?" achieves a truly impressive depth of characterization in such a short space. We are led to both admire and empathize with the protagonist's quiet suffering, with the brave face he assumes in the situation. A song like this fosters understanding of the risks and rewards of romantic engagement, and helps one to feel from the inside what it is like to harbor love for someone who has long ago ceased to care. Sensitive audition of "What's New?," it may not be too much to claim, plausibly puts one in a better position to understand situations of this sort, to assess them morally if called for, perhaps even to deal with them better if one finds oneself in them.

VIII

I here offer a few illustrations of how these exceptional songs, when treated in a jazz context, can have, ethically speaking, a greater or a lesser impact. I have in mind the ways in which specific interpretive choices made in performance by the singer of a song can serve to enhance, whereas others can serve to blunt, its inherent ethical quality.

Regarding "What's New?," suppose that instead of a smooth descent on the words that follow the repeated refrains of "what's new?" the singer offers instead a halting one, almost stopping on each word, something like this, "how ..." "did ..." "that ..." "romance ..." "come ..." "through." If not overdone this can underline the vulnerability of the

song's protagonist and his or her effort of keeping pain in check—trying, though not really managing, to affect an insouciance not felt—making that persona all the easier to empathize with, and making the song all the more effective on the ethical plane.

Regarding "It Never Entered My Mind," both the song's tone of melancholy regret and its poignant portrait of one who wised up too late are arguably best served by a slow tempo and a legato vocal delivery, one that helps to conjure up an atmosphere of wistful reminiscence. A too lively tempo, a too blithe or jaunty vocal delivery, can undermine the effectiveness of this song, and its ethical value in particular.

Regarding "Day In, Day Out," by contrast, adopting a slow, hardly swinging, tempo can make for an outing that is musically interesting, and can succeed in conveying a nice sense of relaxation. But such an approach also makes it difficult to convey the feeling of amorous exhilaration that is, to my mind, at the heart of the song and an important source of its ethical quality. Thus it is probably not an optimal choice for bringing out what is best and most distinctive in it.

IX

It is high time to venture some general reflections, difficult as they are to arrive at, on the ethical power of popular song. The crucial question, it seems, is this: How can setting to music fairly ordinary sentiments and observations—such as the ones we have encountered in this repertoire—make those sentiments and observations so much more affecting or compelling, and hence manage to invest them with what I have called ethical, or life-enhancing, quality? Is it a mere additive effect? Is it a kind of delusion? Are we being duped?

We can formulate a couple of rather difficult conundrums here. The first is this: is it simply that due to our pleasure in the music as such we end up attributing more validity to the sentiments or observations conveyed by the words than we would otherwise do? Or is it rather that setting the words to music in a particular fashion somehow provides a kind of corroboration of the sentiments or observations conveyed by the words? And the second is this: when a song moves us or touches us, and also conveys a substantial thought or distinctive perspective, does the thought or perspective seem more true or apt in part because the song has moved or touched us, or does the song

move or touch us in part because the thought or perspective, musically enrobed, seems more true or apt? These are conundrums I am not sure how to resolve, but I push on in the hope of shedding some light on them.

Recall that of the four sorts of moral relevance that music might have that were canvassed at the beginning of my talk, three seem to remain live possibilities for the songs we have surveyed, namely *epistemic moral force, character-building moral force*, and *ethical quality*. To take the first of these, if a song manages to have epistemic moral force—that is, a capacity to embody and communicate moral insight—it seems that that will depend almost entirely on the words, words capable of conveying an articulate content. Since I want to focus on the specifically musical contribution to a song's moral import, I will accordingly here leave the issue of epistemic moral force to the side.

As regards ethical *quality*, however, and the *character-building* moral force that may be consequent on that, at least two things are clear. The first thing is that the ethical quality of the *purely musical component* of the song will contribute, all things being equal, to the ethical quality of the song as a whole, something it is thus better, for the good of one's soul, to spend time with. For instance, that the music of "Sophisticated Lady" reflects a finer, nobler, more searching mind than the music of, say, "Cherokee"—a sturdy old standard that yet served as a basis of improvisation for many great jazzmen—is at least part of why "Sophisticated Lady" has a higher ethical, and not only aesthetic, value than "Cherokee," and hence a higher artistic value as well. And the second, and most patent, thing is surely that the *particular manner of joining words to music* in these songs also accounts in part for whatever ethical quality the songs end up having, though in ways it is exceedingly hard to generalize about.

One clue to the special ethical quality that songs in this repertoire can have may be the element of exceptional *condensation, concision*, or *compression* they exhibit. In experiencing a great jazz standard well delivered, one has a sense of getting to the heart of a subject, of being presented with its essence, because of the brevity of the medium and the consequent intensity of focus, where all must be said and sounded in no more than three or four minutes, as opposed to the hours involved in the unfolding of, say, a novel, film, or opera. In a great jazz standard every note, every word seems to count, and the economy of means seems somehow to underline the justness or rightness of what is being expressed.

Of course, as has often been noted, condensation, concision, and compression are also part of the power of *poetry*, a good poem often capturing in a small span of words a whole world of thought or feeling. Still, in song there is something additional: not just condensation, concision, and compression, but the conjunction of two *quite different* vehicles of significance or orders of meaning-making—articulate words and inarticulate sounds—which in their interpenetration often manage to convey a single content, and to do so more powerfully than either is able to do on its own.[14]

A great song, one that is not only beguiling in its music and worldly wise in its words, but compelling in its precise marriage of the two, has ethical quality, one might suggest, partly in virtue of serving as an emblem of harmonious and mutually enriching cooperation, a prime goal of interpersonal relations and of social life more generally. And when one responds positively to such a song—acknowledging on an emotional level its utter rightness and fineness of tone—one participates imaginatively in the ideal of sublime interaction that the song represents.

There is also, finally, an undeniable aspect of *liberation* involved in the joining of articulate thoughts or sentiments to music. For it is a curious fact that one allows oneself to sing, or to hear sung, or to compose as a song, what one would be too inhibited or too embarrassed to simply speak, or hear spoken, or offer as a poem. Why? Well, it seems as if music inaugurates a sort of charmed unreality, licensing the expression of feelings too direct or too unguarded to survive without musical protection. And such emotional license, if not overindulged in, may count as an ethical benefit of engaging with songs such as the ones I have examined.

One last remark. I know that my own life, at any rate, would be considerably poorer without the benefits that exposure to and involvement with the best songs in the jazz standard repertoire can afford, and poorer as much ethically as aesthetically. And I am sure, as well, that that is not just the case while I am actually listening to them.

[14] Perhaps the special satisfaction derived from song is partly rooted in some systemic awareness of the two halves of one's brain being singularly united in the comprehension of what one is hearing, on the assumption of the right hemisphere as the main locus of musical processing and the left hemisphere as the main locus of verbal processing.

10

The Expressive Specificity of Jazz

I. Introduction

There is something distinctive about jazz, everyone agrees. Its repertoire, its origins, its ethnic roots, its social situation, its typical venues, and the extraordinary freedom it showcases, set it apart from other musics. But that leaves it open that while jazz is distinctive in many ways—canonically, historically, socially, ethnically, and performatively—it is not distinctive *aesthetically*. We must thus pose the question of whether there is a distinctive jazz *aesthetic*?

The answer to that question is no doubt "yes." However, instead of trying to defend that answer directly, I will focus here on a somewhat narrower question, that of whether there is a distinctive jazz *expressiveness*, since if that is so then at least one of the main pillars of a jazz aesthetic will have been secured. By a distinctive jazz expressiveness or expressivity I mean something like a penchant or propensity of jazz to be expressive of certain emotions, moods, or other mental states rather than others, or a certain range of such emotions, moods, or states.

The specificity of jazz I will endeavor to put in evidence thus differs from the sorts of specificity jazz theorists have more commonly focused on, such as jazz's *rhythmic* specificity, its specificity as to *instrumentation*, its *cultural* specificity, its *political* specificity, or its specificity as regards *performance* practices, though the one I am concerned with—jazz's *expressive* specificity—may depend on those other specificities in various ways.

II. Circumscribing Jazz—characteristic, distinctive, or essential features

I must next say something about how to circumscribe the domain of jazz, whose specific expressiveness I have provisionally posited.

According to André Hodeir's well-known theory of jazz's essence, jazz is *not* essentially blues-based, is *not* essentially improvisational, and does *not* essentially display any particular overall form (Hodeir, 1956). Instead, according to Hodeir, jazz exhibits both a distinctive range of *sound* and a distinctive kind of forward motion or drive, namely *swing* (Brown, 1991).

Swing is a rhythmic phenomenon that can be characterized as involving a delicate balance between tension and relaxation, between a regular underlying pulsation ("infrastructure") and an irregular overlying pattern of notes in partial opposition or contrast to that underlying pulsation ("superstructure"). Here is how one recent commentator puts it: "jazz playing interweaves metrically 'correct' placements of some notes with displacements of other notes. The result is that the musical phrases are felt, by turns, as moving independently of the underlying pulse and then as being recaptured by it ... The duality that defines swing is the basis for the tension/relaxation duality that is peculiar to jazz ... swing embraces tension and release in a single structure" (Brown, 1991: 120–2). Or put otherwise, in jazz music there is typically a fusion of tension-making and relaxation-making elements, typically yielding swing or groove, whereas in classical music there is typically an alternation of tension-making and relaxation-making episodes, typically yielding conflict or drama.

There are, of course, clear limits to Hodeir's account of the essence of jazz. First, some jazz, such as that exemplified by Ornette Coleman or Cecil Taylor, does not swing, does not exhibit a basic underlying pulse. Second, the account fails to acknowledge in any way the idea of performing spontaneity as central to jazz, or the contribution that certain scales and chords—most importantly, blues-inflected ones—make to the feel of jazz.

Some theorists, such as Lee Brown, have claimed, moreover, that there is a necessary connection between jazz and *imperfection*, turning on the role in jazz performance of improvisation and its consequent risks (Brown, 2000). One theorist, Ted Gioia, has proposed that a distinctive

mark of jazz is its fitting a *retrospective* rather than *prospective* model of the performing activity at its core (Gioia, 1988). The suggestion, more specifically, is that jazz involves a performance situation characterized notably by three features: first, "no script or blueprint"; second, "no erasures or revisions"; and third, "constant forced choices" (Brown, 2000: 113–14). These features inevitably yield a result different in character—more sprawling and roughhewn, but also often, more vital and dynamic—than would have emerged if all major moves had been weighed and decided in advance, ahead of playing. We might in addition point to distinctive features of *melody* as manifested in jazz, the heritage of jazz's significant roots in African music, features such as the "call-and-response," "end-repeating," and "vocally derived" character of melodic thinking in jazz.

Summing up, we might take the distinctive features of jazz to include these: (a) constant mixture of tension and relaxation; (b) pronounced forward motion, variously denominated "drive," "swing," or "groove," aided by a steady 4/4 meter and subtle backbeat, emphasizing the second and fourth beats of the measure; (c) improvisatory playing; (d) distortions of sonority, often echoing vocal gesture; (e) blues-inflected or funky-sounding melody and harmony; and (f) phrasing that is fragmentary or motivic rather than arching or cantabile. Of course not every genuine example of jazz exhibits *all* of these features. What is true is that *most* instances of jazz exhibit *most* of these features, while *some* instances of jazz exhibit only *some* of these features. But *no* instance of jazz, I wager, exhibits fewer than *two* or *three* of those features.

Thelonious Monk's solo piano performances usefully test the limits of the above observations. Most notably, they are short on feature (b), having little or no drive or swing and dispensing with steady meter and backbeat. Nor are distortions of sonority particularly prominent. Moreover, they also display feature (a), the constant fusion of relaxation and tension, in a lesser degree than more typical examples of jazz. Nonetheless, those performances unmistakably exhibit features (c), (e), and (f), with their improvisatory feel, melodic off-notes, and spiky rhythmic displacements.

As is evident from my cautious review of plausible features *distinctive* of jazz, the prospects of identifying the *essence* of jazz—that is, a single feature, or even ensemble of features, that can serve as jazz's *sine qua non*— are not bright. But no matter. Something weaker than the essence of

jazz will serve for my purposes. In what follows I will presuppose the notion of *paradigm* or *prototypical* instances of jazz, and I will rely, relatedly, on the notion of a stretch of music "sounding like jazz."

III. The Jazz *Gestalt*—sounding like jazz

I now turn to the idea of "sounding like jazz," the idea of a perceptually salient jazz *Gestalt*. This is something phenomenologically real, which the distinctive features of jazz noted earlier combine to create, and which is anchored in paradigm or prototypical examples of jazz. You know it when you hear it, even if you are unable to analyze it.

Consider the 1926 recording of "Dead Man Blues" by Jelly Roll Morton and his Red Hot Peppers. The intro to this rendition, which alludes loosely to Chopin's famous "Funeral March," is not really jazz, except insofar as it occurs at the outset of a performance that clearly is an instance of jazz. Admittedly, it has something of the sound of jazz, in virtue of its brass-dominant instrumentation, but that isn't enough to give the passage a jazz sound as a whole, to make it "sound like jazz." Jazz proper begins when the basic pulse, the walking bass, and the syncopated, improvisational tune-spinning begin.

Even with fully composed jazz, such as some of Duke Ellington's compositions for big band, in virtue of being heard as jazz such pieces may implicitly be heard as music in which improvisation remains an option even if it is being forgone, where improvisation is always in the wings, even if it never takes center stage. In other words, it is music where we feel that daring moves of an improvisatory sort might always occur, and that if they did they would not be out of place, even if we know that they have been excluded in advance. It is music in which we have a sense of the freedom of the performer to deviate from the score, and where doing so seems licensed in the abstract by the sound of the music, even when this freedom will not in fact be exercised because of the fully composed nature of the piece. Martin Williams expresses this as follows: "Some jazz performances may be purely interpretive [where a pre-existing composition is involved], but the possibility of spontaneous departure is always there. Jazz music is produced in an atmosphere of improvisation, the ability to extemporize [being] part of the jazz soloist's equipment" (Williams, 1987: 9).

IV. Musical Expressiveness

I must now say a little about the basic model of *musical expressiveness*—that is, expression by music of emotions, moods, attitudes, and other mental states—to which I subscribe. On my view, such expressiveness is a matter of music's *ready hearability as* the expression of such states. More exactly, the claim is that a stretch of music will be *expressive* of a mental state S if in virtue of how it sounds we are *disposed* to hear it as the literal—that is, behavioral—*expression* of such a state. Put perhaps too simply, but in a way that is nevertheless useful, and taking emotion as the prime example of a state that music can express, music *expressive* of an emotion is music that *sounds like* someone expressing that emotion—like someone outwardly manifesting that emotion, but through musical *gesture*, through what we in effect hear the music as *doing*. (See Levinson 1996, 2006.)

Crucial to the account is the idea that musical expressiveness resides in the invitation that music extends to a listener to hear it as expression in the primary sense—that is, expression by persons of inner states through outer signs. Thus, to hear music as expressive is to hear it as an instance of personal expression. In short, *expressive* music is music we are disposed to hear *as* expressing; that is what its expressiveness at base consists in.

In any case, the particular philosophical account of musical expressiveness that one accepts doesn't much matter for what I will try to suggest about jazz's specific expressivity, so long as one agrees that instrumental music, whether jazz or otherwise, is often expressive of particular emotions and other mental states, and in manner that is intersubjectively demonstrable.

What I will need for the subsequent discussion, however, is a division of the emotional terrain into four exceedingly rough areas: low-energy positive emotions (LEP), such as gaiety, serenity, pride, hope, cheerfulness, amusement; low-energy negative emotions (LEN), such as melancholy, sadness, nostalgia, regret, depression, shame, and disappointment; high-energy positive emotions (HEP), such as joy, love, lust, exuberance, and ecstasy; and high-energy negative emotions (HEN), such as anger, fear, anguish, scorn, defiance, despair, and grief. Instead of a *low-energy/high-energy* dimension one might alternatively appeal to an *inward-facing/outward-facing* dimension, which would yield a somewhat different division of the terrain, into inward-facing positive emotions (IFP),

outward-facing negative emotions (OFP), inward-facing negative emotions (IFN), and outward-facing negative emotions (OFN). What I would stress is that any such division of the emotional terrain is a crude one, and that the boundaries of the categories thus defined remain terminally fuzzy.[1]

V. Jazz's Expressive Specificity

I begin my attempt to identify or locate jazz's expressive specificity through a negative characterization of it. That is to say, I will seek a clue to that specificity by asking what is difficult, improbable, or even impossible for jazz to express.

It seems there are emotions that are resistant to expression in the jazz idiom, in music that "sounds like jazz," in music that presents the jazz *Gestalt*, emotions such as anguish, anxiety, grief, despair, rage, fear, horror. These are, of course, central examples of the HEN emotional area invoked in Section IV.

Of the distinctive features of jazz canvassed earlier, perhaps the most central are, on the one hand, improvisation, and on the other, a particular rhythmic feel or groove, of which swing is perhaps the most characteristic manifestation. Now both of those, I suggest, conduce to the expression of emotion from what I earlier labeled the HEP emotional area, that of outgoing/joyous/liberating/energizing emotion. It is thus hard for instances of jazz—as opposed to certain jazz standards themselves, considered as notated compositions—to express emotions or states from the LEN, and even more so, the HEN area: pain/sorrow/grief, anxiety/uncertainty, somberness/sobriety/solemnity, and so on. Emotions of that sort involve an element of psychic constriction, repression, or blockage that the basic feel, sound, or *Gestalt* of jazz tends to counter or preclude.

It comports with what I have just suggested that jazz is rarely in a minor key, the modal use of major keys being much more common. One can, of course, list exceptions, among standards favored by instrumentalists, to this tropism toward the major and the modal: "Autumn

[1] Crude though it may be, the quadripartite division of the emotional terrain adopted here is basically the same as that proposed by psychologist James Russell in a much cited article (Russell, 1980).

Leaves," "Yesterdays," "My Funny Valentine," "Alone Together," "Summertime," "Invitation." But they are relatively few, the ratio of major key to minor key standards being perhaps on the order of eight to one.

Even the saddest songs from the repertoire of vocal standards, such as "You Don't Know What Love Is," "Autumn Leaves," "Good-Bye," or "What's New?" do not sound as sad, as wrenching, as heartbreaking in jazz instrumental versions as they do when well sung in fairly straightforward fashion. The reason, I think, is that when interpreted by instrumentalists steeped in jazz these songs inevitably acquire a measure of coolness and ease, a backdrop of freedom and relaxation, in virtue of being transformed into jazz—of being "jazzified," so to speak—which acts to temper the heartbreak they more transparently display in plainer versions.[2]

Consider now instrumentation. Some of the instruments that are most *emblematic* of jazz are ones that favor, though hardly guaranteeing, expressiveness from the HEP emotional area: trumpet, saxophone, vibraphone, electric guitar, drums. The point is perhaps clearer if inverted. The orchestral instruments effectively *excluded* from jazz, those that have almost no presence in jazz, are ones that are rather congenial to expressiveness from the LEN and HEN emotional areas: violin, viola, cello, oboe, horn, bassoon, timpani.

I want to forestall misunderstanding of the thesis I am venturing here. Of course one can write for a typical jazz ensemble—say one of horns, vibes, and bass but no drums—using typical jazz harmonies—many ninth chords and blue notes—at slow tempos, and end up expressing something from the HEN emotional area. But very likely it will not then sound like jazz, because invariably some characteristic element—swing, groove, drive, relaxation, improvisation—will have been omitted, minimized, or sidelined.

Recall again what is required for a recognizable jazz *Gestalt* to emerge. They are features such as steady backbeat, swing or groove, relaxed feel, improvisatory playing, modal melodies, blue notes, altered ninth

[2] There are, of course, exceptions to the rule that sad jazz vocal standards are generally less sad in jazz instrumental versions. One that comes to mind is "Don't Explain" on the Mal Waldron sextet CD *Mal/2*, featuring John Coltrane and Jackie MacLean [Prestige 7111]. But note that Waldron's instrumental version of that standard was closely modeled on the sung performance of it by Billie Holiday, who was also the author of that song.

chords, brassy timbres, impure intonation, rhythmic inventiveness, metric freedom. Call those features *J-features*. Then if music must have a fair number of J-features in order to present a jazz *Gestalt*—in order to "sound like jazz" to jazz-experienced audiences—and if J-features are largely incompatible with, or at least militate against, features that underlie or conduce to expressiveness of the LEN, and most especially HEN, sort, then the upshot seems to be that jazz music cannot express, or at least cannot readily express—psychological states in that emotional area. For example, and more concretely, that music cannot, or cannot easily, both unequivocally sound like jazz and also convincingly express anguish, grief, despair, rage, and the like.

Now of course jazz, which is rooted in the blues, among other musical traditions, can express negative emotion, and in particular, sadness or sorrow. But I wager that such emotion is never as *intense* as that expressed in many works of classical music, such as the first movement of Shostakovich's Eighth String Quartet, the *Marcia funebre* of Beethoven's "Eroica" Symphony, Barber's *Adagio for Strings*, the *Adagio* of Mozart's Piano Concerto, K. 488, or the opening *Allegro* of Beethoven's Quartet, Op. 132. Sadness and sorrow expressed in the jazz idiom generally takes on a gentler, more consoling, and ultimately more upbeat character. Consider Monk's "Ruby My Dear," Coltrane's "Alabama," or Coleman's "Lonely Woman." Sadness, sorrow, and melancholy are assuredly in the scope of jazz. But grief, anguish, and rage seem beyond it, and perhaps happily so.

Consider that almost no one leaves a jazz concert feeling down, disturbed, depressed, or distraught, even when the numbers by Monk, Coltrane, and Coleman just mentioned are on the program. But such might very well be the effect of a symphonic or chamber music concert featuring many works by Brahms, Mahler, Strauss, Schoenberg, Schnittke, or Shostakovich, in virtue of the emotional realms addressed by classical music that jazz is mostly barred from. Consider that when one tunes in a jazz station on the radio one can form in anticipation a more reliable idea of what sort of expressiveness one is likely to confront than when one tunes in a classical station. Both phenomena are signs of the expressive range of classical music being wider than the expressive range of jazz, though clearly there is no metric for exact measurement in this domain. There is doubtless a large amount of overlap in what classical music and paradigmatic jazz express—a Venn diagram of the situation would show a large football-shaped area in the

middle—but there are also substantial emotional areas which are arguably the special province of one but not the other, at least as far as ready or convincing expression is concerned.

Some confirmation of what I've been arguing for here can be found in a telling statement by Ornette Coleman, made around the time of his first recording as a leader: "Music is for our feelings. I think jazz should try to express more kinds of feelings that it has up to now." (Martin Williams, liner notes, *The Shape of Jazz to Come*, Atlantic Records, 1959.) What Coleman's statement reflects, I think, is an awareness of the inherent gravitation of jazz towards a certain sort of expressivity. And what Coleman's own music represents, of course, is an attempt, in some measure successful, to widen the scope of what recognizably jazz music might express.

If paradigmatic jazz offers an indissoluble marriage of tension and relaxation, as has often been noted, my suspicion is that if it thus sounds like jazz, then ultimately it is the *latter* that predominates. If that is right, then this shows that the dyad "relaxation and tension" is not wholly equivalent to the dyad "regularity and irregularity," often also said to characterize jazz music, since although in paradigm instances of jazz regularity and irregularity are indeed in constant balance, the upshot of this is *not* an impression in which tension and relaxation have an *equal* measure, but rather one in which relaxation has the upper hand.

The expressive *specificity* of jazz, if there is justice in what I have been arguing, is just the other side of the coin of jazz's expressive *limitations*. Can the utterly joyous sense of liberation, the unfettered outpouring of feeling that one hears in iconic performances of soloists such as Charlie Parker, John Coltrane, Bud Powell, or Cannonball Adderly, find expression in any recognizably classical idiom? I suspect not.[3] But what allows jazz to achieve such expression is indirectly what accounts for its being unable, or perhaps better, unsuited, to give expression to the sorts of emotion that are the natural terrain of music in the late Romantic and Early Modern styles of composers

[3] It has been suggested to me that Baroque music, which offers substantial freedom for improvisation due to its being less prescriptive as regards ornamentation, rhythmic variation, and harmonic realization than music of later periods, may allow a similarly free and joyous expression as that of the jazz practitioners cited. That may be so. But similar is not identical. The constraints within which one improvises in Baroque music, I would argue, are still more present than in mainstream jazz, and the sense of utter liberation thus not quite the same.

such Wagner, Debussy, Strauss, Sibelius, Schoenberg, Berg, Bartók, or Shostakovich.

Counterexamples to the thesis of jazz's expressive specificity argued for here have naturally been proposed. The jazz musicians most often mentioned as producing music that challenges the thesis defended are Charles Mingus, John Coltrane, Bill Evans, Miles Davis, and Archie Shepp. But even if there is some justice to these examples, they do not really undermine the basic thesis, and for several reasons. A first reason is that the thesis need not be understood as claiming the absolute impossibility of expression of HEN emotion in jazz, but only the relative unlikelihood or striking difficulty of such expression, which the small number of putative counterexamples only serves to confirm. A second reason is that some of the examples commonly cited, such as Davis's "Bitches Brew," lie at the border of jazz and non-jazz, issuing from intentionally genre-blurring sorts of music-making, which thus do not so clearly present the jazz *Gestalt* or jazz sound. And a third reason is that the emotional expression achieved in such examples, even when recognizably negative in character, is often not so uncontrovertibly expression of HEN emotion, or at least not with the same intensity as in music, such as that from the classical repertoire, which that does not at the same time convey a feeling of jazz.

But let me consider more closely three counterexamples to my thesis that I have been offered, Charles Mingus's "Fables of Faubus" and "Moanin'" and John Coltrane's "Transition," all of which were claimed to express anger. I agree that all three are clearly jazz, presenting unequivocally a jazz sound or jazz *Gestalt*. However, I'm afraid I don't find any of them to be expressive of HEN emotions.

"Fables of Faubus," a great piece, does not to my ears express anything like anger, though one might be prompted to think that by dwelling on Mingus's stated intention to express his outrage at the reactionary stance adopted by the then governor of Arkansas, Orval Faubus, to the Supreme Court decision to desegregate schools in Little Rock. "Faubus" is basically a very upbeat number, whose main strain has a nice lilting swing, and which even at its most negative expresses no more than melancholy tinged with complaint. "Moanin'," another of Mingus's triumphs, is no doubt furious and intense at many points, but those two descriptors don't by themselves add up to anger. What's expressed at those points, to my ears, is at most excitement and irritation, and the piece as a

whole is, like most jazz, closer to joyous than angry. Coltrane's "Transition" comes nearer to challenging my thesis than Mingus's pieces, mainly in places where it almost stops sounding like jazz, and more like contemporary improvisation of a non-jazz sort. "Transition" is powerful and intense music, but even the high-pitched dissonant squealing riffs in its last third express, I would claim, at best exasperation, and not anger, despair, or grief.

VI. The Expressive Specificity of All Musical Idioms

I would propose also as a general thesis that *all* musical idioms have limits to expressiveness. This goes against a commonplace of ecumenical music commentary and criticism, to the effect that every genre of music, every style of music, can express, albeit in its own way, every emotion, mood, or attitude. No mode of music—even that which has perhaps the widest expressive range, namely classical music—can express the full range of human emotions and moods.

For instance, what can post-classical minimalist music of the sort that Philip Glass and Steve Reich explored so compellingly in their early works express, or even the later extensions of that style by composers such as John Adams? Surely the expressive range of such music is inherently somewhat limited. Rage, anguish, amorous passion, blissful forgetfulness, and so on, would seem beyond its reach. Can rap music express a state of serenity, a sense of resignation, a mood of melancholy, while still sounding like rap? This seems virtually inconceivable. Can shakuhachi music, a Japanese genre centering on the low-pitched, end-blown bamboo flute of that name, express exhilaration, aggression, horror, defiance, or ecstatic abandon? Can Javanese gamelan music express angst or brooding or terror or anger or pessimism? This too seems rather doubtful.

Confining ourselves to Western music, here are some rough, partly comical characterizations, framed using terms for actions, of the basic "feels" of five of its major genres, namely, rock, classical, blues, rap, and jazz. Rock music "shakes, rocks, and rolls," classical music "heaves, sighs, and soars," blues music "moans, groans, and weeps," rap music "thrusts, jabs, and testifies," while jazz music—well, jazz music "smiles, slinks, and

seduces." If there is any truth to those admittedly crude characterizations, which recall the dominant gestural tendencies in those different musical genres, and if as I hold to be the case, the expressiveness of music is closely tied to the kind of human gesture that can be readily heard in it, then it should not be surprising that the expressive range of those musical idioms are each limited, in different ways and to different degrees.

VII. Conclusion: Illustration of Main Thesis through Examples

I suggest that there exist, or can readily be imagined, instances of jazz music that express the unalloyed happiness manifest in the opening of Mendelssohn's "Italian" Symphony, the songful melancholy embodied in the *Allegretto* of Brahms's Third Symphony, the youthful ardor exuded by the *Allegro molto* of Gabriel Fauré's First Violin Sonata, the exuberant wit on evidence in many a work of Francis Poulenc.

But I suggest that there do not exist, or cannot readily be imagined, instances of jazz music that express what can be heard in the opening *Allegro* of Bartók's First Piano Concerto (aggressive savagery), the opening *Largo* of Shostakovich's Eighth String Quartet (unutterable sorrow), the *Marcia funebre* of Beethoven's "Eroica" Symphony (profound grief), the third of Berg's *Three Pieces for Orchestra* (crushing grimness), or Debussy's *Prélude à l'après-midi d'un faune* (fluid bliss).

Conversely, it is not clear that there exist, or can readily be imagined, in the classical idiom, pieces of music expressively comparable to, say, John Coltrane's "Giant Steps," Thelonious Monk's "Ruby, My Dear," Horace Silver's "Song for My Father," Dave Brubeck's "Take Five," Miles Davis's "So What," Bill Evans's "Waltz for Debby," Benny Golson's "Whisper Not," or Ornette Coleman's "Lonely Woman," whose various kinds of blue, hip, cool, funky, and groovy expressiveness seem inseparable from the sort of rhythms, timbres, metric play, motivic elaboration, and atmosphere of improvisation that, among other things, make for the "jazz sound" they all present.

However, there is no cause for regret in any of that. There is, on the contrary, reason to celebrate the wonderful expressive diversity of music as a whole, and to look forward to what as yet uninvented musical idioms may make available to our imaginations in that regard.

A question might be raised in light of what I have said as to whether the *expressive range* of a musical idiom, genre, or style—the breadth or scope of what it can express of the human condition—is a criterion of *musical value*. Indeed, I have just raised that question. But I will postpone its pursuit to another time and place.[4]

References

Brown, L. (1991). "The Theory of Jazz Music: It Don't Mean a Thing . . ." *Journal of Aesthetics and Art Criticism (JAAC)* 49: 115–27.

Brown, L. (2000). "Feeling My Way: Jazz Improvisation and Its Vicissitudes—A Plea for Imperfection." *JAAC* 58: 113–23.

Gioia, T. (1988). *The Imperfect Art: Reflections on Jazz and Modern Culture.* New York: Oxford University Press.

Hodeir, A. (1956). *Jazz: Its Evolution and Essence.* New York: Grove Press.

Levinson, J. (1996). "Musical Expressiveness," in *Pleasures of Aesthetics.* Ithaca, NY: Cornell University Press.

Levinson, J. (2006). "Musical Expressiveness as Hearability-as-Expression," in *Contemplating Art.* Oxford: Oxford University Press.

Russell, J. (1980). "A Circumplex Model of Affect", *Journal of Personality and Social Psychology* 39: 1161–78.

Williams, M. (1987). *Classic Jazz.* Washington DC: Smithsonian Institution.

[4] I thank the several attentive audiences—in Berlin, Paris, Antwerp, Dijon, Granada, Uppsala, and, most of all, Oberlin—whose comments and suggestions have substantially improved this paper.

11

Instrumentation and Improvisation

The notions of instrumentation and of improvisation are at the heart of the phenomenon of music, viewed across cultures and across the ages. Few have done more to illuminate those topics than Philip Alperson. What follows is an appreciative commentary on Alperson's two most recent essays on these subjects, "The Instrumentality of Music"[1] and "A Topography of Improvisation".[2]

1. Reflections on "The Instrumentality of Music"

The idea of the practice of music in the *sociocultural* sense has as its very basis the practice of music in the *activity* sense, that is, the playing, executing, interpreting, rehearsing—and yes, practicing—of music. A primary way to *categorize* music, as Alperson notes, is by the sort of instruments involved, for example steel band music, wind music, keyboard music, gamelan music, big band music. Virtuosity and other *performance virtues* often make essential reference to features of the instrument involved, such as what it does with ease and what it does with difficulty. And instrumentation in symphonic music, usually called *orchestration*, is a primary focus of many nineteenth- and twentieth-century symphonic compositions (37).

[1] *Journal of Aesthetics and Art Criticism (JAAC)* 66 (2008), 37–51. Page references to this essay will be given in parentheses in the text.

[2] *Journal of Aesthetics and Art Criticism (JAAC)* 68 (2010), 273–80. Page references to this essay will be given in parentheses in the text.

There is a commonsense view of musical instruments, but according to Alperson it should be replaced by a more sophisticated view of them, whereby they are seen as "necessarily embodied entities" with an "inescapably immaterial aspect" (38). The most salient elements of the commonsense view are as follows.

First, on a commonsense view musical instruments are devices that performers *use* to make music and that are *designed* for that purpose. This must be immediately qualified, however. For some things that performers use to make music are *not* designed or fabricated, but simply found in nature, such as shells, coconuts, or bones. And some, though designed and fabricated, were not designed *as* music makers, such as sirens, typewriters, or oil drums. Still, in all such cases, Alperson observes, the objects in question are *appropriated for* music-making, are repurposed or reconceived to that end, and so become at least de facto musical instruments.

Second, on a commonsense view musical instruments are *discrete* and *autonomous* objects manipulated by performers so as to produce musical sounds. But this needs even more qualification, according to Alperson, since the distinctness of instrument and performer is in many cases blurred.

The distinctness of performer and instrument is perhaps most clearly challenged in the case of singing, since the singer's instrument—what one usually refers to as her *voice*—is in effect her *body*, or at any rate, that part of her body involved in vocalization. But note how extensive that part is, going beyond the larynx and the lungs, and including the diaphragm, the mouth, the head, and in a sense, the whole torso. Moreover, the more one trains one's voice, the more attention one pays to and the more awareness one has of the contributions of one's body to the production of vocal sounds.

The blurring of instrument and performer is also evident in the case of the guitarist and his fingernails, the clarinetist and his mouth, the trumpeter and his lips, the pianist and his fingers. In such cases we may speak of the "fit" between the performer's body and the performer's instrument, and how this varies in degree from one instrument to another, a performer naturally having the greatest affection for and ease with the particular instrument that fits him best. Alperson sums this up nicely as follows: "Many musicians put the matter clearly when they speak of their instruments as extensions of their bodies" (40).

But the case of singer and voice aside, is it *really* difficult to tell, as Alperson maintains, "where the instrument ends and the rest of the performer's body begins" (40)? I think not. At the end of the gig the saxophonist or trumpeter disassembles his instrument and puts it in its case; he doesn't do this to his body, leaving it free to engage in a variety of other activities, including drinking, eating, gabbing, and, if lucky, lovemaking. Consider also that though a player would not do so lightly, he might lend a beloved instrument to another player, but he would not so readily lend a part of his body—even a relatively unimportant one.

That a non-protoplasmic instrument may form a bond with the protoplasm of its player, that the two might constitute a unified whole when interacting, that during performance each might adapt in subtle ways to the affordances and resistances of the other, that a musician may feel like a part of himself is missing when his instrument is not at hand, doesn't, I submit, finally mean that the performer's body and the performer's instrument are not distinct objects, or that the boundaries between them effectively dissolve.

What Alperson rightly targets, however, can be put another way, one that does not entail boundary dissolution between the performer and the performer's instrument. What happens in those happy cases of success-ful interaction and mutual modification between a performer and an instrument is that a *higher-order*, or perhaps *virtual*, instrument emerges, one consisting in the performer's instrument in the ordinary acceptation plus those parts of the performer's body most directly and intimately involved in the production of sound on the instrument ordinarily under-stood. Thus, for a saxophonist, this virtual instrument is roughly the saxophone plus the saxophonist's mouth and fingers; for a guitarist, the guitar plus the guitarist's arms and fingers; for the organist, the organ plus the organist's fingers and legs. Alternatively, one could think of the virtual instrument as consisting in the instrument ordinarily conceived together with various psychomotor memories, disposition, or routines whose essential reference is to that instrument. And one might then, with some justice, view the music produced in performance as the product of this *virtual* instrument rather than the instrument as ordin-arily understood, and also view the performer, if not quite as *playing* this instrument, at least as *deploying* or *activating* it when performing so as to make music.

The point to stress, I think, is the installation of a kind of *symbiosis* between the performer and the performer's instrument, the emergence of an *integrated system* for producing music in which both are crucially involved. But it is unnecessary to go so far as to say that the performer and the instrument as normally conceived lose their distinctness as objects or have their identities fundamentally altered. And later in his essay Alperson in effect says just that: "The performer's musical instrument is best understood as an amalgam of material object, the performer's body, and bodily dispositions connected to the development of various musical skills" (46).

There is another, deeper challenge to the commonsense idea of musical instruments as simply material objects to which our attention is drawn by Alperson. It is that instruments are necessarily *historicized* objects, ones that carry with them traditional uses, performing customs, and the traces of notable practitioners. "We cannot regard the instruments of music simply as material objects. For as musical instruments they are culturally and conceptually situated objects" (42). That is certainly true, and carries implications for the proper appreciation of the music such instruments produce.

Alperson next notes that there are, in the standard scheme of musical situation, five *poles* of musical activity, namely these: composer, score, work, performer, and audience. On this scheme instruments are normally ranged under the pole of the performer. Yet as Alperson reminds us, instruments are as essential to composers as they are to performers, in the sense of tools with which to compose (42). "Historically, many composers have composed at the piano, trying out at the keyboard various permutations of musical phrases, sections, and so on" (43). And modern computer programs such as *Band in a Box* allow contemporary composers to do that and more, handily making up for the limited auditory imaginations of those who do not have gifts of Mozartean magnitude.

But listeners may *also* be said to have musical instruments, Alperson claims, namely the variety of devices available to bring music in audible form to the listener. These include CD players, MP3 players, headphones, home stereo systems, equalizers, and so on. Even concert halls may be thought of as listener instruments, in that they exert an influence on what is heard once the instruments of performers have done their part.

Still, are listener instruments on a par with performer instruments, or even composer instruments? Aren't the senses of "instrument" involved crucially different, so that assimilating them is more misleading than helpful? Let us take note of some differences. First, listeners' instruments require little or no *training* to operate. Second, listeners' instruments involve little or no *skill* in operating. Third, listeners' instruments have no influence over the music that is *made*, but only over how that music is *perceived*. And fourth, it would be rare for the sort of *symbiosis* noted above that often holds between a performer and a performer instrument to ever establish itself between a listener and a listener instrument. We certainly have little trouble telling, say, where a listener leaves off and where his headphones or his listening room begins.

I recall now a final observation in this essay, one with which I concur completely. It is that appreciating the performance of a musical work has a *twofold* character, having two proper targets: one is the *work* that is performed, and one is the *performing* of the work. The quality of the former is the measure of the *composer's* achievement, while the quality of the latter is the measure of the *performer's* achievement. The two sorts of excellence just invoked are, though related, quite distinct.

2. Reflections on "A Topography of Improvisation"

At the outset of this essay Alperson proposes that we can understand as improvisatory any activity in which "certain of the fundamental features of both the activity and the product of that activity are determined in the very doing of the activity" (273). That is to say, in improvisatory activity what is done is, in important respects, the product of spontaneous and unrehearsed action on that very occasion. Viewed in this light, almost all human action can be seen to have an improvisatory dimension, for we are not robots who simply carry out programs or plans of action that we have set for ourselves at some prior time. If that is so, then the activities we specially mark out as improvisatory must be ones that display spontaneity, unplannedness, and unforeseeability to a substantial or unusual degree. As Alperson notes, such activities are perhaps most evident in the spheres of musical and theatrical performance.

In the course of an interview I participated in on the subject of improvised action for a French social science journal, when asked for my definition of improvisation I came up with something akin to Alperson's proposal. What I said, for starters, was that improvisation was activity where what one will do has not been fixed in advance, or at most, only in broad outline.[3] Of course that's not to say that anticipating or envisaging what one will do prior to engaging in such activity is excluded. It is simply to underline that if one improvises one has not decided in detail what one will do once activity is underway.

Still, I thought, the specificity of *artistic* improvisation is perhaps only captured if one goes a step further. In improvising artistically not only does one *not* decide or fix in advance what in detail one will do, one also decides in advance *not to decide* what in detail one will do. Where musical improvisation is concerned this means that, at least in paradigm cases, there is a sort of prior *commitment* to spontaneous generation of music rather than execution of already existing music. In other words, paradigm cases of musical improvisation involve a kind of Elsterian engagement to *not* fix the course of events in advance. There are, admittedly, non-paradigm cases, where a performer plays in a spontaneous fashion without having antecedently committed himself to so play. But those cases are, I suggest, a minority of those encountered.

The point could be put less contentiously, avoiding the issue of what is paradigmatic and what is not as regards improvisation. So let me do that. Even if musical improvisation per se does not strictly require a prior commitment to spontaneous music-making, as I have conceded, a prior decision on the global level to *not* decide in advance on the local level might be definitive of what it is to create or establish an improvisational musical *situation*.

Concentrating on jazz improvisation, Alperson's main concern, both theoretically and practically, throughout his career, Alperson aptly notes a prime focus of interest for a listener in attending to a jazz improvisation is "the sense of actually witnessing the shaping activity of the improviser . . . of gaining access to the performer's mind at the moment of creation" (274). And more important for the listener than the

[3] "Improvisation: De la philosophie de l'action à l'écoute musicale," *Tracés* 18 (2010), 211–21.

performer's *purely technical skill* as an improviser—what is often referred to as the performer's "chops"—is what Alperson labels the performer's *expressive musical intelligence* (275). Alperson offers a description of what this involves, summarizing it finally as the performer's ability "to hear, conceive, and manage the expressive and aesthetic qualities" of the music produced in the course of improvising, noting some of the specific musical choices or moves the performer might make to effect this.

But though all right as far as it goes, that characterization seems to leave out something important, and prompts me to venture a somewhat different characterization of the expressive intelligence—or perhaps more broadly, musical intelligence—that makes a musical improvisation artistically successful. Of course an improviser strives to imbue his improvisation with expressive properties. But those are largely the upshot of more fundamental objectives a successful improviser must have in view. If the improvisation is successful, different sorts of expression will no doubt emerge, such as wittiness, insouciance, diffidence, bravado, sorrow, joyfulness. But again, those are more often by-products than explicit targets of improvisation.

What an improviser must strive for, first and foremost, is *cogency* in the succession of gestures, motives, riffs, chord sequences, and quotations that constitute his improvisation on the ground level. It is sometimes said that a good improvisation tells a story or presents a narrative, though in musical guise. That may sometimes be true, in some non-trivial sense of story or narrative, but what I mean by *cogency of succession* is more basic than that and covers a much wider range of cases, hopefully all those in which improvisation succeeds. Such cogency is a matter of moving or shifting from one musical gesture to another—for simplicity I will take such *gestures* be the basic building blocks of an improvisation—in a way that listeners find *convincing*, not so much by analogy with the steps of a valid argument, but rather more, by analogy with the transitions in an intelligible monologue or the turns in a coherent conversation. Relatedly, a good improviser has the ability to come up with music that is unpredictable in advance, yet strikes one as almost inevitable after the fact. This may be another way to capture what I mean by the *cogency* with which a successful improvisation unfolds.

At a few points in this essay Alperson touches on what one might consider the *ethical* dimension of improvisation. This dimension is

particularly marked in improvisation, even if there is an ethical dimension to virtually all artistic activity. The general principle which applies manifestly in the case of musical improvisation is that everything, artistic or non-artistic, should be appreciated for what it is, and not, or not only, for what it may seem to be, even to the point of indiscernibility. The fact is that we as human beings set store by truthful dealings and interactions, in and out of art. Thus an improvisation must be appreciated as such, that is, a singular and unique production of a sequence of sounds that has not been premeditated or ordained in advance, but instead conceived and realized on the spot, here and now, a sequence of sounds that is not the instantiation or representation of some more abstract and already existing musical entity.

As Alperson and many others have helpfully brought out, if someone listens to music that he believes to be improvised, he attends to it, reacts to it, judges it, and evaluates it differently than he would a sonically identical stretch of music that he believes to be rather the interpretation of an already existing composition. For instance, he will have different expectations for the character of the music heard and for its likely evolution, he will be more tolerant of errors of intonation or fingering, he will estimate differently the nature and degree of the accomplishment manifested by the performance.

Now one might be tempted to say that it doesn't matter if a perceivable phenomenon—whether, gesture, movement, discourse, or solo—has been reflected, planned, rehearsed, prepared in advance, so long as it does not *appear* to be so. But to accede to this temptation would be a mistake, because the truth or falsity of our engagements with the world counts, and that includes our engagements with artistic phenomena. Audiences have the right to know exactly what they are dealing with faced with an artistic presentation, as much in the artistic sphere as in that of everyday life. Whence the distress or dismay if one has been deceived as to the fundamental character or status of what one has been presented with and which one is striving to arrive at a proper appreciation of. This is not to say, of course, that an artistic presentation cannot include feints, ruses, disguises, multiple layers of fiction, games of make-believe, *trompe l'œil* effects, and so on. It is only to say that a presentation's basic nature or fundamental category—for instance, fiction or non-fiction, installation or workspace, painting or calligraphy, piano étude or composition for player piano—should be correctly

grasped by the spectator. And this goes, of course, for musical *improvisation* versus musical *execution* of a preexisting composition, the contrast that concerns us here.

Towards the end of Alperson's discussion of the sorts of improvisatory skills displayed by improvising jazz musicians he mentions those he labels *interactive* skills, ones involved in "reacting on the spot to what is happening in an ensemble" (277). This prompts me to some observations on the salient differences between solo improvisation and group improvisation, whether of the wholly free variety or the rather more common sort in which a melody and a set of changes provide a common basis for improvisation.

In the case of group improvisation, certain features are present which are absent in the case of solo improvisation: first, the possibility, even the inevitability, of *interaction* among players, where what one player does musically is normally both a response to what another player has done, and a spur to what another player will do; second, a significantly reduced *degree of control* over the evolution of things compared to the degree of control had when improvising solo; and third, a more pronounced *unpredictability* as to the unfolding of events, in large part the consequence of the just-noted reduced control over that unfolding.

The upshot of these features is that in the course of group improvisation one likely digs more deeply into one's resources of musical invention and adaptation, because of the necessity to detect and respond fittingly and with suppleness to the fugitive signs, aims, and intentions of one's fellow players. (Of course, in another way, this is not true. Solo improvising, especially of any extent, is more demanding than group improvising in that it is "all on you" to keep things going and to sustain a listener's interest. It is also harder in that you don't have the spur and stimulation of reacting to what others are doing, no possibility of feeding off or piggybacking on the musical directions that your fellow players have opened up.) In group improvisation one must to an extent bend oneself to the general will, while guarding in some measure one's own proper trajectory and artistic personality. One notable way that jazz musicians have of assuring some degree of unforeseeability in the proceedings and effectively precluding prior rehearsal is the custom of "calling tunes," whereby it is up to each player in turn to propose the standard that will serve the group as a support for their next collective improvisation.

3. A Connection Between Instrumentation and Improvisation

There are at least two directions in which one might look for a connection between instrumentation and improvisation. On the one hand, one might look to the instrumentality of improvisation, that is, the *uses* to which improvisation may be put and the values that may be realized through it. Most of what I have said so far falls, at least loosely, under that rubric. On the other hand, one might look to the improvisation of instrumentality, that is, the extent to which instrumentation falls within the *scope* of improvising, something one can in effect improvise on or with. It is that idea that I will develop in closing.

A good example of the improvisation of instrumentation is the sequence of solos in a jazz combo version of a standard. Unlike, say, Ravel's *Bolero*, a classical composition in which the succession of instrumental gestures and timbres in successive statements of the unvarying theme is not only entirely planned, but almost the whole focus of attention, the succession of instrumental gestures and timbres in the sequence of jazz solos is not fixed in advance and can be somewhat unpredictable. Such a sequence in effect constitutes a kind of "spontaneous orchestration" of the piece of jazz music that comes into being in the very act of playing. This phenomenon is even more pronounced in the quick succession of instruments and associated timbres involved in the phase of "trading fours" that often crowns a given jazz combo treatment of a standard. Furthermore, improvisation, in the sense of choosing actions on the fly, can even be present with regard to instrumentation on an individual level. Think of the triple-threat wind player, who decides on the spot which of his three "axes" to take up for a solo— say, alto sax, clarinet, or flute. He too is improvising on or with instrumentation. And the same for a trumpeter or trombonist who decides to play with or without mute, for all or part of a solo.

It is true, as Alperson observes in the second of the two papers examined here, that there are informal protocols about the order of solos in a group outing on a standard. For instance, that after the statement of the head horn solos come first, followed by solos of other instrumentalists, with a drum solo coming last, if at all. But such protocols operate largely as defaults, I suggest, and can be freely departed from, often with refreshing results on a given occasion. In my

experience of such outings, mostly recorded ones but not a few live ones, the number and placement of the pianist's solos, especially, is highly variable, often coming first or last, or both first and last, or somewhere in the middle. Such flexibility of format is one of the earmarks of jazz, and a key to part of its charm.

12

What Is a Temporal Art?

with Philip Alperson

I

In an interview aired on National Public Radio, novelist Margaret Atwood discussed the problem of adapting her novel, *The Handmaid's Tale*, to the film screen. One of the great difficulties of transforming a novel into a film, Atwood observed, is that novels have what she called "stretchy time." Films, she said, have what she called "set time." This temporal difference was significant enough, Atwood told her interviewer, that she became quite nervous about writing the screenplay for her novel and, in the end, entrusted the task to Harold Pinter.[1]

It is a common critical observation about the various arts, at a fairly general level, that some of them are temporal arts, and some are not, or that some arts are more purely temporal than others. Lessing, for example, is well known for his argument that painting is a spatial art, best suited for the imitation of visible objects whose parts coexist in space, whereas poetry is an art of time more adept at narrative presentations of action.[2] Music is usually given pride of place as the most purely temporal art (especially by musicians), as for example, in Zuckerkandl's claim that music is "the temporal art *par excellence*"[3] or Nattiez's comment, "La musique, elle, est fondamentalement art du temps. Comment

[1] "Morning Edition," National Public Radio, March 5, 1990.
[2] Gotthold Lessing, *Laocaön: An Essay on the Limits of Painting and Poetry*, trans. E. A. McCormick (Indianapolis: Bobbs-Merrill, 1962). See especially chs. 16 and 20.
[3] Victor Zuckerkandl, *Sound and Symbol* (Princeton: Princeton UP, 1956), 151.

alors réussir à lui conférer une transcendance intemporelle?"[4] But the honor (if such it be) has also been accorded to other arts, as in Gerald Mast's suggestion that "the cinema is the truest time-art of all, since it most closely parallels the operation of time itself."[5]

On the surface, critical claims such as these would seem to involve a relatively straightforward distinction. A temporal art is presumably one that involves or concerns time in some obvious way. The phrase "the time arts" is sometimes used, in fact, as a variant label for the category in question. But what is it for an art form to involve or concern, or even require, time? This is already disturbingly vague, for if taken sufficiently, though not outlandishly, broadly it appears capable of encompassing all the arts; activities and experiences are crucial to appreciation in all the arts; activities and experiences possess, as does any segment of life, temporal duration; thus, all arts are temporal arts. Evidently, this would be to give up without even a conceptual tussle the distinction that is intended to be marked by the pair "temporal/non-temporal."

Apart from the intrinsic interest of ferreting out plausible senses of this distinction, there is an additional justification for doing so. Often, when the notion of temporal arts is invoked, the thinker goes on either to offer a further generalization about the temporal arts ("All the temporal arts display the following features . . ."), or else to make some evaluative or normative claim regarding the temporal arts ("Their fundamental value lies in the following . . ."). It will be impossible, manifestly, to tell what is being asserted, much less gauge its validity, if we do not know what senses may conceivably be assigned to the phrase "temporal art" and which arts are therefore comprised in its ambit.

Consider, as an example, one specific normative claim often advanced about the arts: the ideal of medium-specificity. This is the idea, associated particularly with Lessing in the eighteenth century and with Clement Greenberg in the twentieth, that each art should pursue or exploit its own specific nature most vigorously, or even exclusively. Evidently, insofar as temporality turns out to be central to the nature of a number of arts, it will be necessary to be clear as to the differing "temporal

[4] "Music is fundamentally a temporal art. How, then, can we ascribe to it transcendence of the temporal?" J. J. Nattiez, "Gould singulier: structure et atemporalité dans la pensee gouldienne," in *Glenn Gould Pluriel*, ed. G. Guertin (Quebec: Louise Courteau, 1988), 61.

[5] Gerald Mast, *Film/Cinema/Movie* (New York: Harper, 1977), 112.

natures" they possess, if we are fairly to assess a normative ideal such as medium-specificity.

Our goal in this chapter is to fix the main aesthetically significant senses in which one might say of an art that it is "a temporal art." First, we propose a set of specific criteria to which such an attribution might appeal, either implicitly or explicitly. Second, we review these specific criteria and gather them up into three groups, yielding those which refer primarily to temporal characteristics of art objects, those which bear upon the temporality of the experience of art objects, and those which pertain to reference to temporality by works of art. In so doing, we hope to present a reasonably complete taxonomy of such ascriptions. Third, we briefly consider some further questions about the adequacy and interest of the distinctions we have outlined.

II

We shall take it that an art (or art form) is to be described as temporal if, and only if, its standard or paradigm objects display some distinctive characteristic—possibly relational, and possibly involving the mode of experience at which they aim. To put this even more neutrally, we shall assume that we can at least frame the question of an art form's possession or lack of temporality in terms of some condition on the standard or paradigm objects of the art form. (Thus, the fact that avant-garde or self-consciously experimental instances of the art might not meet the condition would not count against its adequacy as a characterization of the art form's temporal status.) What we are after, of course, are construals of "temporal art" that count some of our familiar arts as temporal and some as not, that make for interesting groupings among these familiar arts, and that permit "temporal art" to have application to art forms which do not currently exist, but which are theoretically possible. In line with our effort to make sense of familiar intuitions about the arts, we shall construe the artistic object as a physically embodied entity or historically tethered type, rather than as an "ideal object" in the manner of Croce or Colling-wood. We shall also hold as a background condition of adequacy the intuition that certain existing art forms (e.g. music) must end up counting as temporal, and others (e.g. painting) as non-temporal, on any acceptable construal.

We now proceed to consider several time-related characteristics of the arts which might count as conditions by appeal to which we could

plausibly characterize an art (or paradigm instances of works of the art) as "temporal."

(1) *Objects of the art form require time for their proper aesthetic appreciation or comprehension.* This, the notion that engagement with an artwork takes time, is certainly an obvious enough idea. But its defect is equally obvious: it would appear to cover almost any conceivable art since most, if not all, artistic experiences are durational. This temporal aspect is therefore not likely to be what anyone has in mind in thinking of the temporal arts as a special group. The imaginable exceptions to this condition would be avant-garde forms of visual art designed and projected ideally for instantaneous reaction or absorption. One is reminded of Vlaminck's desire for an art which could be fully comprehended from the window of a speeding automobile or of Noland's determination to produce "one-shot paintings, perceptible at a single glance."

(2) *Objects of the art form require a significant interval of time for the mere perception or apprehension of their full extent.* This is a notion that covers music, dance, film, novel, murals, architecture, sculpture, drama, epic poems, kinetic sculpture—but not haiku, easel paintings, small facades or reliefs. By "apprehension of their full extent" we mean here a fairly minimal perceptual sort of experience, rather than something like adequate artistic comprehension or understanding—which might take quite a while even for the tersest haiku.

(3) *Objects of the art form require time in presentation, that is, they require performance or exposition of some sort over an interval of time; the parts of the artwork are not all available at any one moment, but only consecutively.* Here is a notion which comprises music, dance, film, kinetic sculpture, spoken poetry—but not novels or written poetry or murals. It is roughly this meaning of "temporal art" that Susan Sontag is invoking when she argues that "both cinema and theatre are temporal arts. Like music (and unlike painting), everything is not present all at once."[6]

(4) *Objects of the art form consist of elements or parts arranged in a linear order, with definite direction from first to last.* Strictly speaking, the quality of linear order with definite direction from first to last is what

[6] Susan Sontag, "Theatre and Film," *Styles of Radical Will* (New York: Farrar, Straus and Giroux, 1966); repr. in Gerald Mast and Marshall Cohen (eds.), *Film Theory and Criticism* (3rd edn, New York: Oxford University Press, 1985), 354.

we normally describe as "sequentiality," and sequences (such as the series of positive integers) are not necessarily temporal. Linear order and unidirectionality are, however, so closely associated with the notion of time that we may well think of sequentiality as a temporal condition. On this conception of temporality, music, dance, drama, novel, poem, film, and certain indoor "installations" count as temporal, but not painting, sculpture, architecture, kinetic sculpture, or mural—though in these last cases there may be something analogous, but weaker: a suggested direction of appreciative movement.

(5) *Objects of the art form are properly experienced in the order in which their elements are determinately arranged, and at a rate defined by, or inherent in, the artwork itself or its prescribed mode of presentation or performance.* In other words, the order and pace of an audience's experience is fixed by the manner in which the work is made available for appreciation. The parts of a Beethoven sonata, for instance, are made available only successively in a performance, at tempi broadly inherent in the sonata as composed—though narrowly determined by the pianist on a given occasion. The events of a play are enacted on stage in a definite order, without repetition, and at a pace determined collectively by the director and the actors. Something similar could be said for the role of dancers' and choreographer's choices in fixing what an audience will behold at each point. This conception would seem roughly to pick out what are called the "performing arts," with the understanding that film must also be included, given the way in which the sequentiality and fixed speed of projection of film wholly constrain what viewers will see and when they will see it.

Thus, music, dance, drama, and film fall under this conception, but not novel or poetry: there the reader properly, and as intended, controls pace and the possibility of immediate re-experiencing (rereading) and back-referencing (flipping back), as he or she judges appropriate or useful. A similar claim would apply to murals.

It is worth remarking how the advent of VCRs and CD players, which enable the experiential prescription inherent in the musical or cinematic object and its intended mode of presentation to be sidestepped or virtually neutralized, is clouding this difference in practice, and even threatening to obscure the conceptual point.[7] At any rate, this feature

[7] Gerald Mast's discussion of this matter is tonic: "[a film's] experience is exactly as long as it is, and no one . . . can tamper with its ceaseless flow once it has begun . . . the cinematic

of temporal control by the artwork over the structure of the experience of appreciation or apprehension itself, with regard to the order and rate of presentation of its elements, is not entailed merely by the sequentiality of a work's elements, as shown by the example of novels and poems.

Thus, there is a fundamental distinction here between music and film, on the one hand, and literature, on the other. Yet one might have doubts, for something like the control over the pace of absorption of the successive elements of the work which is inherent in music and film may be at least approached in certain forms of experimental poetry. Nicole Broissard, a Quebecoise writer, claims to have crafted the poems in her book *Picture Theory* in such fashion that the reader's speed of reading, traditionally a matter of individual decision, is effectively manipulated and constrained by the text's inherent structure. And even traditional poetry has always had at its disposal numerous resources and techniques for influencing the tempo at which a reader progresses through a text, for example enjambment, caesura, line length, syncopation, clustering of consonants.

Still, there is a difference between the kind of control exerted by a prearranged sequence of shots projected at an invariable rate and that exerted by an arrangement of words spread out over several pages which guides a receptive eye and hand without coercing them. Perhaps we would do better to speak, not of degrees of control, but of *determination* (in the case of music and film) as opposed to *direction* (in the case of literature), of the order and pace of an appreciator's experience.

(6) *Objects of the art form are such that non-temporally extended parts of the object do not count as aesthetically significant units of it. That is to say, such parts are not isolatable for study in a way that contributes significantly to the full experience of the object.* For example, the individual frames of a film, even if not detectable as such in normal viewing, are components of a film in a way in which instantaneous slices of sound are not components of a musical work. "Freeze-frame" is possible in viewing a film, but there is no such thing as "freeze-moment"

work moves ceaselessly forward. Cinema fugit. The apparent exceptions truly prove this rule. One is the possibility of studying a film, viewing it alone—stopping, starting, reversing, slowing, speeding it, as the kind of study demands. But studying a film is not experiencing it as was intended; it is a dissection which, at best, reveals how and why it is experienced" (*Film/Cinema/Movie*, 112).

in auditing a piece of music; "freezing" (e.g., pushing the "Pause" button of one's CD player) gives you nothing, rather than some smallest quasi-perceptual unit. A temporal cross-section, an instant, of a film—but not a piece of music—has some intrinsic interest, is part of the aesthetic object from the point of view of analysis, and can be related to the film as experienced in proper time. What this points to is that music is an unbreakable temporal process, and that its essence lies in relationships of elements which are intrinsically almost formless (e.g. single notes, chords) to a greater degree than in film.[8]

(7) *Objects of the art form are about time, or our experience thereof, in some significant way.* Music, dance, novel, film all figure here—but also some paintings, such as Renaissance allegories of Time, Futurist pictures by Balla and Severini, Dalí's *Persistence of Memory* with its melting pocket watches, or Peter Blume's *The Eternal City* which depicts a devastated Rome in the wake of Mussolini's fall.[9] Some would claim that certain examples of postmodern architecture (much of the work of Michael Graves, for example) are also about time insofar as they seek by means of architectural "quotations" to allude to the architecture and symbolic meanings of the past as well as to the relationship between architecture and the passage of time.

A noteworthy subcategory of works which refer to time would be works that are about time in the sense that they project, sometimes surprisingly, a sense of *timelessness*. A good example might be Schubert's String Quintet in C, whose slow movement conveys to a listener a sense of utter suspension, at least in a good performance. Paradoxically, in such a case the essential temporality of music is highlighted by contrast. Something similar might be said of certain peculiarly temporal films as Michael Snow's minimalist *Wavelength*. This film, in which an ostensibly static view of the walls of a room is progressively transformed, succeeds, in opposition to the usual invisibly edited Hollywood

[8] Relatedly, serialization—some tonight, some tomorrow night, and the rest next week—makes some sense with novel or film, but (typically) much less with music: you would not give one movement tonight and the next tomorrow night, or (even more clearly) the exposition and development of a sonata movement tonight, and the recap and coda tomorrow. Wagner's *Ring* Cycle might initially appear to be something of a counterexample, but the fact that it is a *theatrical* (and not just musical) work, and consists of four relatively *independent* operas, obviously puts it in another class altogether.

[9] Both these latter pictures are in the Museum of Modern Art, New York, which one of us frequented much as a teenager.

narrative, in foregrounding processes of duration and perception through time.

(8) *Objects of the art form use time as a material, or as an important structural feature.* Obviously, music and dance come to mind here, then (arguably) novel, drama, film—but less plausibly sculpture, architecture, painting. Again, it is true that any art could be said to use time as a material in the weak sense that duration seems to be an essential condition of experience generally. It is also true that certain works of architecture, painting, and sculpture sometimes seem to approach the use of time as material, especially in the case of works of extraordinary size and scale (the cathedrals of Notre-Dame and Chartres, the ceiling of the Sistine Chapel, the Statue of Liberty) where some claim might be made in virtue of the durational and sequential aspects of the experience of the work. But the point here is rather that certain arts typically play with time, so to speak, or manipulate it, and that such play or manipulation is central to the aesthetic interest of objects of the art.

(9) *Objects of the art form generate a kind of time that is peculiar to them, that exists for a perceiver only in and through experience of the work.* The most plausible candidates here are music and film. Claims of this sort have been advanced by Langer and Zuckerkandl for music, and by Balázs and Morrissette for film. Langer, for example, writes, "All music creates an order of virtual time, in which its sonorous forms move in relation to each other—always and only to each other, for nothing else exists there ... Music makes time audible, and its form and continuity sensible."[10]

(10) *Objects of the art form represent a series of events in time distinct from the series of events constituting the art object.* This is a distinct potential of novel and film, and to a lesser extent, of theatre, but only faintly realizable in, say, music, dance, or kinetic sculpture. Novel and film are temporal in a sense difficult if not impossible for music, unassisted dance, and kinetic sculpture, insofar as they can explore temporal relations *representationally.* They can represent a series of events having their proper temporal relations within themselves, while presenting those events in a manner not necessarily paralleling, or conforming to, that internal order.

[10] Susanne K. Langer, *Feeling and Form* (New York: Scribner's, 1953), 109–10.

Drama can also do this, but not with the freedom and flexibility of narrational forms. In a narrative art such as novel or film, we are often confronted with two series: one, the series of presentational events comprising the filmic or literary narration, and two, the series of fictional events which we reconstruct, or posit, on the basis of that. Although in conventional narrative there is usually little obvious discrepancy between these series, in more adventurous narrative efforts (e.g. those of Proust, Kundera, Robbe-Grillet, Welles, Resnais) their distinctness and independence can become foregrounded, sometimes shockingly so. Since the result of this foregrounding is invariably to induce reflection on the nature of time, memory, and the process of living—or perhaps constructing—a life, such art can be considered temporal in a more special and potent sense than most others we have invoked. In any case, this power to explore temporality representationally is doubtless what critics and theorists often have in mind when they regard novel and film as quintessential "time" arts.[11] It is true that certain musical techniques point in the direction of such capacity (Wagner's use of leitmotifs, the *idée fixe* intended to denote images of the Beloved in Berlioz's *Symphonie fantastique*), but they fall far short of enabling depiction of a series of events and their internal relations.

(11) *Objects of the art form are created in the act of presentation, so that the time of creation, time of presentation, and (usually) time of reception all coincide.* We can distinguish an artistic object's "time of creation" (the extent of time of the artist's conception and production of the object), the object's "time of presentation" (the extent of time during which the object is made available for direct apprehension by its appreciators), and the "time of reception" of an object (the extent of time during which the object is actually apprehended by its appreciators). Leonardo's *Mona Lisa* was created over a four-year period (probably from 1503 through 1507), which was its time of creation in the specified sense. Its times of presentation and reception probably coincide, ranging from roughly 1507 to the present. In painting, as in most art forms, time of creation clearly precedes times of presentation and reception.

[11] One might, within this rubric, take it to be a mark of even greater "temporality," if the representation *of* temporal relations in the art form was standardly achieved *by* temporal—as opposed to other (e.g. spatial, grammatical) relations or features—in the artworks themselves. Film and drama would thus score higher, by these lights, than novel or mural.

In the case of certain arts, however, the time of creation coincides with the time of presentation, and often the time of reception as well. Manifestly, we have to do here with the category of *improvisational* performing art, for example jazz or some modern dance. One of the chief sources of delight in the case of improvised art is clearly the appreciation of the-artwork-in-the-process-of-being-produced. When we listen to an improvised piece of music, for example, we accept as a matter of course all sorts of musical sounds and effects which, in the usual listening situation, where time of composition and time of performance are entirely disjoint, we would regard as mistakes. We are more forgiving in the case of improvised music in part because we understand that the times of composition and performance have been collapsed, with revision being an option only for future trials. We attend to a different set of qualities because we are apprehending a specific sort of aesthetic object generated by a distinctive sort of human activity: we appreciate the work as the production-of-the-object-in-time in relatively spontaneous creation.[12] The temporality of improvisational performing art, then, as opposed to that of its non-improvisational analogues, thus deserves special notice.

(12) *Objects of the art form require presentation in a time lived through and by the presenters.* What this aims to capture is the role of performers in even notated, non-improvised music, in contrast to that of projector (or even projectionist) in film. Our primary access to the object (e.g., a musical composition) is through an instance produced by living performers then and there, as we experience it. This distinction might be loosely glossed as that between "live" and "canned" time in an art object or its presentation. Recordings of "live" performances are interesting, in part, because they on the one hand preserve, but on the other hand, negate or belie, the temporality of the music in the sense in question.

(13) *Objects of the art form lack relatively fixed identities over time, but are rather mutable and shifting.* This distinguishes certain folk arts with oral traditions of transmission—for example Norse sagas, or the Wayang Kulit shadow puppet plays of Java—from typical Western high art forms, especially those whose masterworks are thought to comprise a canon.

[12] See Philip Alperson, "On Musical Improvisation," *Journal of Aesthetics and Art Criticism* 43, no. 1 (Fall 1984), 17–29.

III

If we step back for a moment, and consider the thirteen criteria or conceptions of "temporal art" we have come up with, they can be seen to fall roughly into three broad groups, which we may label "object-based," "experience-based," and "content-based." Although all the criteria were uniformly formulated as conditions on the (standard or paradigm) objects of the art form, they are not all "object-based" in the sense we are now invoking. An *object-based* criterion of temporality is one which asks for duration, temporal extent, successiveness, or changeability over time, primarily in the objects of the art themselves (or in their form of presentation). An *experience-based* criterion demands rather that the characteristic experience or central way of interacting with the art object possess some non-trivial duration, temporal extent, or imposed linear order. And a *content-based* criterion, finally, is one which locates temporality primarily in an artwork's referential or representational relation to time or temporal process. With a certain amount of squeezing, criteria (3), (4), (6), (11), (12), and (13) can be ranged in the object-based drawer, criteria (1), (2), (5), and (9) in the experienced-based one, and criteria (7), (8), and (10) in the content-based one.

The object–experience–content trichotomy is important because it corresponds to three obvious foci of attention in artistic practice. At the same time, we should note how closely interrelated these three wider categorizations are. Consider, for example, the relationship between features of the artistic object and features of the artistic experience. To the extent that artistic experience is experience of an artistic object, we can expect a strong parallelism of features between artistic objects and the experiences thereof. This was already implied in our previous discussion of VCR and CD technology, where we spoke of the experiential prescription inherent in the art object.

Similarly, when we distinguish between artistic experiences which are temporal in the sense that they are normatively sequential and those experiences which are both sequential and determinate with respect to tempo or rate, we can apply the same distinction with respect to artistic objects. A novel, at least insofar as we consider it to be a structure of words or sentences, might be considered inherently sequential but indeterminate with respect to tempo, whereas a piece of music in performance is both sequential and determinate with respect to tempo. Tempo is

both an "experience-based" attribute as well as something that can be predicated of the object, as is the case when the tempo of a musical piece is specified by a metronome marking.[13] In a similar vein, the claim that, from an experiential point of view, we can distinguish between the epic poem and the haiku on the grounds that the former requires a greater interval of time for the mere perception or apprehension of its full extent, depends upon certain (quite reasonable) assumptions about the time of presentation of the respective art objects: the time of the mere perception of haikus is shorter because haikus themselves are shorter. Or, to move to a different pair of categories, to say that an art's temporality may be "content-based" insofar as time may be used as an artistic material is very close to identifying an object-based characteristic.

These reflections suggest the possibility of one further proposal, broader in scope, perhaps, than any of the preceding [leaving (1) aside]:

(14) *Objects of the art form are such that their proper appreciation centrally involves understanding of temporal relations within them.*[14] This proposal clearly straddles the "experience-based" and "content-based" classifications, and may cover most of the narrower criteria of greatest interest formulated earlier. It is possible that when an art form is described as "temporal," without any further specification of what is meant, then this proposal, with its built-in relevance to criticism, provides the best overall default construal.

Having formulated a number of individual conditions in an attempt to cover all that might conceivably be meant in predicating temporality of an art form, we should at this point acknowledge the likelihood that a fair number of critical observations involving temporality may not conform exactly to any of our conditions, either singly or conjunctively.

[13] Actually, the situation is further complicated by a distinction one might wish to draw between musical *objects* and musical *works*. If, for example, we construe the musical *work* as some sort of type which can be instantiated in particular performances which are understood as particular musical *objects*, then given the vagaries of notation and performance practice, the musical work—in comparison, say, with a cinematic work—would seem to be only *relatively* determinate with respect to tempo. For more on musical works vis-à-vis performances, see Jerrold Levinson, "What A Musical Work Is" and "Evaluating Musical Performance," both in *Music, Art, and Metaphysics* (Ithaca, NY: Cornell UP, 1990).

[14] Note that this formulation cannot read merely "involves understanding temporal relations" *tout court*, since all artworks require to be placed in their historical relation to previous works if they are to be properly appreciated. Thus, the relevant mark here is internal, as opposed to external, temporal relations.

Workable critical vocabulary might easily cut across, to some extent, the senses we have clinically laid out. The example with which we opened our essay is instructive, perhaps cautionary, in this regard. It turns out that when Margaret Atwood spoke of the difference between the "stretchy time" of a novel and the "set time" of a movie, she had three points in mind. First, the novel can represent a character's evolving thoughts; it is more difficult to portray an interior monologue on the screen. Voice-overs can be used in film, but they can quickly make the film seem artificial or precious. It is possible to show a disparity between the character's words and actions and his or her facial expressions, but this can at most suggest what a character is thinking. Second, the reader has some control over the sequence of events and descriptions in the novel, insofar as he or she has the freedom to reread sections or even jump ahead, whereas the sequence of events and portrayals on the screen is controlled by the filmmaker(s). And third, the reader determines the amount of time spent in reading the work, by which Atwood appears to mean, not that the amount of time spent in reading a novel or a section of it is in itself of great aesthetic importance, but rather that the reader has the freedom to speed up or slow the rate at which he or she reads or dwells upon this or that passage or section. The amount of time spent watching a film is fixed by the filmmakers (assuming that the film does not break, that the projector runs to speed, that the audience does not fall asleep, and so on).[15]

The terms "stretchy time" and "set time" as Atwood uses them, then, are multifaceted, ranging over several of the categories we have been delineating, functioning in this way like Langer's term "virtual time." The terms have a conceptual integrity in themselves and are certainly aesthetically relevant to the question of the temporality of The Handmaid's Tale in book and film form, respectively. Atwood tells her interviewer that she was anxious about writing the screenplay for her novel because the overall effect of the difference between "stretchy time" and "set time" is to make films more strictly narrative (and therefore constraining) than novels. In reading The Handmaid's Tale, with its dark narrative twistings and turnings, its stories and reconstructed stories, one can well understand her nervousness about the difference. We therefore must

[15] That is, the period of time *normative* for viewing the film is fixed by the filmmakers in making it.

allow that there may be an indefinitely large number of artistically relevant temporal descriptions, each important in its own way, but we suspect that most of the content of such descriptions would be articulable in the context of the taxonomy presented above. Still, the articulation between such descriptions as they occur "in the field," and the senses we have explicitly delineated, may often be rather rough.

IV

Might there, finally, be any point in trying to decide which art form is the "most" temporal of all? One could, of course, determine which art counts as temporal by the greatest number of criteria and award the title—Oscar-style—to the candidate with the largest number of votes. But the purpose of such an exercise seems obscure outside of a context in which the ascription of temporality acquires some positive value.

Such a context might be supplied, however, by a global theory of art in which the temporality of an art would figure prominently. If one held to an imitation theory of art, for example, one might claim (in the manner of Lessing) that some arts (such as poetry) might, in virtue of certain of their temporal features, be better (or best) suited to narration and representation of, say, human action. On the other hand, there is also a historically important line of expression theorists extending from Schopenhauer and Hegel through Susanne Langer, each of whom places one art—music—at a strategic point in his or her theory on the basis of a specifically temporal feature of music. The reason for this is that they have been convinced by the Kantian claim that time, as the form of inner sense, is intimately bound up with the very idea of consciousness and they believe that music has an unusually strong referential relationship to time or time-consciousness, either as a copy or objectification of the movements of the human (and cosmic) will(s) (Schopenhauer), as the most adequate nonspatial sensuous presentation of the inner life (Hegel), or as an illusion begotten by sounds of psychological time (Langer). The general form of their arguments is something like this:

(a) Identify some temporal aspect of music as the core of musical experience or significance.
(b) Argue that no other art exhibits this temporal feature as purely or prominently as music.
(c) Argue that this aspect of temporality is intimately associated with consciousness.

(d) Argue that music, the most temporal of the arts, is therefore best suited to the expression of consciousness.

(e) Advance an expression theory of art.

(f) Conclude that music, in virtue of its being the most temporal of the arts, is the purest or highest form of art.

If one were to buy into this sort of argument, one would have identified a very important reason indeed for settling which of the arts is the "most temporal." We are far from personally recommending the argument, but it is certainly one which has been influential in the history of aesthetics.

Another approach to the question of the "most" temporal art would be to review our conditions and decide which of them are really the most crucial or aesthetically *significant*. This would be to allow that being temporal in some senses was more weighty than being temporal in others. Thus, we might venture that (3), (5), (7), (8), (10), and (11) define more distinctive, central, and critically noted modes of temporalness than the others, and thus that art forms satisfying the former, rather than the latter, criteria are in a way more properly qualified as "temporal." But this suggestion must await fuller development at another time.

Index

Adair, Tom 125
Adams, John 141
Adderly, Cannonball 139
Adorno, Theodor 44
Allen, Woody 46
Alperson, Philip 5, 144–54, 164 n. 12
Aristotle 90, 116
Arlen, Harold 4, 122
Atwood, Margaret 155, 167
Austen, Jane 46

Babbitt, Milton 121
Bach, Johann Sebastian 10, 42, 60, 61, 63, 65
Baker, Chet 126 n. 13
Balazs, Béla 162
Balla, Giacomo 161
Barber, Samuel 61, 138
Bartók, Béla 61, 64, 65, 142
Baudelaire, Charles 63
Beardsley, Monroe 20 n. 5
Beethoven, Ludwig van 10, 12, 13, 15, 42, 46, 47, 60, 61, 64, 65, 78, 138, 142
Bencivenga, Ermanno 59 n. 1
Benjamin, William 78
Bentyne, Cheryl 112
Berg, Alban 61, 64, 65, 142
Berkeley, George 16
Berlioz, Hector 163
Bernstein, Leonard 8, 22
Bicknell, Jeanette 80, 82, 83, 100 n. 2
Bigand, Emmanuel 23 n. 11, 41 n. 12, 42 n. 16, 70, 75
Blume, Peter 161
Boccherini, Luigi 61
Booth, Wayne 117 n. 2
Borges, Jorge Luis 46
Boulez, Pierre 121
Brahms, Johannes 44, 46, 60, 61, 64, 65, 142
Brinkman, Aleck 42 n. 14
Broissard, Nicole 160
Brown, Lee 132, 133
Brubeck, Dave 142

Bruch, Max 70
Bruckner, Anton 55
Budd, Malcolm 23n. 12–13, 26 n. 18, 77
Burke, Johnny 126
Busoni, Ferruccio 70

Caccini, Giulio 79
Cage, John 9 n. 2, 14, 15
Chopin, Frédéric 45, 48–50, 59, 64, 134
Cohen, Leonard 121 n. 6
Coleman, Ornette 132, 138, 139, 142
Collingwood, R. G. 157
Coltrane, John 104, 137 n. 2, 138, 139, 140–1, 142
Cook, Nicholas 42 n. 13
Copland, Aaron 22
Croce, Benedetto 157
Currie, Gregory 46

Dalí, Salvador 161
Danto, Arthur 19, 46
Davies, David 52 n. 7
Davies, Stephen 18 n. 2, 23n. 12–13, 26 n. 18, 74, 97 n. 5
Davis, Miles 140, 142
Debussy, Claude 60, 63, 65, 142
De Falla, Manuel 61, 64
Dehmel, Richard 98
De Kooning, Willem 55
Dennis, Matt 125
Deonna, Julian 94 n. 4
De Paul, Gene 123
Descartes, René 10
Dodd, Julian 52 n. 6
Dvořák, Antonín 116

Eldridge, Richard 21 n. 6
Ellington, Duke 125, 134
Evans, Bill 140, 142
Evnine, Simon 52 n. 9

Faubus, Orval 140
Fauré, Gabriel 1, 26–7, 60, 83, 142
Feagin, Susan 17 n. 1

Fenner, David 19 n. 4
Ferguson, Donald 23 n. 12
Ferry, Luc 12 n. 5
Field, John 59
Fine, Kit 52 n. 8
Fitzgerald, Ella 102, 107
Flaubert, Gustave 47
Furia, Philip 122 n. 9, 125 n. 12

Gaut, Berys 79
Gershwin, George 122 n. 8
Gioia, Ted 132
Glass, Philip 9 n. 2, 14, 15, 141
Goldie, Peter 60 n. 2
Golson, Benny 142
Gombrich, Ernst 46
Gottlieb, Henrik 42 n. 15
Graves, Michael 161
Greenberg, Clement 156
Grice, Paul 106
Grisey, Gérard 60
Gurney, Edmund 23 n. 12, 33, 72, 78, 85

Haggart, Bob 126
Hanslick, Eduard 62, 72, 78, 85
Hart, Lorenz 4, 70, 123
Hartman, Johnny 104
Hauser, Mark 75
Haydn, Franz Joseph 8, 10, 60, 63, 118, 119
Hegel, G. W. F. 168
Hesse, Herman 7
Higgins, Kathleen 70
Hodeir, André 132
Holiday, Billie 84, 137 n. 2
Hopkins, Anthony 22
Houellebecq, Michel 121
Howell, Robert 52 n. 6
Hume, David 10, 16
Huovinen, Erkii 38 n. 8
Huron, David 75
Huxley, Aldous 7

Iseminger, Gary 21 n. 8
Ives, Charles 60

Kafka, Franz 55
Kant, Immanuel 10, 16
Karno, Mitchell 42 n. 15
Kemp, Gary 21 n. 7
Kieran, Matthew 79

Kierkegaard, Soren 16
Kivy, Peter 2, 22, 23n. 10–11, 25 n. 17, 26 n. 18, 32–41, 72, 74, 79, 115, 117–18, 120
Koehler, Ted 123
Konečni, V. J. 42 n. 15

Lalitte, Philippe 23 n. 11
Langer, Susanne 23 n. 12, 72, 80, 85, 162, 167, 168
Leddy, Tom 20 n. 5
Leibniz, Gottfried Wilhelm 8–9
Lessing, Gotthold 155, 156, 168
Levitin, Daniel 75
Ligeti, György 60
London, Justin 43

MacLean, Jackie 137 n. 2
Mahler, Gustav 7, 13, 36, 60, 61, 64, 65, 81, 116
Mann, Thomas 7, 62, 63
Mapplethorpe, Robert 121
Massenet, Jules 60, 65
Mast, Gerald 156, 159 n. 7
Maus, Fred 25 n. 16
McDermott, Josh 75
McNeil, William 70
Mendelssohn, Felix 64, 78, 142
Merrill, Helen 112
Mersenne, Marin 79
Messiaen, Olivier 13
Meyer, Leonard 72, 86
Mingus, Charles 140
Mondrian, Piet 46, 121
Monk, Thelonious 133, 138, 142
Morizot, Jacques 46
Morrissette, Bruce 162
Morton, Jelly Roll 134
Mozart, Wolfgang Amadeus 7, 10, 42, 61, 138

Nabokov, Vladimir 121
Nattiez, J. J. 155
Nietzsche, Friedrich 8, 16, 66, 67–8, 71
Noland, Kenneth 158

Ockeghem, Johannes 63
O'Day, Anita 112

Parish, Mitchell 125
Parker, Charlie 139

Penderecki, Krzysztof 61
Pinter, Harold 155
Pollock, Jackson 46
Porter, Cole 4, 101, 110, 111–12
Poulenc, Francis 60, 65, 142
Powell, Bud 139
Proust, Marcel 83
Puccini, Giacomo 65
Putman, Daniel 97 n. 5

Raksin, David 64
Ravel, Maurice 60, 153
Raye, Don 123
Reich, Steve 9 n. 2, 14, 15, 141
Riefenstahl, Leni 121
Rodgers, Richard 70, 123
Rodogno, Raffaele 94 n. 4
Rosch, Eleanor 65 n. 4
Rothko, Mark 121
Russell, James 136

Saint-Saëns, Camille 62–3
Satie, Erik 8
Savile, Anthony 79
Schellekens, Elisabeth 60 n. 2
Schoenberg, Arnold 7, 14, 15, 36, 42,
 60, 61, 97–8
Schopenhauer, Arthur 7, 8, 16, 72,
 85, 168
Schubert, Franz 44, 60, 61, 64, 161
Schumann, Robert 15, 60, 63
Schuur, Diane 107, 112
Scriabin, Alexander 13, 15
Scruton, Roger 8 n. 1, 19, 22,
 23n. 12–13, 28, 29–31
Sessions, Roger 68, 70
Severini, Gino 161
Shepp, Archie 140
Shostakovitch, Dmitri 65, 138, 142
Shelley, Percy Bysshe 45
Silver, Horace 142

Smetana, Bedřich 61
Snow, Michael 161
Sontag, Susan 158
Spinoza, Benedict 10
Stecker, Robert 20 n. 5, 21 n. 8, 53
Stockhausen, Karlheinz 9 n. 2
Stolnitz, Jerome 20 n. 5
Strauss, Richard 7, 61, 97–8
Stravinsky, Igor 60, 64, 65
Styron, William 3, 92–3
Sullivan, J. W. N. 72, 80, 85–6

Takemitsu, Toru 61
Taylor, Cecil 132
Tchaikovsky, Peter Ilyich 60, 63, 64, 118
Teroni, Fabrice 94 n. 4
Tillmann, Barbara 23 n. 11, 41 n. 12,
 42 n. 16
Tinctoris, Johannes 79
Titian 43
Tolstoy, Leon 123

Varèse, Edgar 60
Vaughan, Sarah 112
Vaughan Williams, Ralph 13
Vlaminck, Maurice 158

Wagner, Richard 8, 15, 61, 161 n. 8, 163
Waldron, Mal 137 n. 2
Walton, Kendall 46
West-Marvin, Elizabeth 42 n. 14
Wilde, Oscar 121
Wilder, Alec 122 n. 9
Williams, Bernard 90
Williams, Martin 134, 139
Wollheim, Richard 19, 46, 52
Wolterstorff, Nicholas 50

Xenakis, Iannis 14, 15, 61

Zuckerkandl, Victor 155, 162

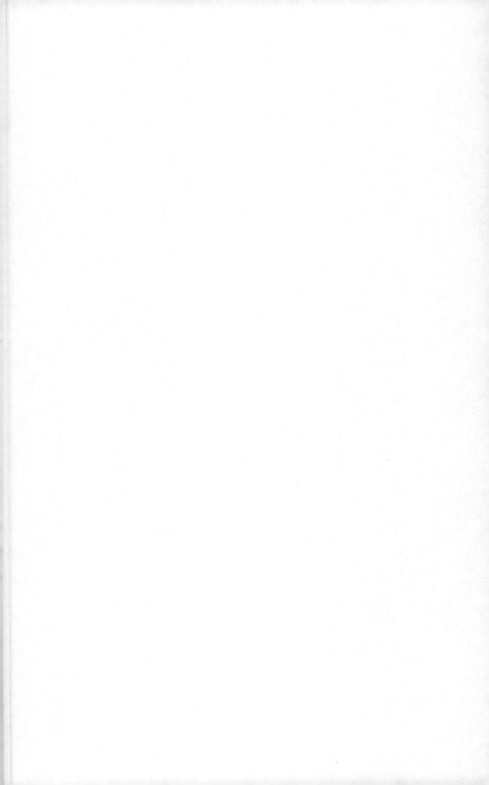